Daily Life

Nature

Sports

Long-Term Projects

Lars Boering

Managing Director, World Press Photo Foundation

Who speaks out for photojournalism?

Conflict uproots people and forces them to seek asylum. Inequality produces injustice. Humanity's impact on the environment threatens species. Innovative technological advances disrupt established industries. The transformation in the media economy means more people than ever produce, share and enjoy visual imagery.

In this world, where there are so many stories that need to be told, and so many ways of telling them, but where the social and cultural value of imagery is not always matched by its economic worth, who speaks out for photojournalism? Who looks out for and supports the professional photographers who provide the context and the narrative we so badly need in order to comprehend these changes?

At the World Press Photo Foundation, we work to develop and promote quality visual journalism because people deserve to see their world and express themselves freely. Freedom of information, freedom of inquiry and freedom of speech are more important than ever, and quality visual journalism is essential for the accurate and independent reporting that makes these freedoms possible. Today, when the world, the press and photography itself are undergoing seismic changes, we strive to help both visual journalists and their audience understand and respond to these transformations so these freedoms can be secured.

When we were founded in 1955 the idea was clear and simple: learn from others and share your work. More than sixty years on that is still at the core of what we do. We help visual journalists present their stories to a global audience that seeks fresh insights and new perspectives, and celebrate the highest standards of visual journalism, as the great work in this book shows. We train new talent in both the craft of visual storytelling and good journalistic practice, as well as through research, analysis and debate involving both the profession and the public and we also seek new opportunities and ways forward in meeting the many challenges confronting visual journalism.

Inspiring, engaging, educating, supporting. That is our mission for our community. A very strong and vital community. We love and cherish this community, we nurture it and we empower it. We do this in striving to make the world a better place for visual journalism. That is because we believe that quality visual journalism helps to make the world a better place, period.

Francis Kohn
Chairman of the 2016 Jury

Chairing the general jury of the 2016 Photo Contest, and working with six other highly experienced professionals from around the world, was a great privilege and very stimulating. The jurors had strong points of view but were very open to discussion and persuasion. From the beginning we debated about how to approach our task, asking ourselves what were the main events of 2015. A majority of us thought first of the refugee crisis, but we also believed the contest should reflect the diversity of world events as long as the photos were compelling.

Our topics were determined by the subjects entered. In all the news categories, including contemporary issues and daily life, the majority of photos dealt with the refugee crisis. Given that, we had to be very selective with the photos, which were often repetitive. We also viewed photos from Syria, events on the border between Syria and Turkey, and the January and November attacks in Paris—all of which are in effect part of the same global story—as well as stories from a number of African countries, China, Nepal and the United States.

At every step, we were looking in depth at each photo, considering both its aesthetic qualities and editorial content, referring regularly to captions in order to understand the intentions of the photographer, and evaluating the merit of their narrative. There were also many discussions about new approaches to telling a story. Could news photography be more daring, subtler, than the so-called classical, straightforward, mode of reporting? The jury was open to innovative ideas, and some prizes in the People category reflect that. But originality for the sake of originality did not win favor with the majority of jurors.

The picture that became the photo of the year was not 'love at first sight' for some jurors, but the feeling for the photo kept growing, almost silently, as the contest advanced through its many rounds. During the final debate, we were partly concerned with the global significance of the refugee crisis versus other issues. In the end the jury chose this image because it is both simple, powerful and symbolic. When all the elements of this black and white photo came together, we saw it told the whole story: crossing a border at night, the barbed wire, and a man passing a baby to another who is like a shadow. The photo tells of fear, of hardship, and of hope.

Warren Richardson
World Press Photo of the Year 2015 winner

How did you get into photography?

I started when I was nine or ten, I kept stealing my father's camera and I just started taking pictures. I didn't work as a photographer to start with, in fact I became a plumber. In my teens I was diagnosed with cancer. I remember this one woman in the treatment center; before she died, she said go and kick all the goals in life that you can because one day it'll be never there for you again. Nothing lasts forever, she said, and I took that to heart.

Years later I heard those words ringing in my head. I woke up one morning and realized that being a plumber wasn't for me and two weeks later I booked a ticket and left the country. I had an old Pentax camera, but I never went with the idea of taking pictures, I went with the idea of escape. I was tired of seeing the world from a television or a magazine, I wanted to see it for myself. I went to Thailand, then Nepal. And Laos. Laos really had a strong pull on me and I spent a lot of time on the Ho-Chi Minh trail and I became familiar with the Mines Action Group. I recalled the pictures of the Vietnam War, looking at refugees and wars, and I got to know the aftermath.

When did you start covering the refugee issue?

I run a photographic tour in Budapest and part of my route goes into a hard area of Budapest near Keleti station. I went up there every single day and I just documented the situation for maybe six weeks.

I went there one night and in front of me was a Syrian man and his whole family, and on the fence was a Muslim woman with her head covered. I took a picture and one of the men stood up and screamed at me, 'No photos, no photos.' I said I'm sorry, I should've asked you, and he said, 'Sit down with me,' and we talked until nine o'clock the next morning. I took the whole family back to my house. They stayed for a couple of days and it was liberating in a lot of ways; I was actually doing a lot more.

The family said they'd found a way to get to Germany, but they failed and were sent back to Keleti. One morning I went up to take photos at the station again and who do I see but the family again. But this time relatives have caught up with them. So now I have 15 to 20 people and they all come back to the house. I did all the washing again, one man had really bad blisters on his feet so we soaked them in salt to kill any infections, they smoked like there was no tomorrow and I could see they were really stressed.

Inside the house where I live, there are some old women who are all normally a bit paranoid. One of the neighbors had gone to close the door and she looked out of this little crack and I think she was panicking; she saw these Muslim women

walking past, men with beards. Two hours later I get a knock at the door and the old woman, with a bunch of other people, had made a whole lot of food for the refugees and said, 'Eat, this is yours.' And it was quite an emotional experience. You could see that the Syrians were very, very taken back by it and it was quite a wonderful thing to see. In the end the family, they hatched a plan, they had a friend in Dubai that paid for a couple of vans to come down to Budapest to pick them up, and they gave me a call and an email about two days later to say they were in Munich, they'd made it.

Tell us how your winning photograph was made.
I camped with the refugees for five days on the border. A group of about two hundred people arrived, and they moved under the trees along the fence line. They sent women and children first, then fathers and elderly men. I must have been with them for about five hours and we played cat and mouse with the police the whole night. I was exhausted by the time I took the picture. I was up and down this ditch, going through mud, coming back up, going down again, just to capture that moment of what's going on. There were people holding out their hands like, 'Come on, quickly, quickly,' and they were all racing under the fence. It was around three o'clock in the morning and you can't use a flash while the police are trying to find these people, because it would just give them away, so I had to use the moonlight alone.

How do you think about the impact your photo might have?
I have asked this question myself, but it's not about it being seen or the glory of it being seen. To me this is a part of our history, it's giving me a much greater understanding. I really appreciated meeting new people. I was hearing a lot of negative things about these people but what I've been experiencing with them is the complete opposite. They are family orientated; they just want the same life we enjoy. At the end of the day, this earth is not just mine or yours, it is theirs as well. Why would I build a fence to say you can't come on this piece of dirt, you must stay on that one?

Photo: Ildiko Fulop

Warren Richardson is a freelance photojournalist currently working in Eastern Europe. Born in Australia in 1968, he is self-taught photographer who undertakes long term projects dealing with human and environmental issues, as well as assignments for newspapers, magazines and companies.

The 2016 Singles

Zhang Lei

China, *Tianjin Daily* /
1st Prize Contemporary Issues

A cloud of smog hangs over
Tianjin, in northeastern China,
in December. Tianjin, the fourth
most populous city in China, is
an industrial and logistics hub.
Its port forms a gateway to
the national capital, Beijing.
Hazardous smog blanketing
China's northeast triggered red
alerts in a number of cities
throughout the month, including
Beijing and Tianjin. Schools were
advised to stop classes, and
people were told to stay inside
and restrict vehicle use.

Adriane Ohanesian

USA /
2nd Prize Contemporary Issues

Adam Abdel (7) was badly burned when a bomb dropped by a government plane landed next to his family's home in the rebel-held territory of Burgu, Central Darfur, Sudan. Adam was blown out of the house by the force of the blast, and his clothes caught fire. Two weeks later, his burns were still healing. Treatment was hard to obtain, because the government continued to deny NGOs and relief workers access to rebel-held territory. Unrest in Darfur ignited in 2003, after the government of President Omar al-Bashir cracked down on an insurgency. Since then, hundreds of thousands of people have been killed and millions displaced.

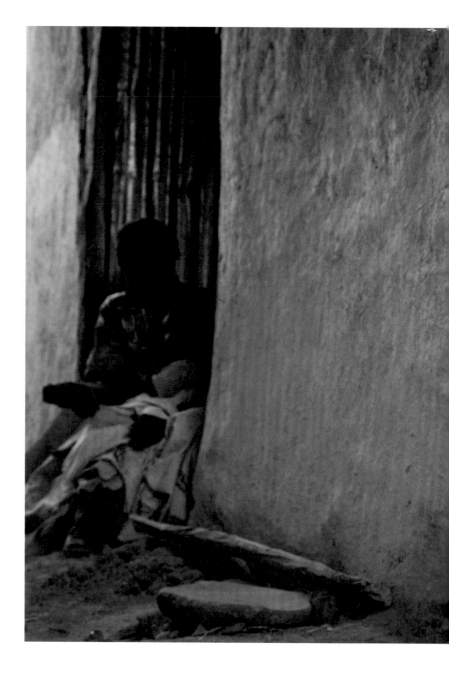

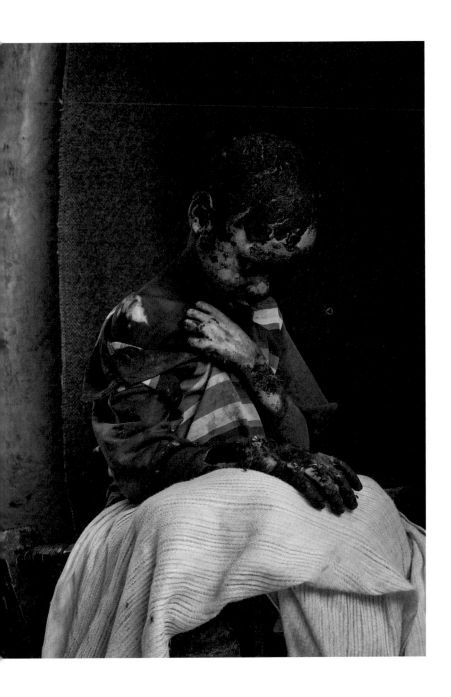

John J. Kim

USA, *Chicago Tribune* / 3rd Prize Contemporary Issues

Lamon Reccord stares down a police sergeant during a march against police racial violence, in Chicago, Illinois, USA, on 25 November. Protests had taken place almost daily since the release of a police-car dashcam video showing 17-year-old Laquan McDonald being fatally shot by a Chicago police officer. McDonald, who was armed with only a knife, was shot 16 times by the officer, who said he feared for his life. The protest was one of a number that occurred through-out the year, following episodes elsewhere in the country where the police were accused of using excessive violence against black men, often involving fatal shootings.

→

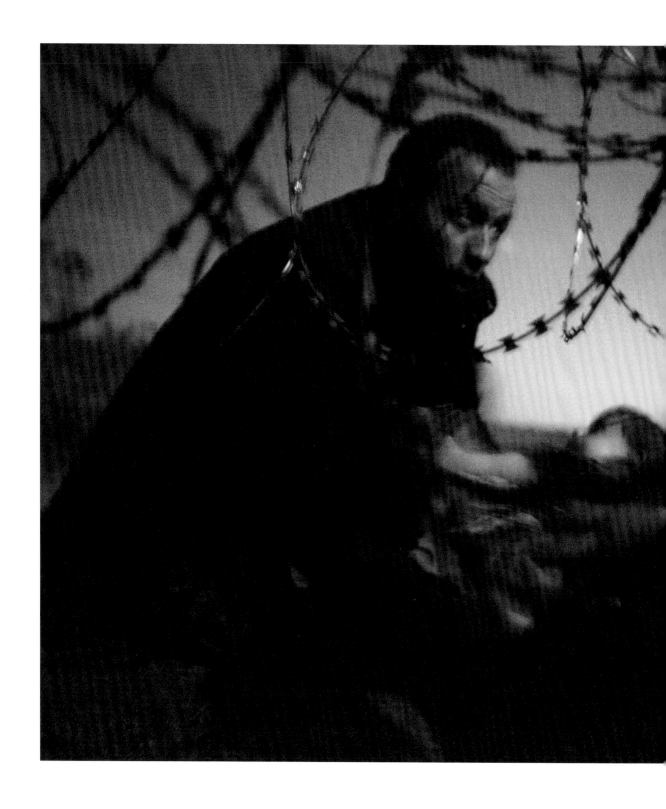

Warren Richardson

Australia /
World Press Photo of the Year 2015 /
1st Prize Spot News

A baby is handed through a hole in a razor wire barrier, to a Syrian refugee who has already managed to cross the border from Serbia into Hungary, near Röszke, on 28 August. Hungary was hardening its stance towards refugees attempting to enter the country. In July, Hungary began construction on a four-meter-high barrier fence along the entire length of the frontier with Serbia, to close off border crossings through all but official routes. Refugees attempted to find ways through before the fence was completed on 14 September. This group had spent four hours hiding in an apple orchard at night, dodging border police, being gassed with pepper spray, and trying to find a way across.

Corentin Fohlen

France, Divergence /
2nd Prize Spot News

People demonstrate their solidarity with victims of terrorist attacks, and voice support for freedom of speech, at the end of a rally at the Place de la Nation in Paris, on 11 January. *Marches républicaines* (Republican marches) were held throughout the country, following the shootings by Islamist gunmen at the offices of the satirical magazine *Charlie Hebdo*, and a succession of other attacks in and around Paris, which resulted in 16 dead (including three of the assailants). The Paris march took place from the Place de la République to the Place de la Nation. French government officials estimated that between 1.2 million and 1.6 million people attended what was the largest public rally the French capital had seen since liberation from the Nazis at the end of World War II.

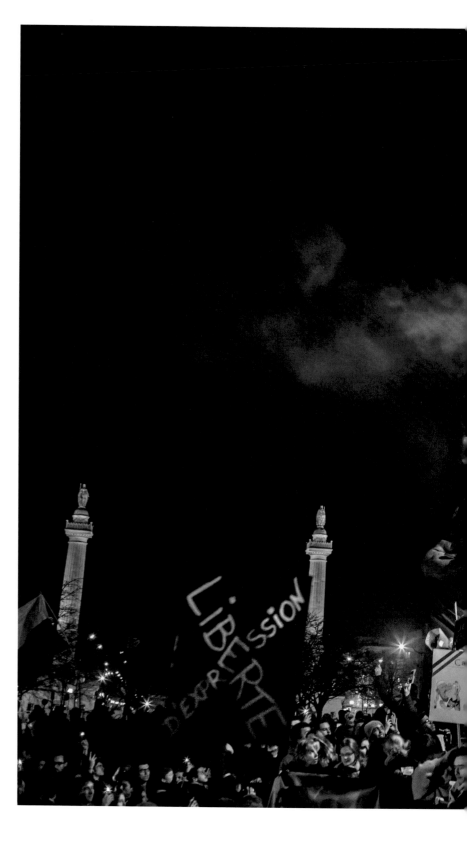

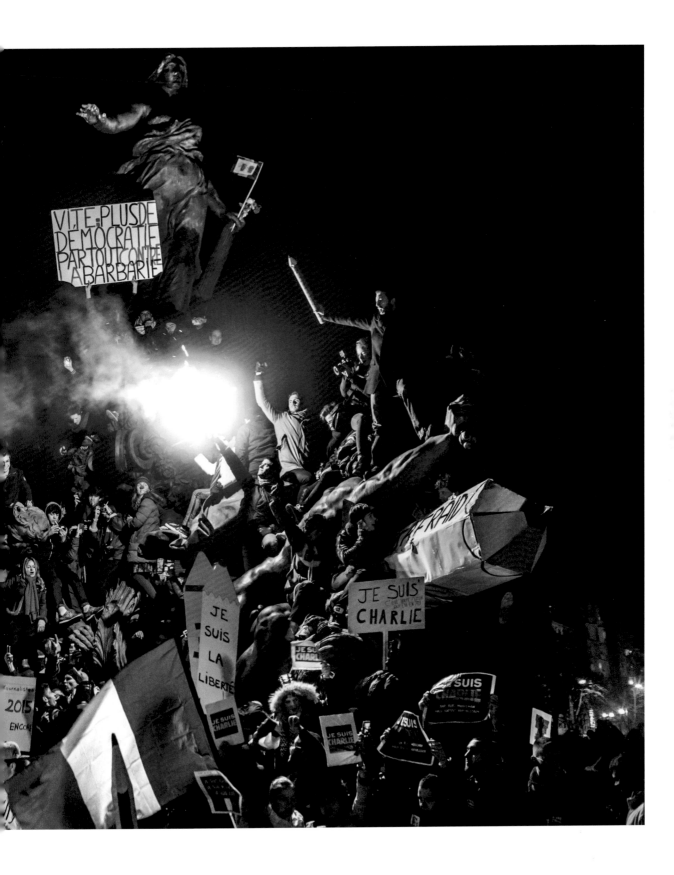

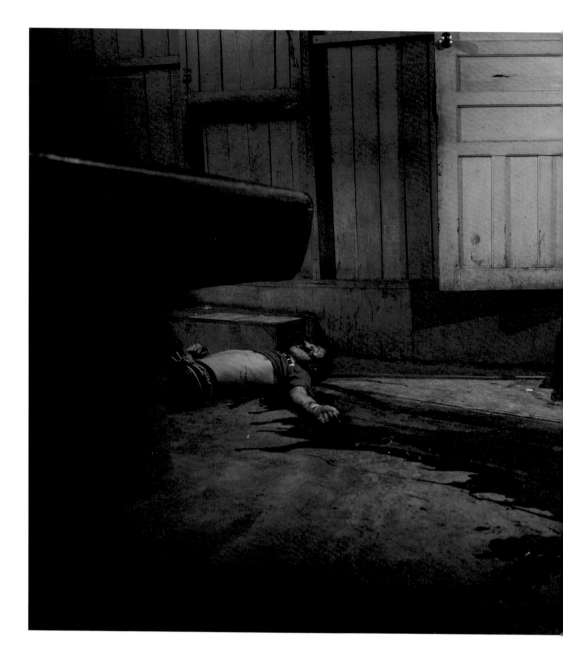

Niclas Hammarström
Sweden / 3rd Prize Spot News

A man lies dead after a gang shoot-out in San Pedro Sula, Honduras, on 4 April. He was the fourth victim on the same street of an ambush by members of the 18th Street gang on their rivals MS13. For the past decade, Honduras has been at the top of the world's homicide list. Violent deaths have declined since a 2011 peak, but Honduras still officially recorded 5,047 homicides in 2015. Most of the violence is gang-related, in a country which is on a transit route for drugs, and where corruption is widespread and gangs wield great power.

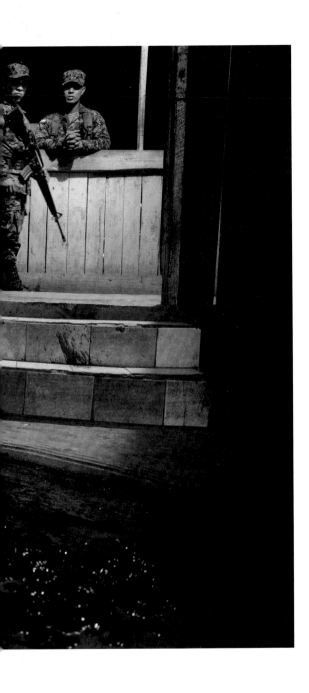

Matic Zorman

Slovenia / 1st Prize People

Refugee children covered in rain capes wait in line to be registered in Preševo, Serbia. Most refugees who crossed into Serbia continued their journey north, towards countries of the European Union.

→

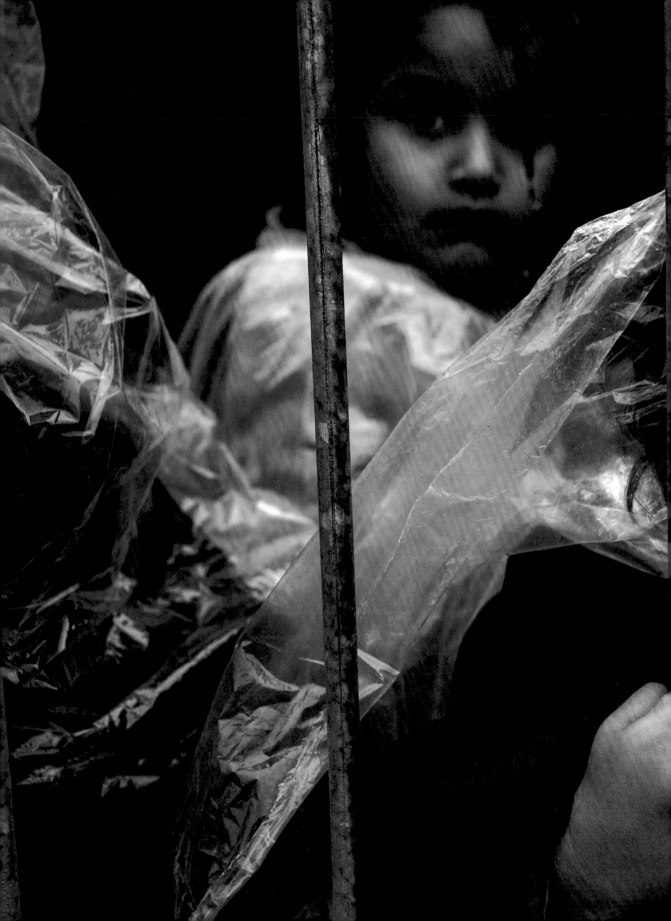

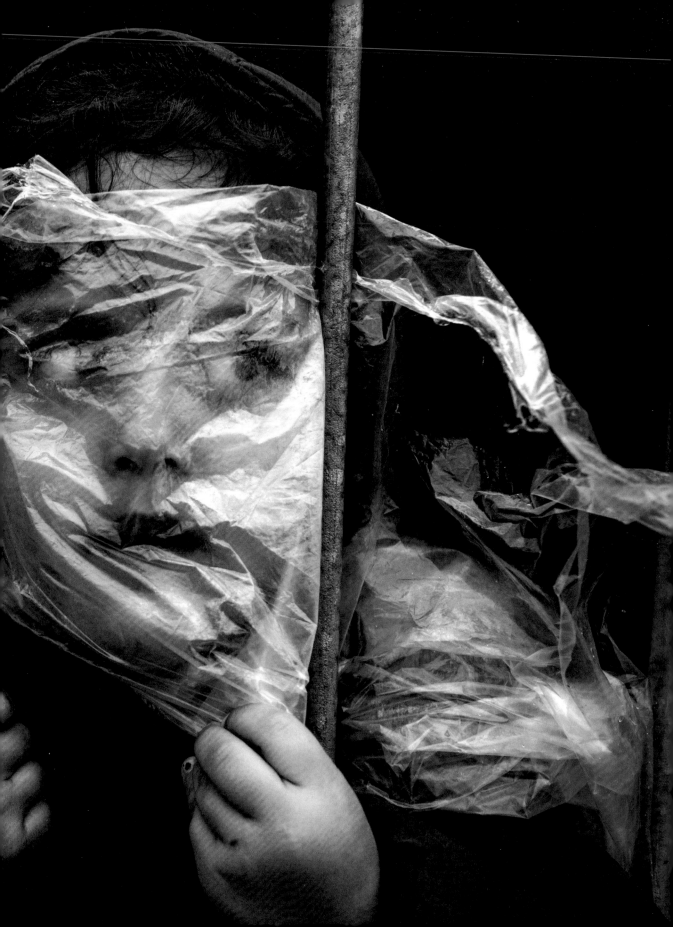

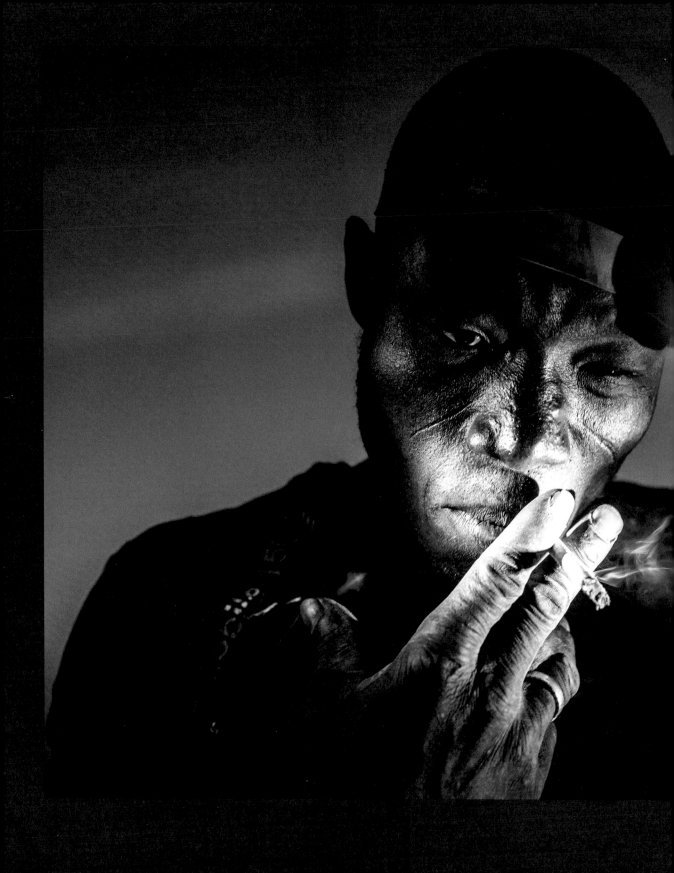

Matjaz Krivic
Slovenia / 2nd Prize People

Arzuma Tinado (28) leads an eight-member crew of miners at Djuga, an artisanal gold mine in north-eastern Burkina Faso. Around 15,000 people work in the area, in pits hacked into the ground, some barely wider than a manhole. As the price of gold fell, people began to dig ever deeper to find enough to make a daily wage. Arzuma works some 20 meters underground. Mining under these conditions is backbreaking labor, during which miners are constantly breathing in dust. The subsequent process of extracting the gold exposes them to mercury and cyanide.

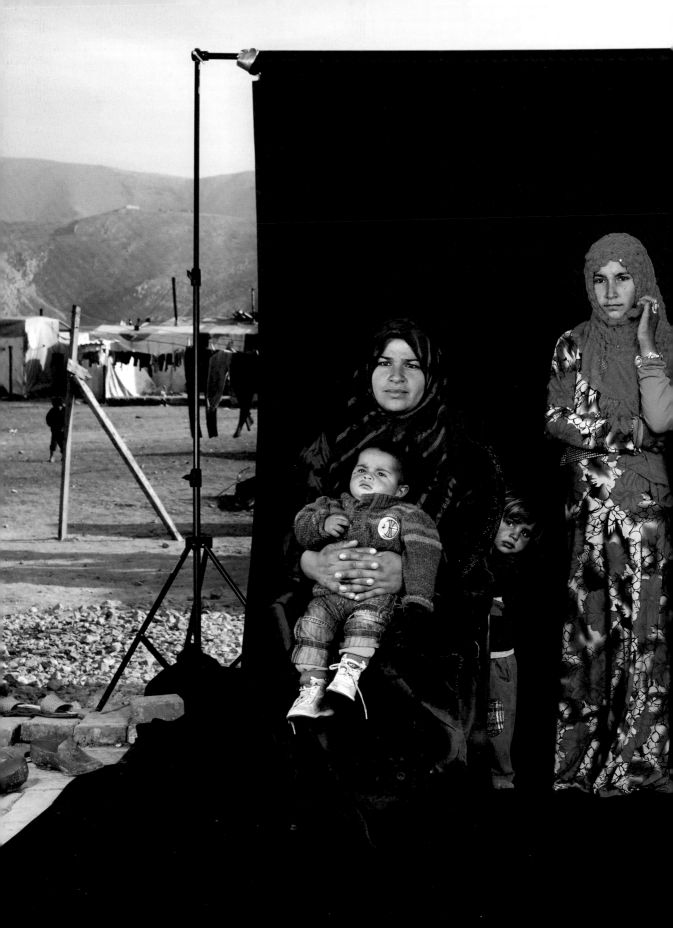

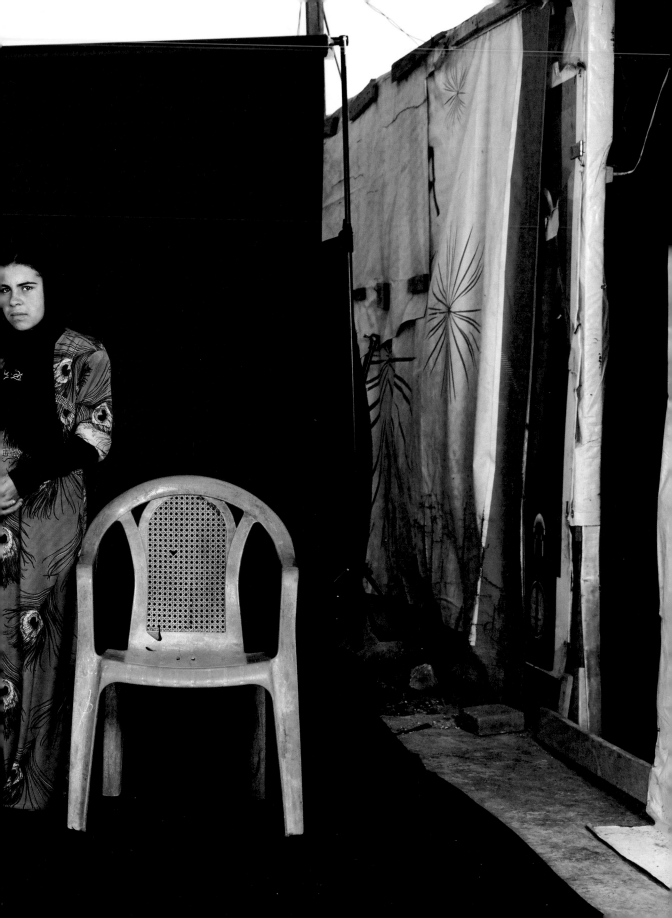

Dario Mitidieri

Italy, for CAFOD / 3rd Prize People

A Syrian family in a refugee camp in the Beqaa Valley in Lebanon stands beside a chair representing a missing family member. According to UNHCR, by the end of the year, more than 370,000 Syrian refugees were living in camps in the Beqaa Valley, close to the Syrian border.

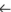

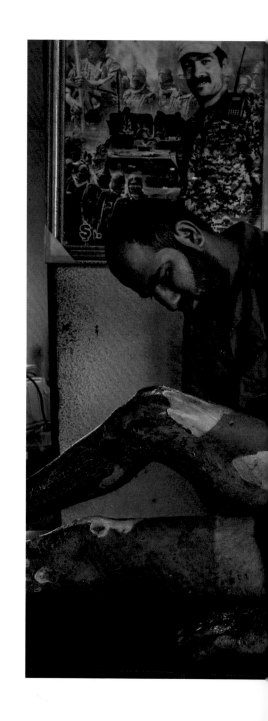

Mauricio Lima

Brazil, for *The New York Times* / 1st Prize General News

A doctor rubs ointment on the burns of Jacob, a 16-year-old fighter from the group calling itself Islamic State (IS), in front of a poster of Abdullah Öcalan, leader of the Kurdistan Workers' Party (PKK), at a hospital in Al-Hasaka, northern Syria. The hospital was controlled by the People's Protection Units (YPG), a Kurdish force opposing IS incursion into a Kurdish region in northeastern Syria. IS, which aims at establishing an Islamic caliphate in the region, was in control of other northern areas around Raqqa and Aleppo. According to YPG militiamen, Jacob was the sole survivor of a YPG ambush on a truck alleged to have been carrying six IS fighters on the city outskirts.

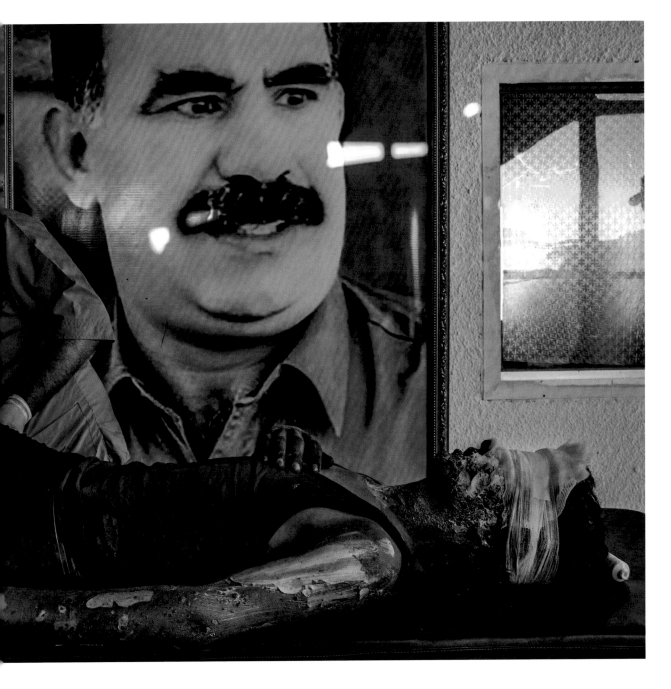

Paul Hansen

Sweden, *Dagens Nyheter* /
2nd Prize General News

Volunteers assist refugees
arriving on the Greek island of
Lesbos, after crossing by boat
from Turkey under cover of
darkness, on 6 December. In
November, the European Union
granted Turkey three billion
euros for border control, and to
keep refugees within the country.
Police and coastguard patrols
stepped up significantly, and to
avoid detection many attempted
the crossing at night, often in
flimsy or unseaworthy craft.
Many people drowned after
boats capsized or sank, and
those who survived the cross-
ing often arrived in a state of
hypothermia.

Chen Jie

China, Beijing News /
3rd Prize General News

A large pit, wrecked vehicles and damaged buildings remain in the aftermath of explosions in the container storage station of a logistics company in the Port of Tianjin, northeastern China. The warehouse, owned by Ruhai Logistics, was registered for storage of hazardous chemicals. Safety regulations stipulating that public buildings should be at least one kilometer away were not heeded. A series of explosions at the facility resulted in damage to some 17,000 residences and 8,000 vehicles, killing over 170 people (95 of them firefighters) and injuring hundreds more. Later investigation concluded that the first explosion occurred in an overheated container of dry nitrocellulose, which set off further explosions, including one that involved the detonation of around 800 tonnes of ammonium nitrate.

Kevin Frayer

Canada, Getty Images / 1st Prize Daily Life

Smoke billows from stacks as men push a tricycle through a neighborhood next to a coal-fired power plant, in Datong, northern Shanxi province, China. The region is the leading producer of coal in China, with annual production exceeding 300 million tonnes. Air pollution is estimated to contribute to around 17% of all deaths in China, and a heavy dependence on burning coal for energy has made China the source of nearly a third of the world's CO_2 emissions.

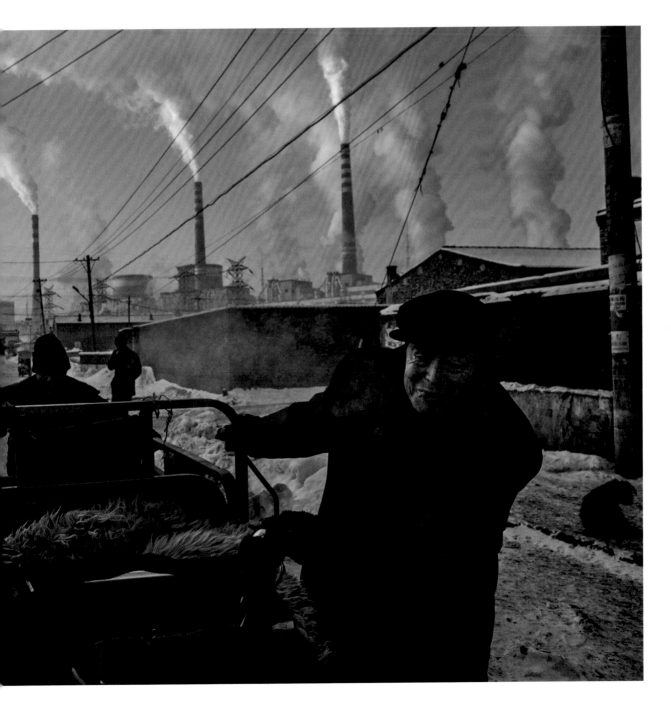

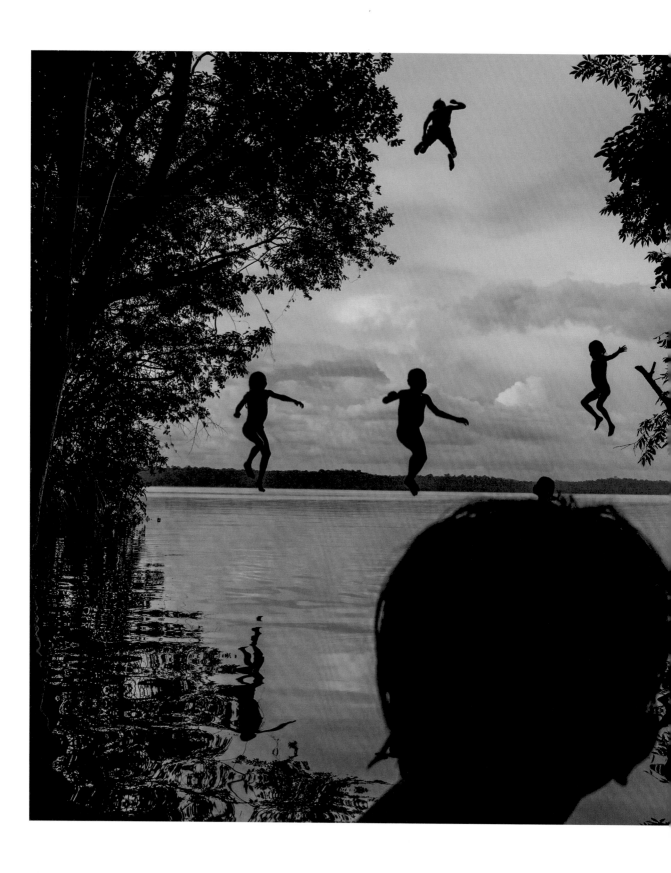

Mauricio Lima

Brazil, for Al Jazeera America /
2nd Prize Daily Life

Children play in the Tapajós River,
home to the Munduruku people, in
the Brazilian Amazon. The Mundu-
ruku is one of the largest ethnic
groups in Brazil and for at least
three centuries its people have
lived along the Tapajós River. The
Tapajós is one of the last great
Amazonian rivers without a dam,
but the Brazilian government is
planning a hydroelectric plant
which will flood much of Mundu-
ruku land. Their leaders say they
have a constitutional right to
remain on their land, but that
the government is refusing to
acknowledge it.

Zohreh Saberi

Iran, Mehr News Agency / 3rd Prize Daily Life

Raheleh (13), born blind, stands behind a window in the morning. She enjoys the warmth of sunlight on her face. Raheleh lives in Heijle, a highland village in the north of Iran. Her father is a farmer, and her mother suffers from multiple sclerosis, but is able to do some household chores. Raheleh is curious about life, and always wants to know more. Although she is unaware of color, she can sense light during the day, and darkness at night, and she explores her surroundings through touch, listening to sounds, and smell.

Rohan Kelly

Australia, *The Daily Telegraph* /
1st Prize Nature

A massive shelf cloud moves towards Bondi
Beach, Sydney, Australia, on 6 November.
The cloud was part of a weather front that
brought violent thunderstorms, with local
media reporting damaging winds, hail-
stones the size of golf balls, and heavy
rainfall. Shelf clouds are low cloud banks
often with smooth or layered surfaces,
and black, turbulent bases. →

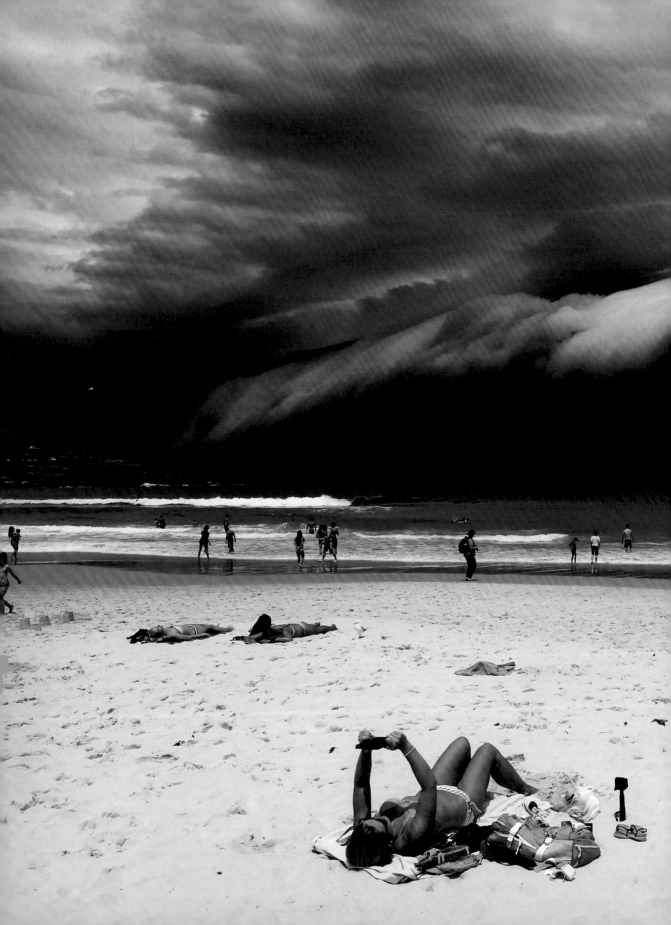

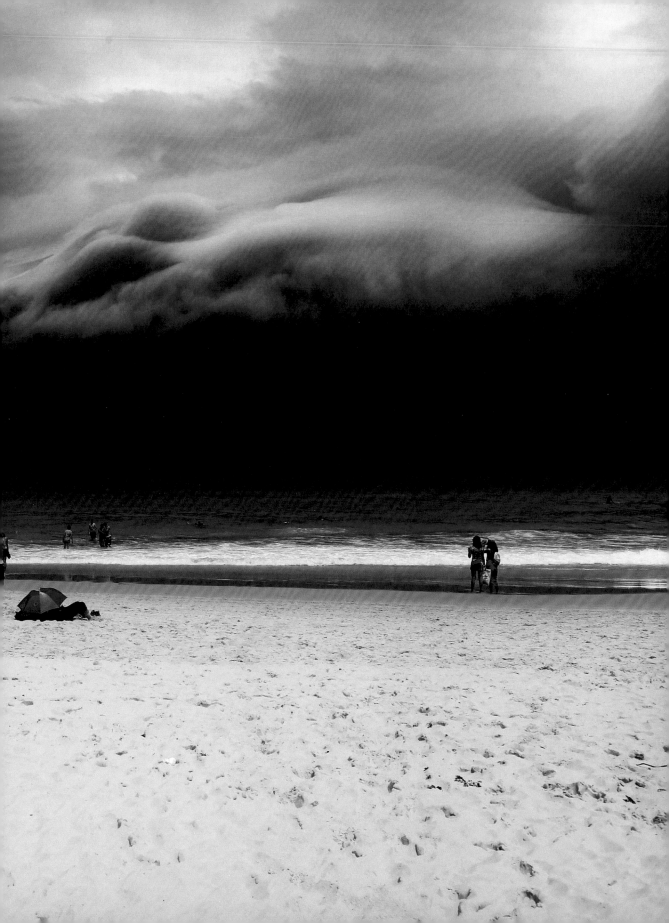

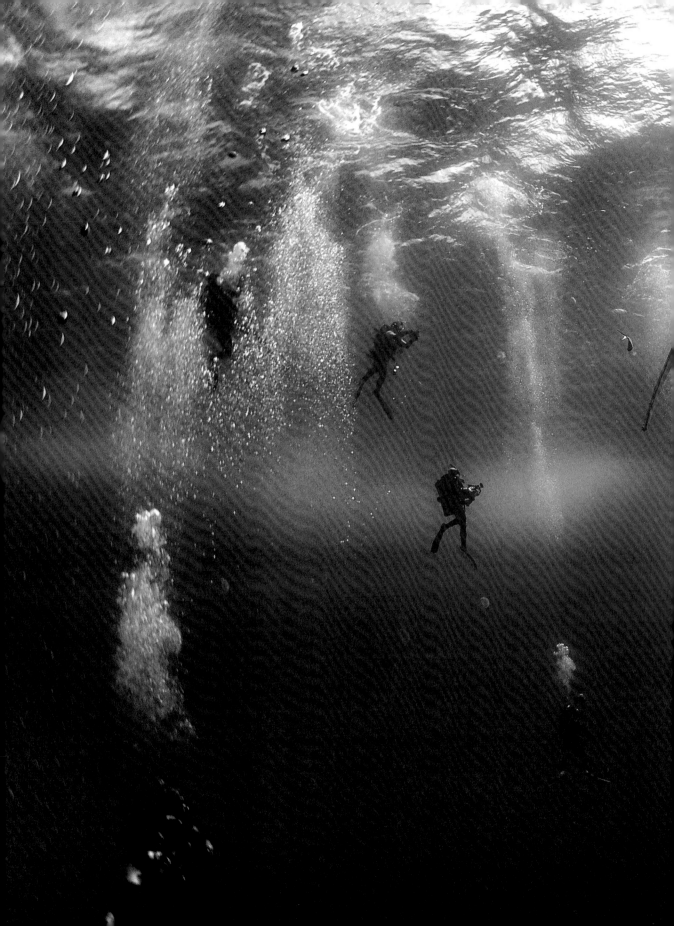

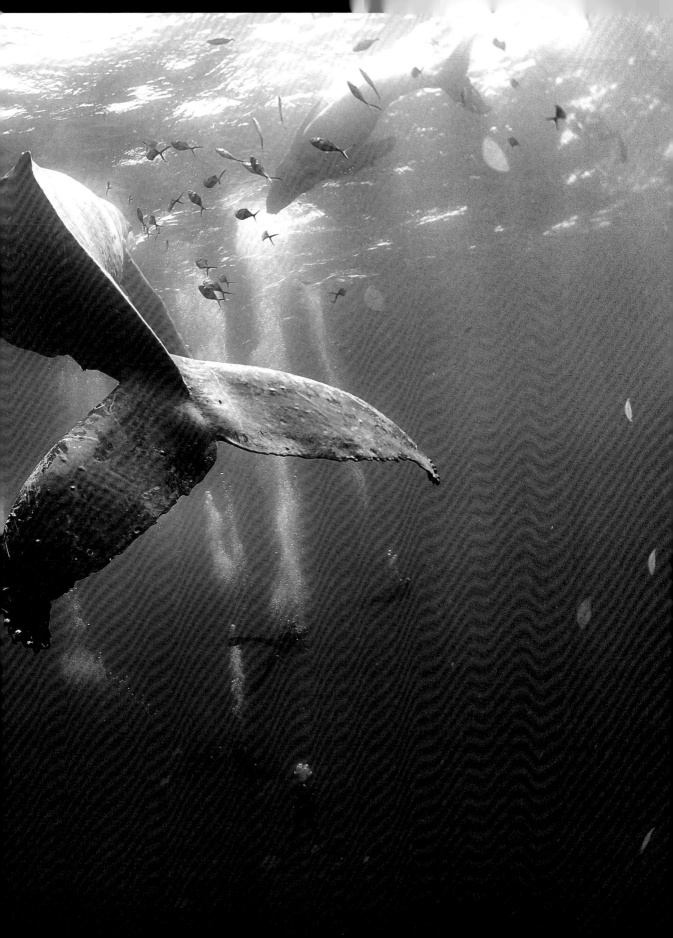

Anuar Patjane Floriuk

Mexico / 2nd Prize Nature

A humpback whale and her newborn calf
swim near Roca Partida, the smallest of
the Revillagigedo Islands, off the Pacific
coast of Mexico. During the mating season,
the island waters are home to a large
population of humpback whales, and are a
popular diving destination. The islands are
volcanic and are themselves uninhabited,
apart from a small naval presence. They
were declared a biosphere reserve in 1994,
and are currently under consideration as a
UNESCO natural heritage site.

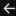

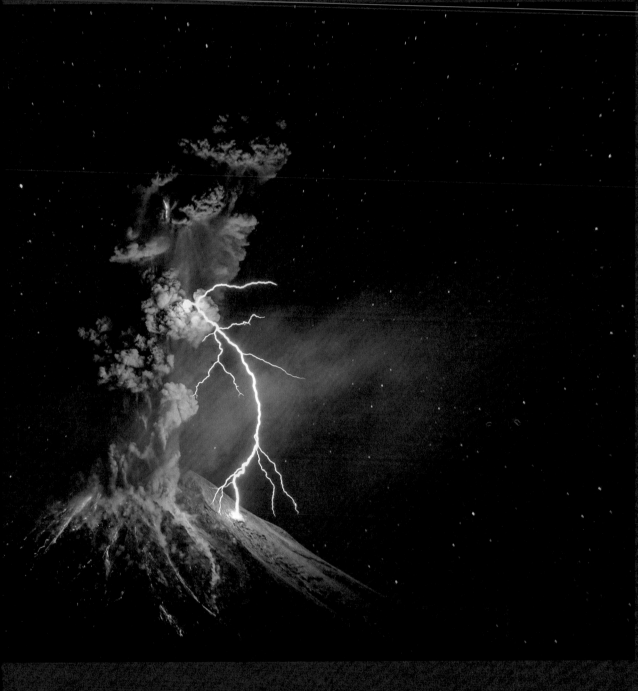

Sergio Tapiro
Mexico / 3rd Prize Nature

Colima Volcano erupts with rock showers, lightning, and lava flows, on 13 December. The volcano, which is one of the most active in Mexico, showed an increase in activity from July onwards. Lightning in volcano eruptions is generated when rock fragments, ash and ice particles in the volcanic plume collide, producing static charges—just as ice particles do in clouds.

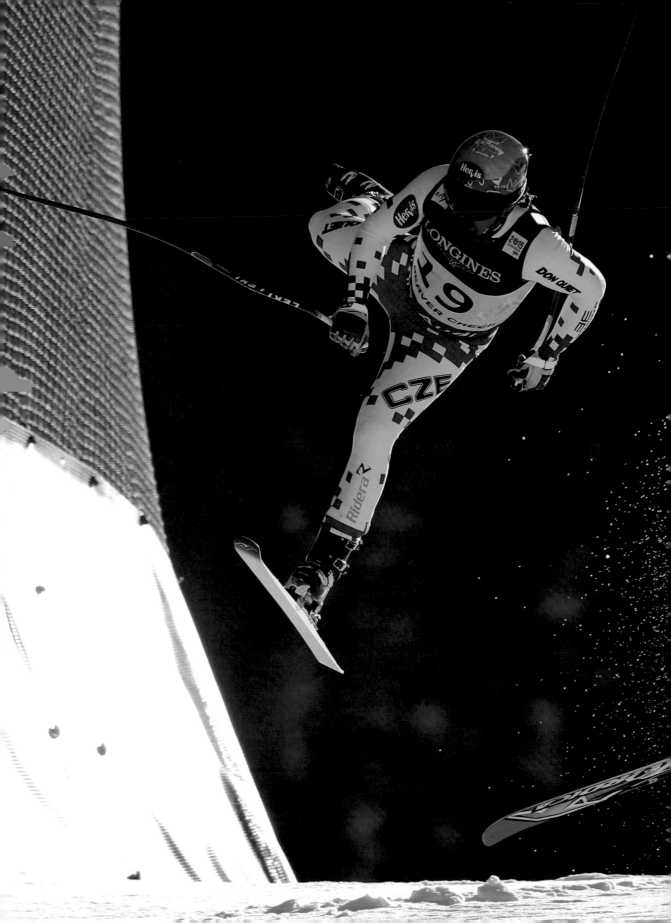

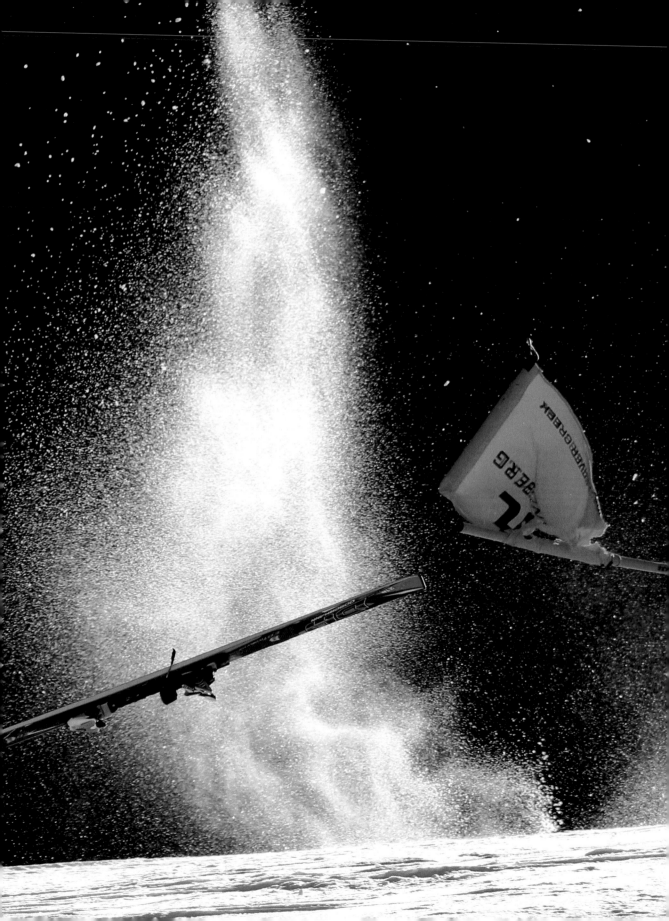

Christian Walgram

Austria, GEPA pictures /
1st Prize Sports

Czech skier Ondrej Bank crashes during
the downhill portion of the alpine com-
bined contest, at the FIS Alpine World Ski
Championships in Beaver Creek, Colorado,
USA, on 8 February. Bank stumbled and
lost control just before the final jump. He
was hospitalized with concussion and
facial injuries.

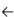

Greg Nelson

USA, for *Sports Illustrated* / 2nd Prize Sports

Ron Baker (31) shoots over Nick Zeisloft (2), as Hanner Mosquera-Perea (12) and
Rashard Kelly (0) battle for position under the basket, at the National Collegiate
Athletic Association (NCAA) Men's Division I Basketball Tournament game between
Wichita State and Indiana, at the CenturyLink Center in Omaha, Nebraska, USA.
Wichita won 81-76. The tournament, held each spring and popularly known as 'March
Madness', is a major national competition, featuring 68 college teams. Since its
creation in 1939, it has become the most popular basketball tournament in the US.

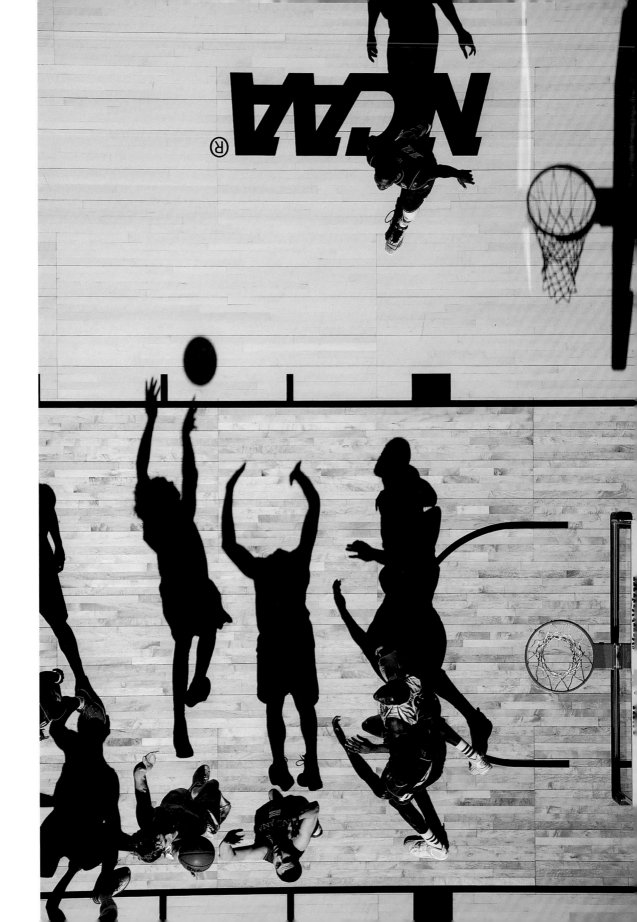

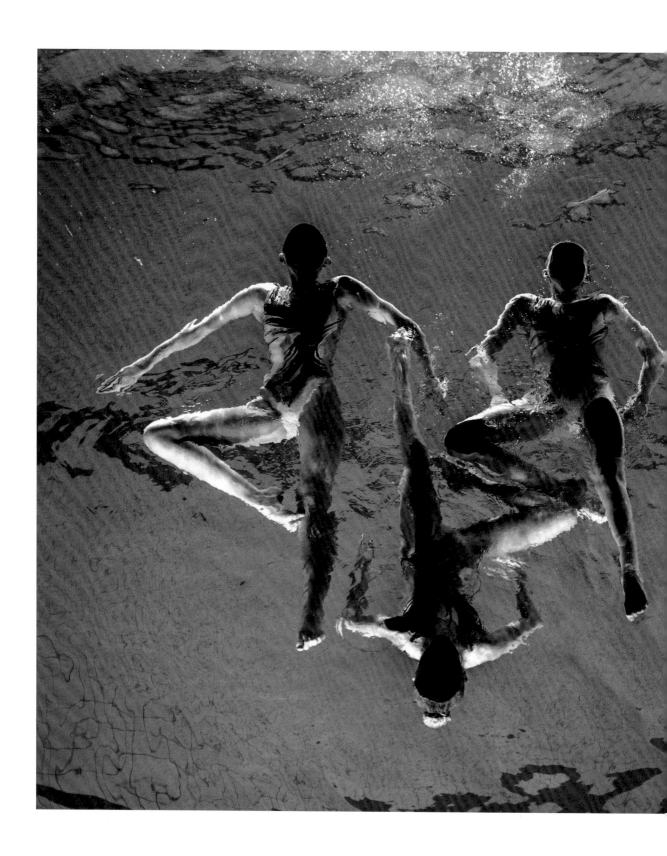

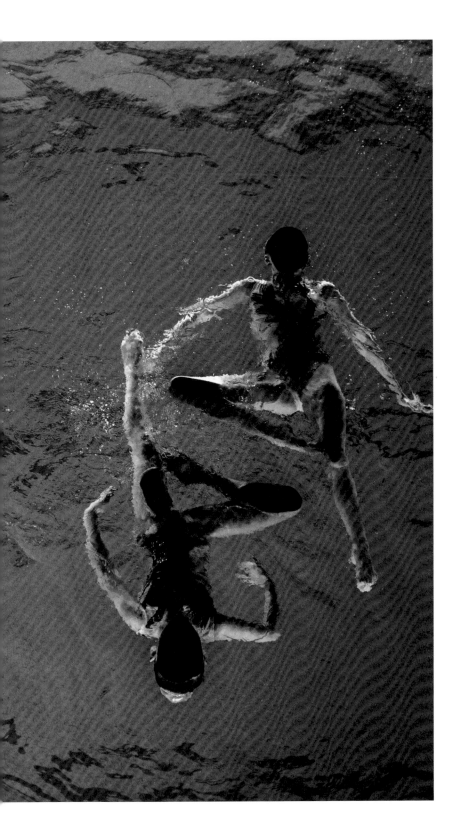

Jonas Lindkvist

Sweden, *Dagens Nyheter* /
3rd Prize Sports

Members of Neptun swimming
club's synchronized swimming
section perform in sailboat
position, during pre-Christmas
Lucia festivities in Stockholm,
Sweden. Synchronized swimming
demands advanced water skills
and requires strength, flexibility
and breath control, as well as
artistry and precise timing.
Neptun has nearly 100 members
who participate in synchronized
swimming, ranging from four to
65 years old.

The 2016 Stories

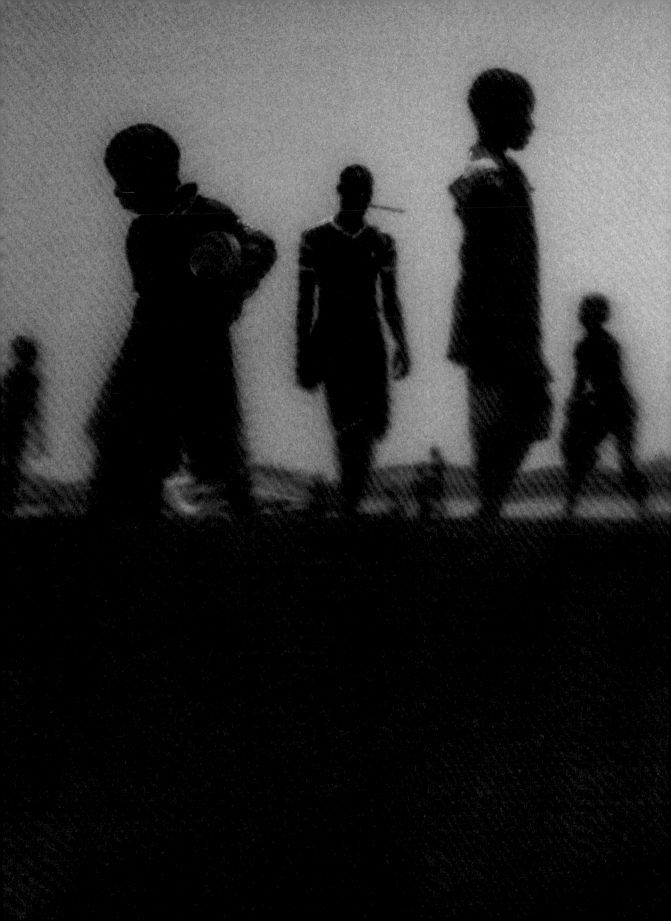

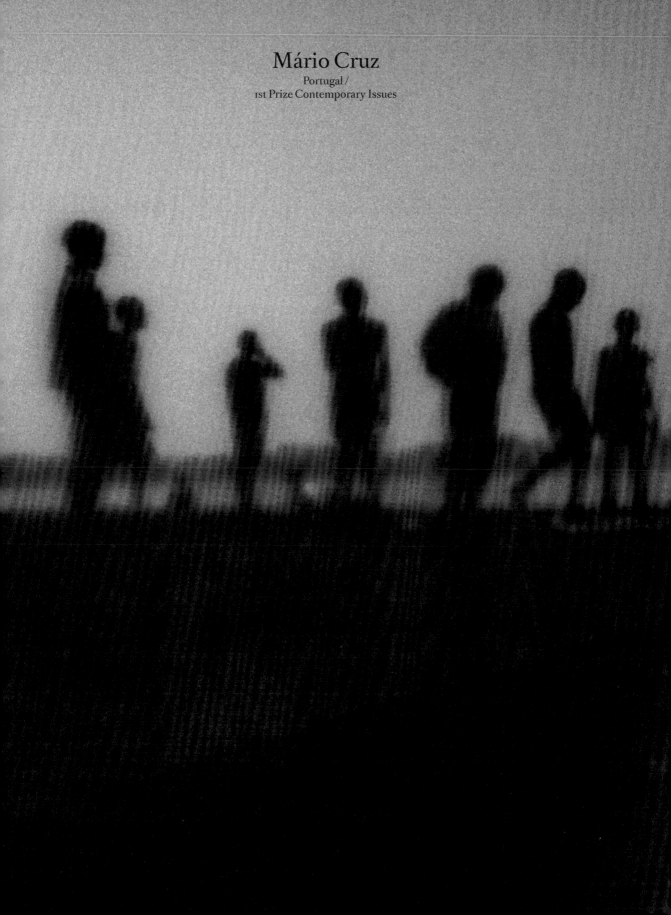

Mário Cruz

Portugal /
1st Prize Contemporary Issues

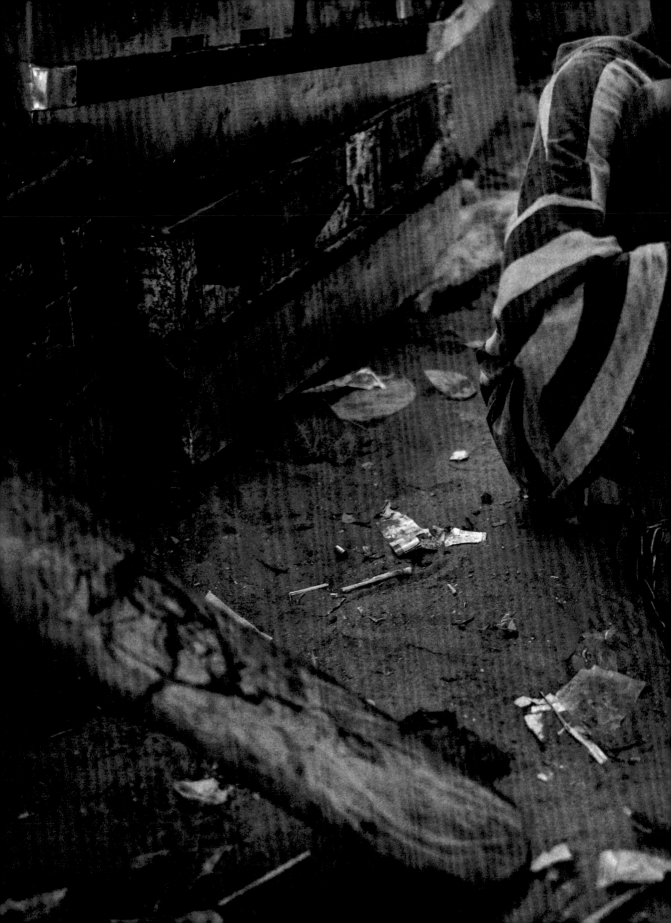

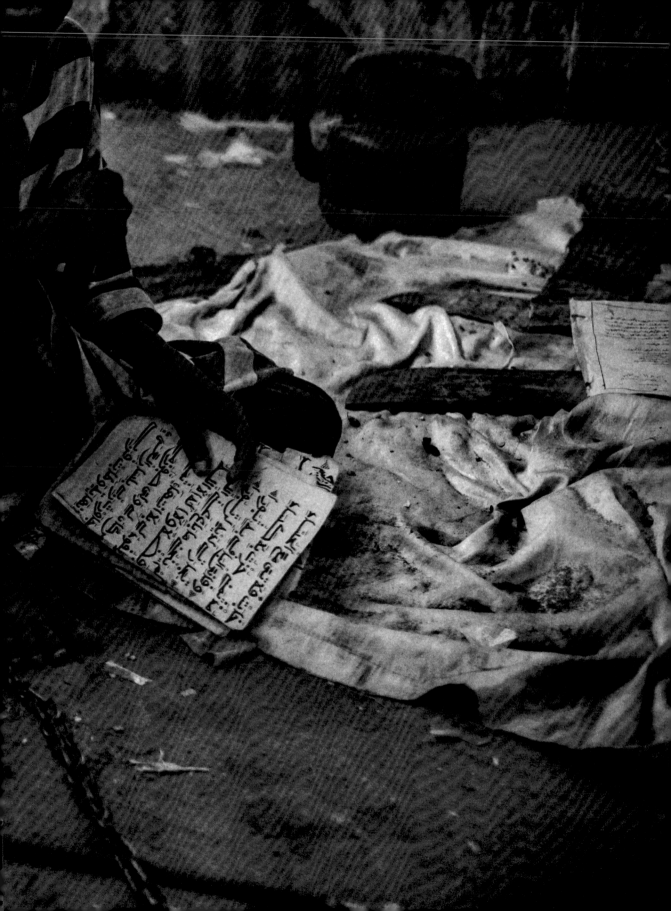

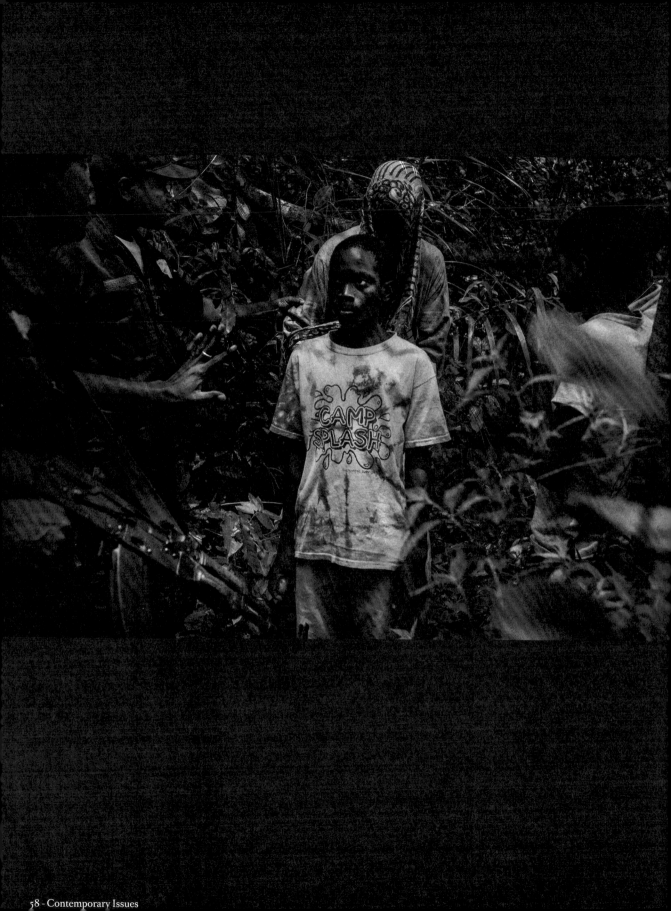

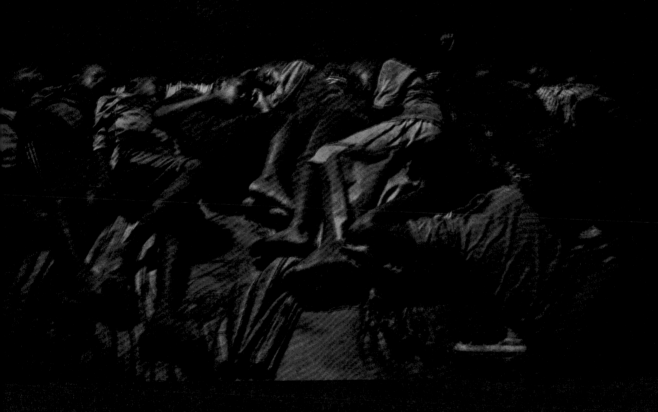

Koranic boarding schools in Senegal, known as *daaras*, traditionally give children between the ages of five and fifteen a religious education and teach them Arabic. But the schools are highly unregulated, and conditions in many are poor, with near-starving children living in overcrowded, unsanitary circumstances. The pupils, or *talibés*, are beaten, sometimes kept in chains for hours on end. Some are the victims of child-trafficking. *Talibés* are frequently made to beg on the streets for up to eight or nine hours a day, giving all they collect to their *marabout* (teacher). Human Rights Watch reports that more than 30,000 boys are forced to beg in the Dakar region alone. Many choose to live on the streets rather than return to

their *daara*. Parents often send their children to *daaras* in the hope of giving them a better education, or because they cannot afford to keep them at home. In July, the Senegalese government adopted a law prohibiting begging and trafficking, but has been accused of inadequate progress at improving the situation by Human Rights Watch. *Two spreads back:* Runaway *talibés* stand on the banks of the Senegal River, in Saint-Louis, northern Senegal. *Previous spread:* A young *talibé* sits in chains in a *daara* in Touba. *Facing page:* Guinean military police approach a group of children walking through a forest near the Guinea-Bissau border. *This page:* Children sleep together in a *daara* in Saint-Louis.

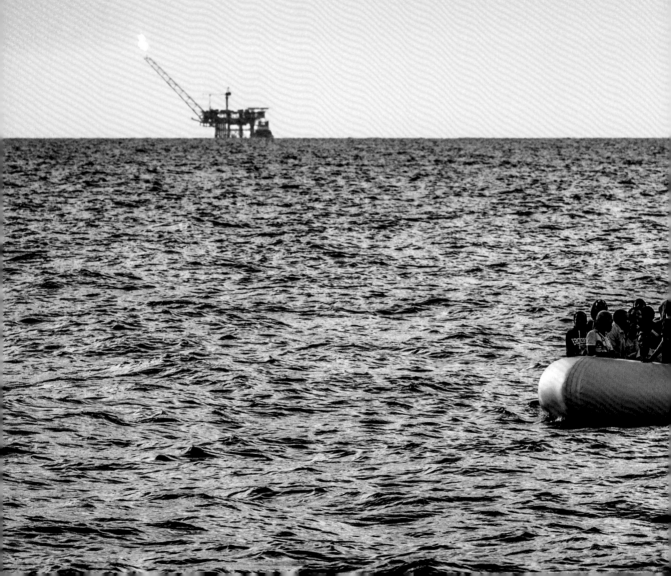

Francesco Zizola
Italy, Noor for Médecins Sans Frontières /
2nd Prize Contemporary Issues

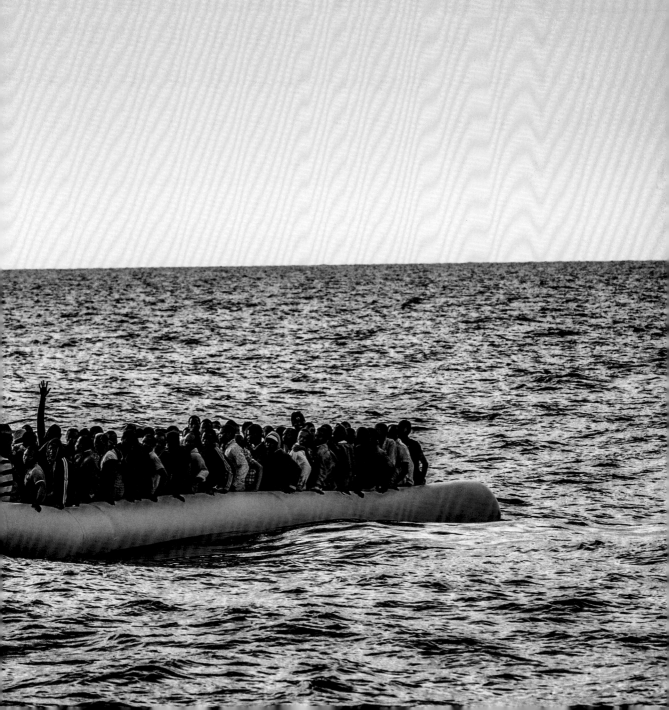

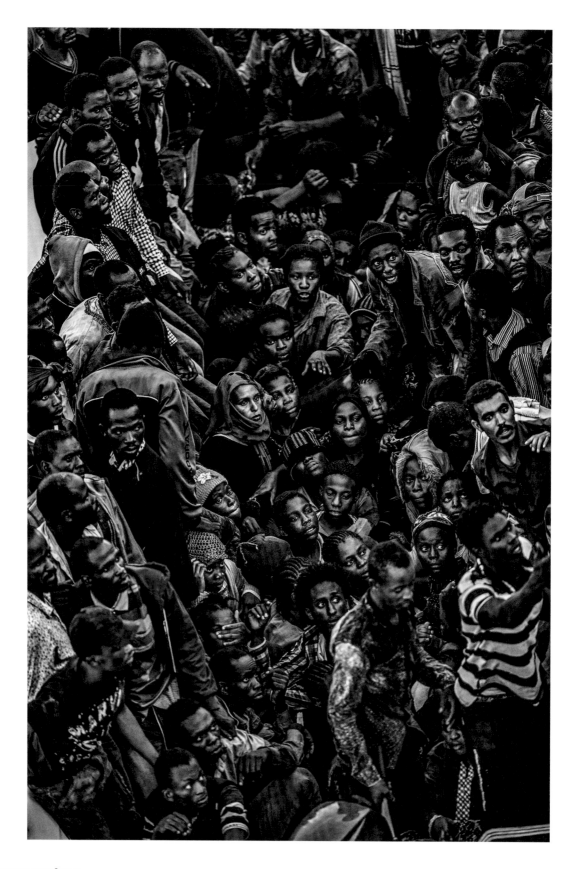

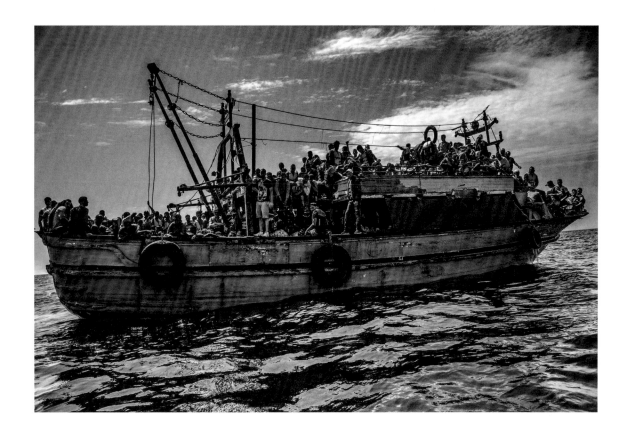

For some years, refugees have been crossing the strait in the Mediterranean Sea between Libya and Italy, often in unseaworthy vessels. The passage is longer and more dangerous than at more recent crossing points, between Turkey and Greece. Nearly 140,000 people reached Italian soil from Libya in 2015, but more than 2,800 drowned while trying to make the crossing. Search and rescue operations are carried out in the region by a number of bodies, such as the international medical relief organization Médecins Sans Frontières (MSF).

Previous spread: Refugees on board a rubber dinghy, in international waters off the Libyan coast, await rescue after sending out a distress call. *Facing page:* People on the overcrowded dinghy wait as an MSF rescue boat approaches alongside. *This page:* A wooden fishing vessel, carrying more than 500 passengers, sails from Libya in the direction of Italy. *Next spread:* After two days and two nights on board a rescue vessel, refugees, still wrapped in emergency blankets, come in sight of the Italian coast.

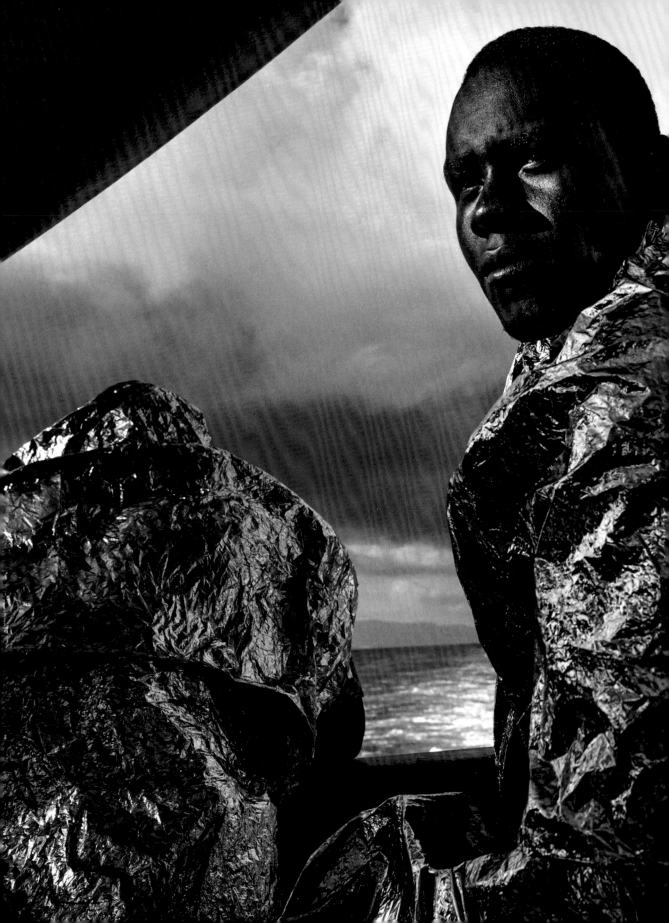

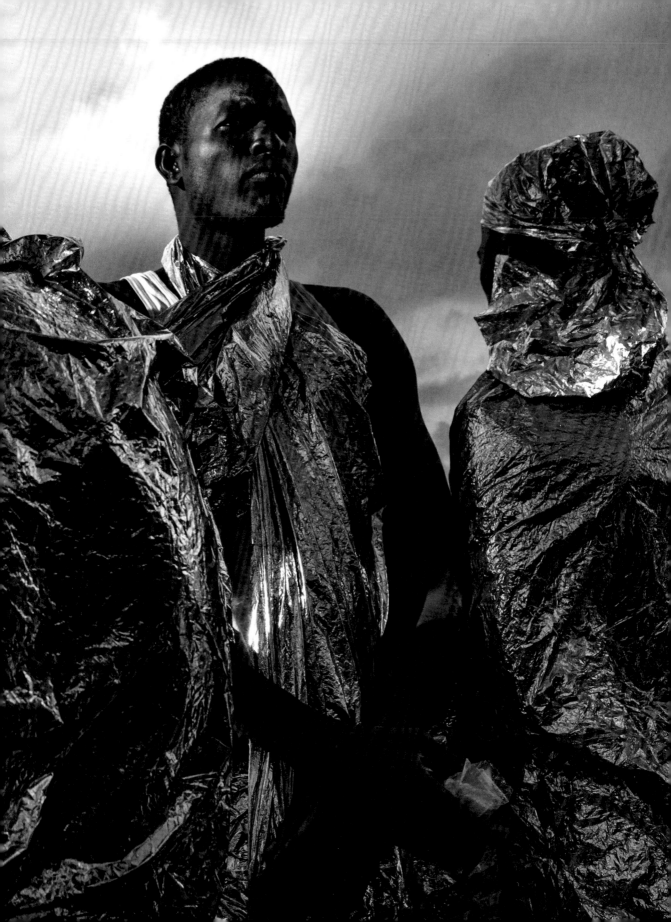

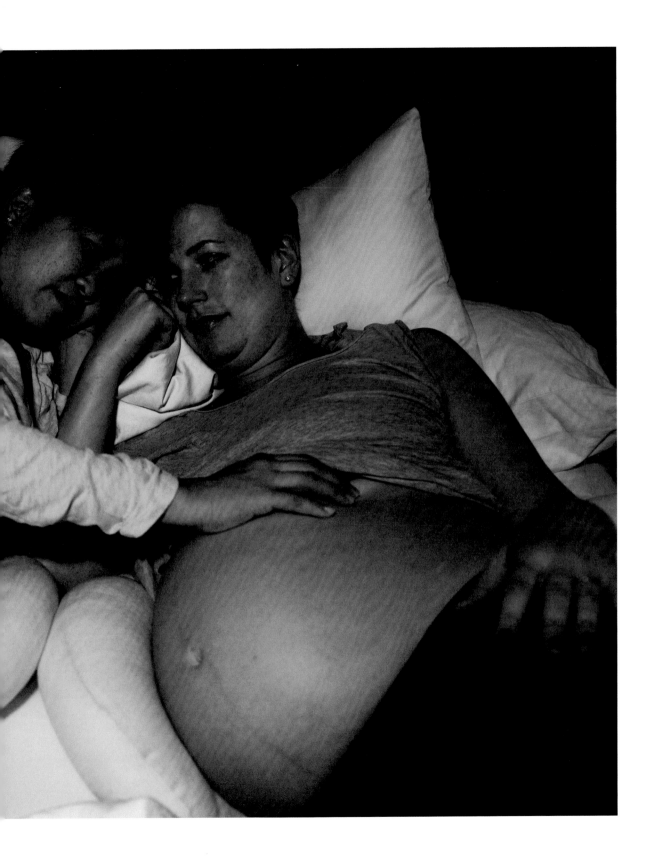

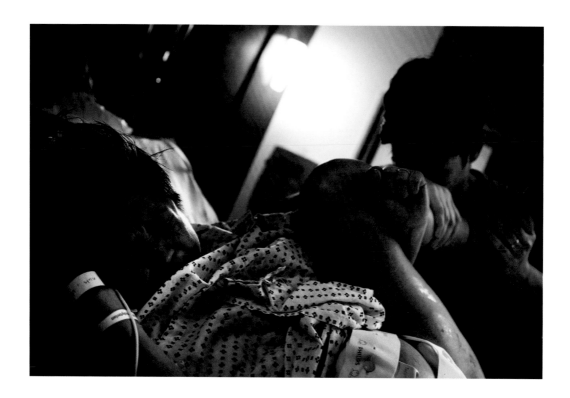

Emily and Kate are married to each other, and live in Maplewood, New Jersey. Both became pregnant at the same time, though that had not initially been their plan. Kate had been undergoing in vitro fertilization but it appeared not to be working, and she asked Emily to try, using the donor they had chosen together. Emily became pregnant almost immediately, and while Kate was winding down her treatment, so did she. Emily gave birth to Reid, and Kate to Eddie just four days apart. Kate and Emily embraced pregnancy, childbirth, and mother-hood in tandem, as two women experiencing the challenges, intimacy, and transformations together. *Previous spread:* Kate touches Emily's belly and talks to Reid. *This page:* Emily helps Kate, who had a difficult labor. *Facing page, top:* Emily brings Reid to meet his newborn baby brother. *Below:* Emily rubs sleep out of her eyes while feeding Reid. The women shared the responsibilities of night feedings, but because Emily produced more breast milk than Kate, she often had to feed both babies.

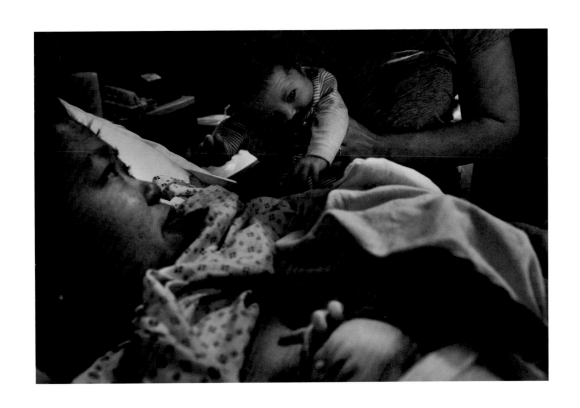

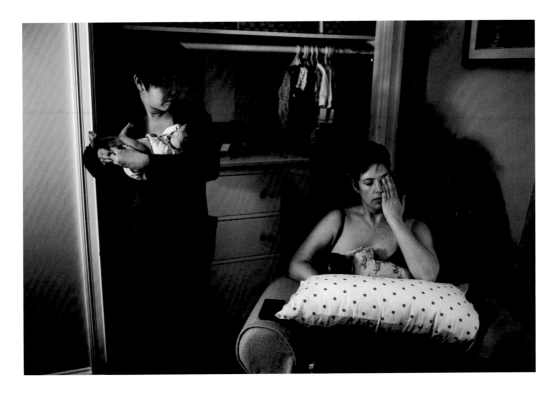

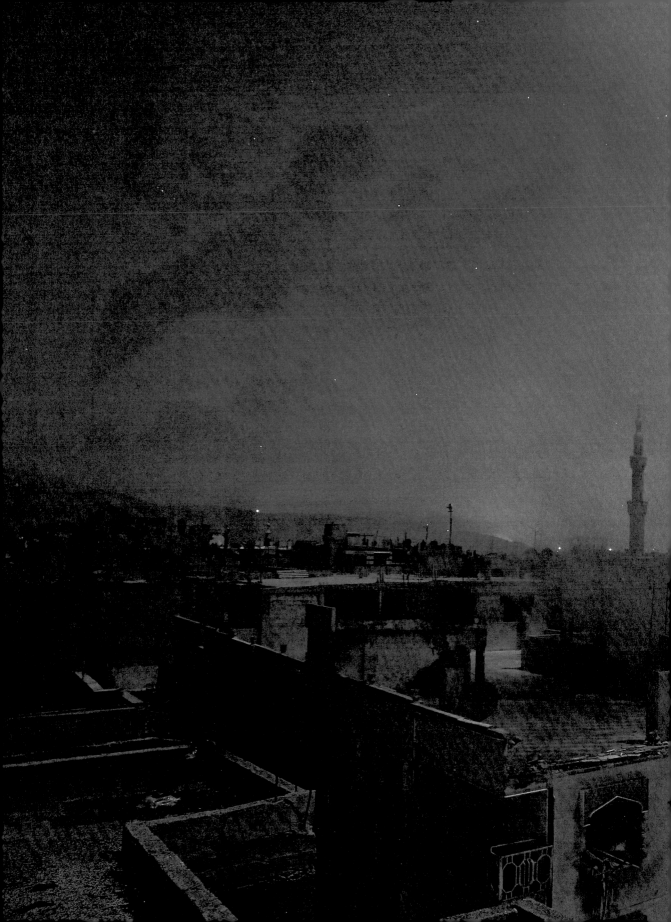

Sameer al-Doumy

Syria, Agence France-Presse /
1st Prize Spot News

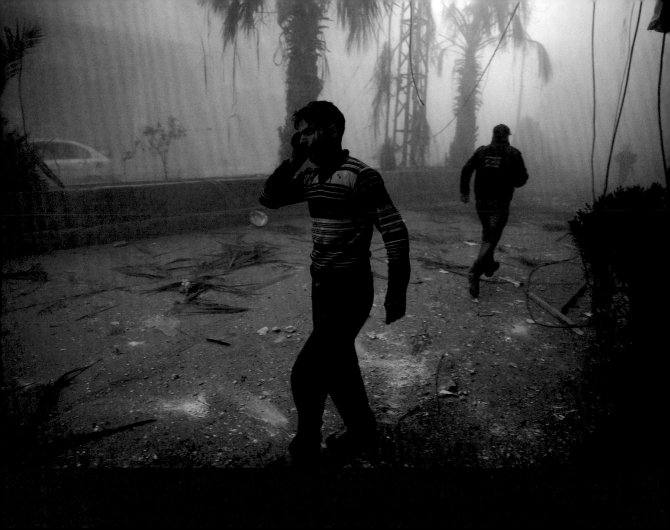

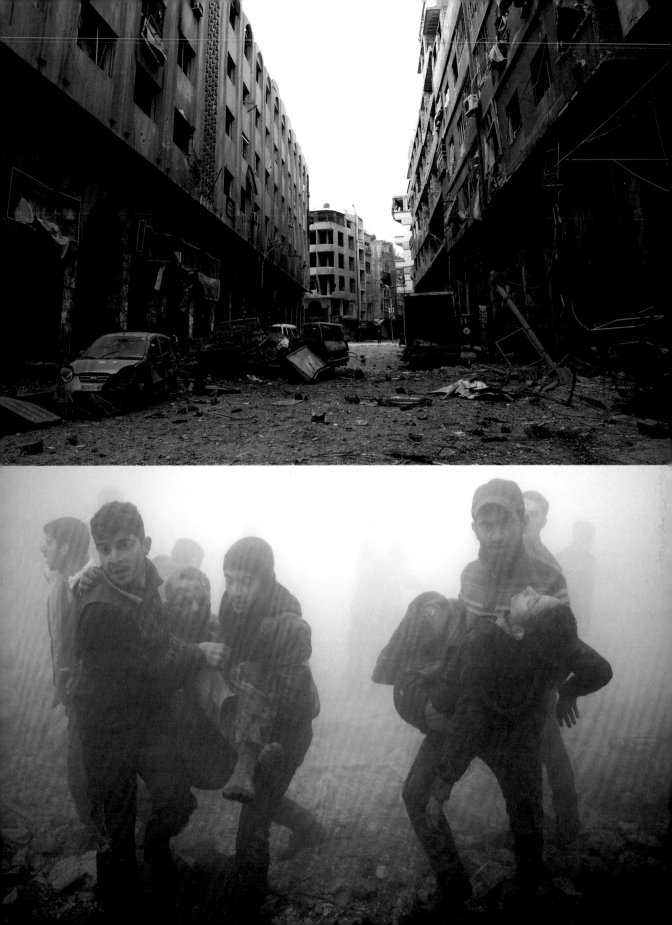

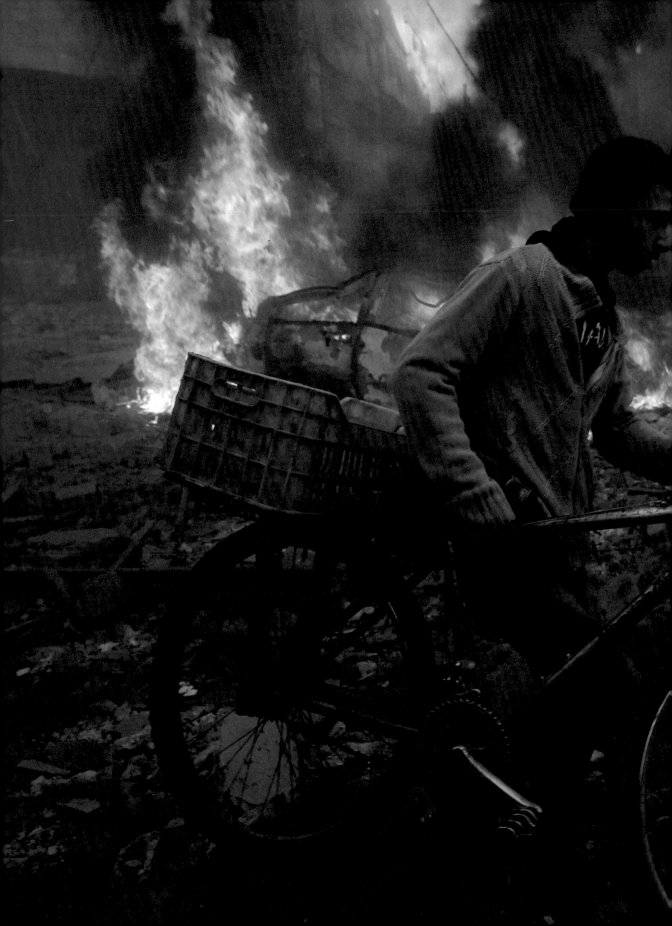

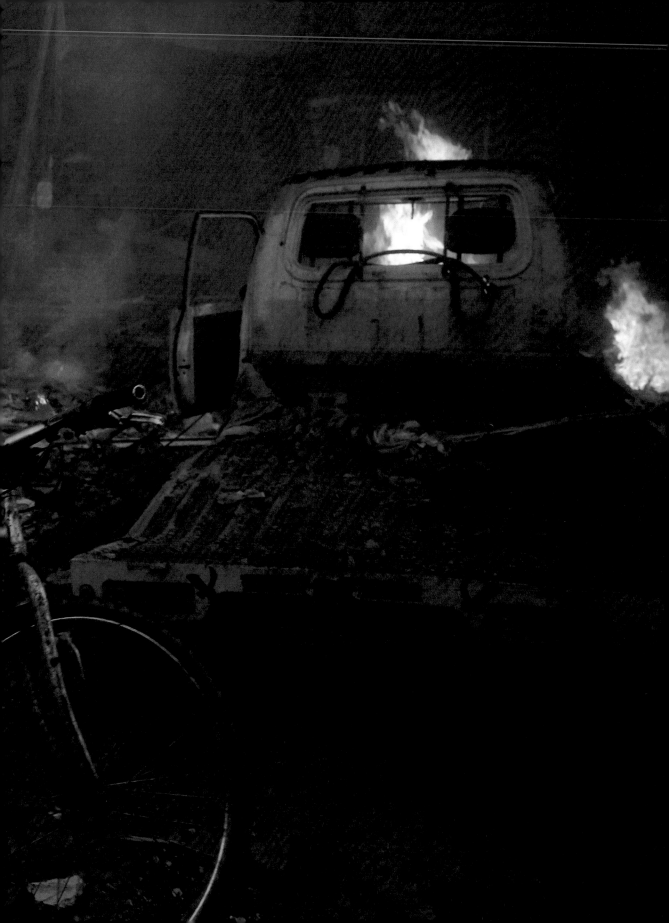

Roberto Schmidt

Colombia/Germany, Agence France-Presse /
2nd Prize Spot News

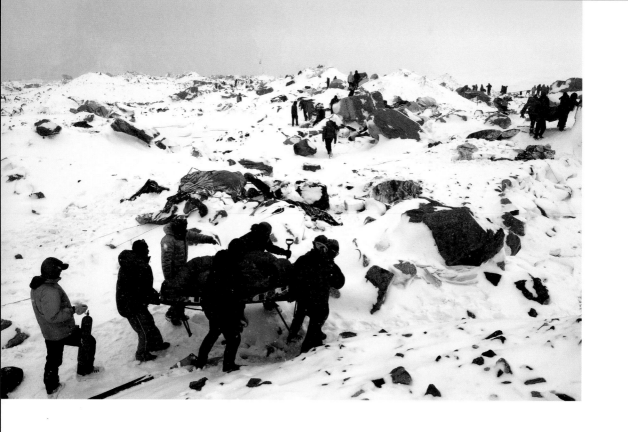

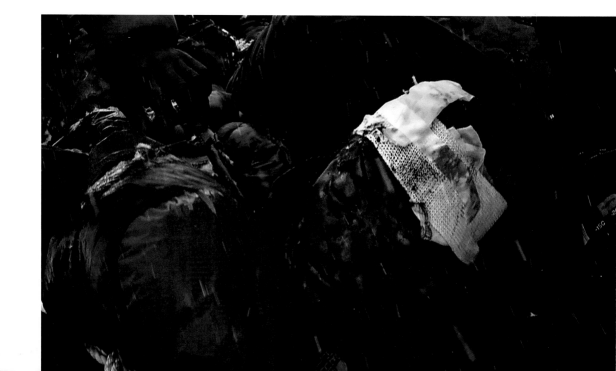

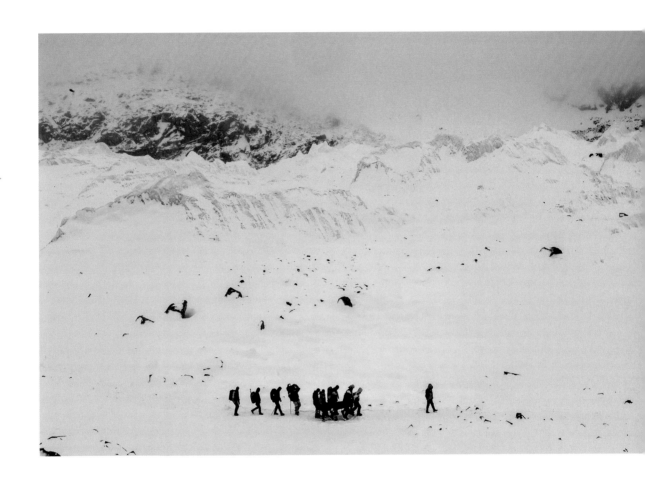

A massive avalanche, triggered by the 7.8 magnitude earthquake that struck Nepal on 25 April, descended on the southern Everest Base Camp, killing over 20 people and injuring scores more. Other climbers were stranded at camps further up the mountain, having lost secure descent routes. Strong aftershocks, bad weather, and inaccessibility of terrain hampered rescue efforts, while survivors feared further avalanches. The first rescue helicopters arrived some 18 hours after the avalanche. *Previous spread:* A roaring wall of rock, snow and debris slams down on the Everest Base Camp. *Facing page, top:* Rescuers using a makeshift stretcher carry an injured person, moments after the avalanche. *Below:* A man suffering severe head trauma is placed into a sleeping bag being used as a stretcher. *This page:* People carry an injured climber to a medical tent.

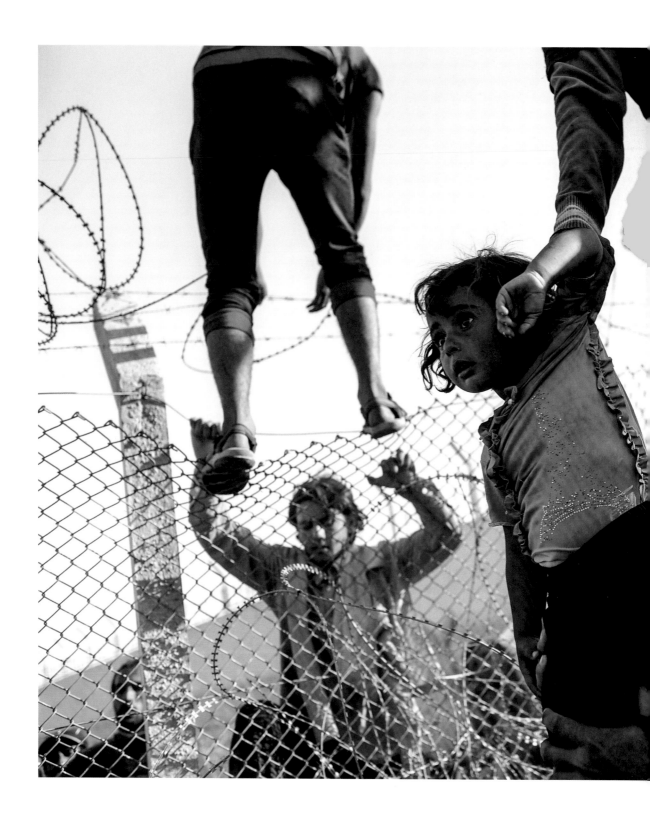

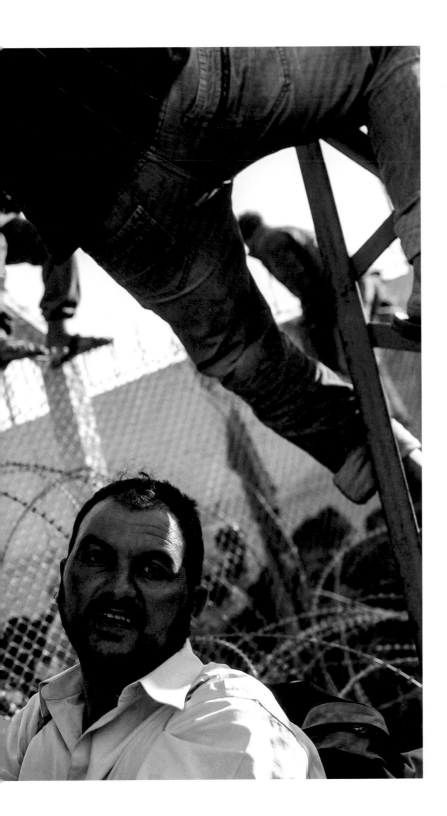

Bulent Kilic
Turkey, Agence France-Presse /
3rd Prize Spot News

81

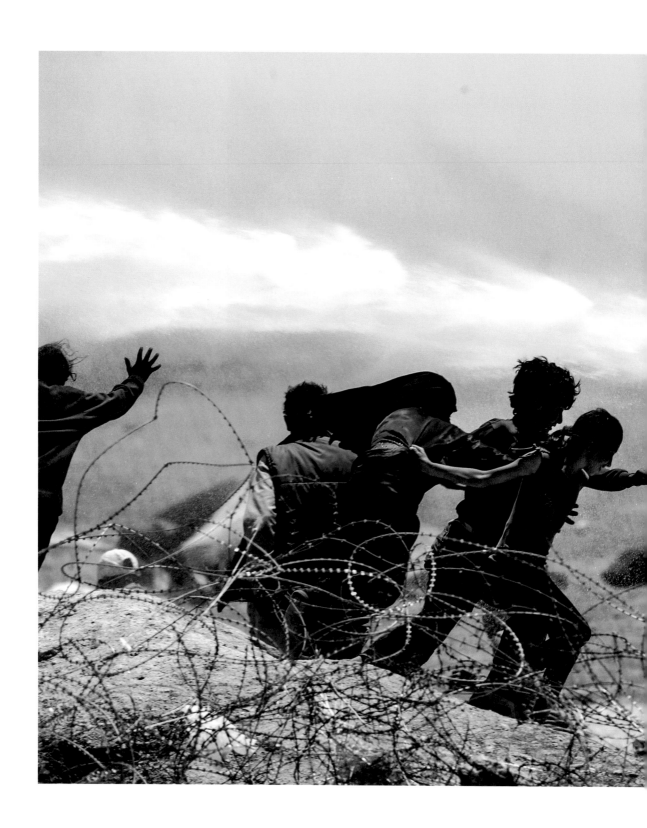

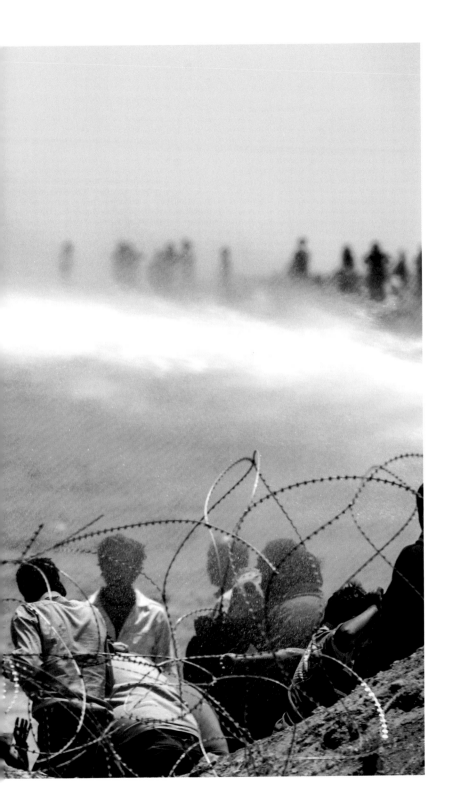

When conflict erupted in Syria in 2011, Turkey initially operated an open-door policy to people fleeing the violence. In June 2015, new fighting in northern Syria, between members of the so-called Islamic State (IS) and a coalition of Kurdish and opposition militia, led to a sharp increase in border crossings, as civilians fled both airstrikes and ground battles. Turkey began to take measures to limit the numbers of refugees coming into the country, so people attempted other ways of entering. *Previous spread:* People cross into Turkey through a broken fence, near the official border crossing at Akcakale, on 14 June. *This spread:* People run from water cannon, fired by Turkish soldiers to keep them away from border fences near Akcakale, on 13 June. (continues)

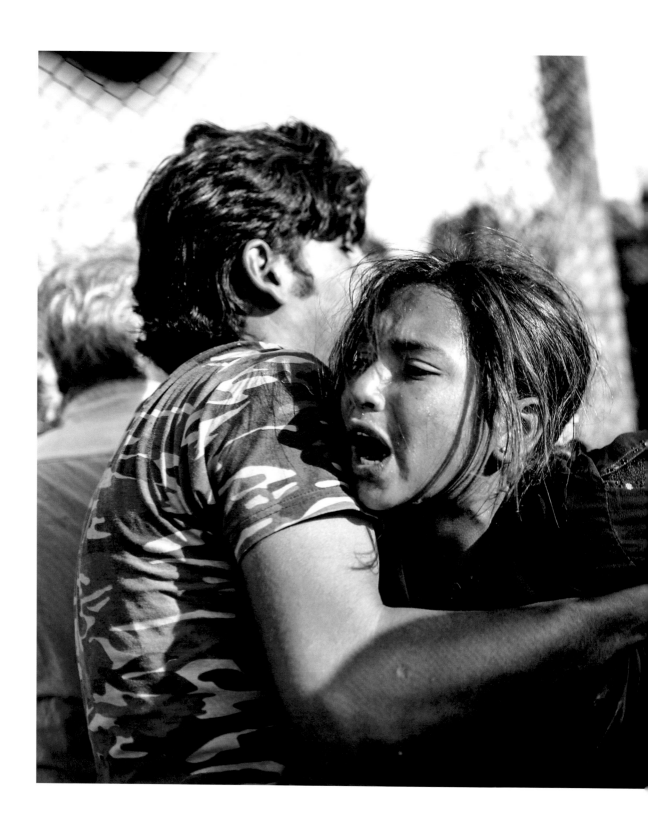

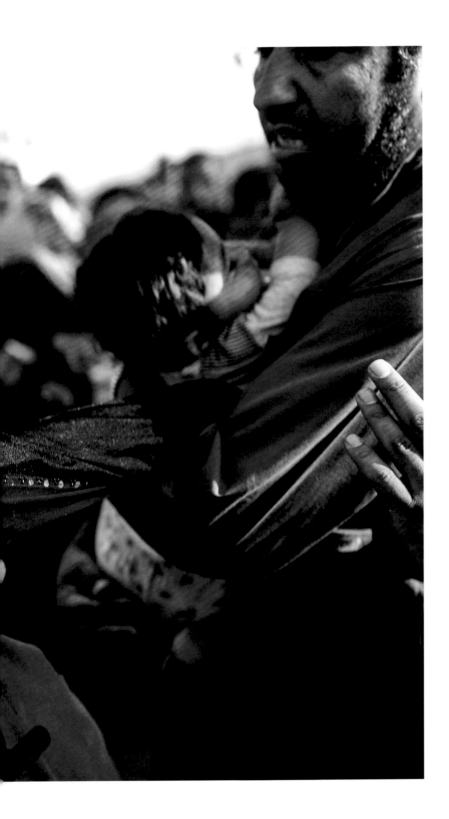

(continued) Akcakale and the Syrian town of Tel Abyad are directly adjacent to each other, with the border running through the middle. The UNHCR said that in the first half of June, fighting in the region led to more than 23,000 refugees fleeing into Turkey, with some 70% of those being women and children. *This spread:* Refugees cross through a hole in the border fence near Akcakale, on 14 June.

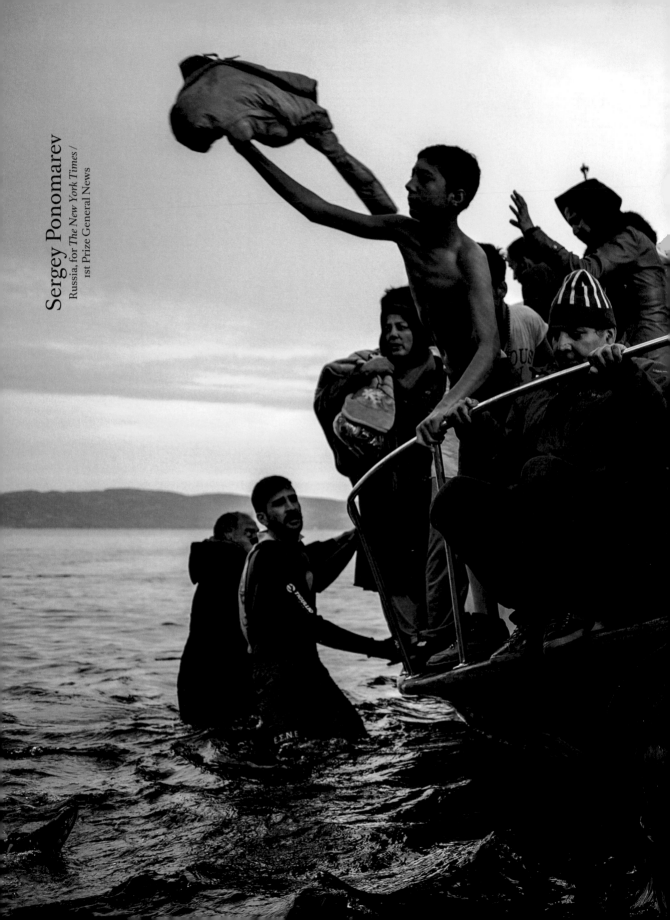

Sergey Ponomarev
Russia, for *The New York Times* /
1st Prize General News

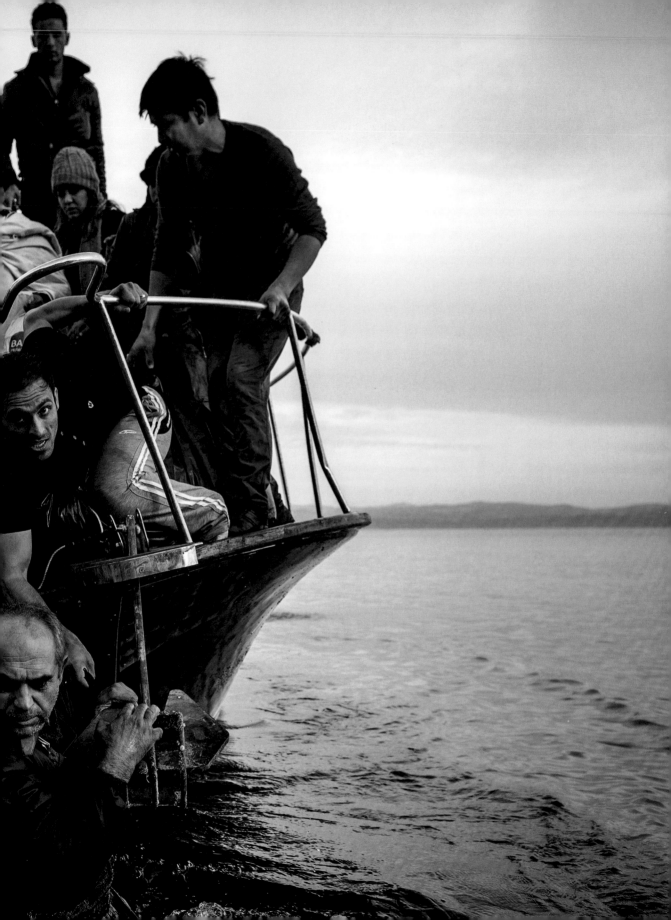

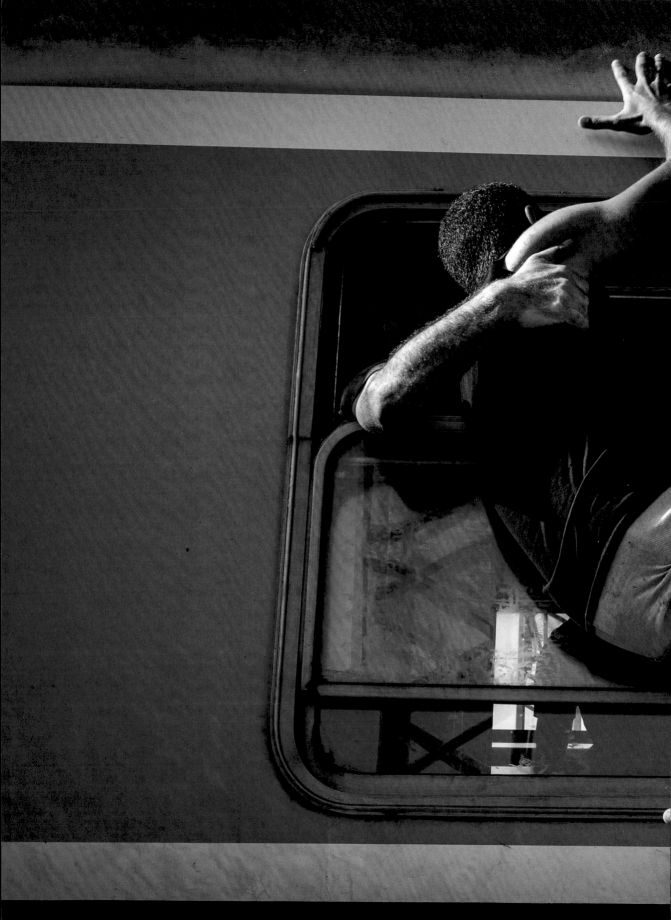

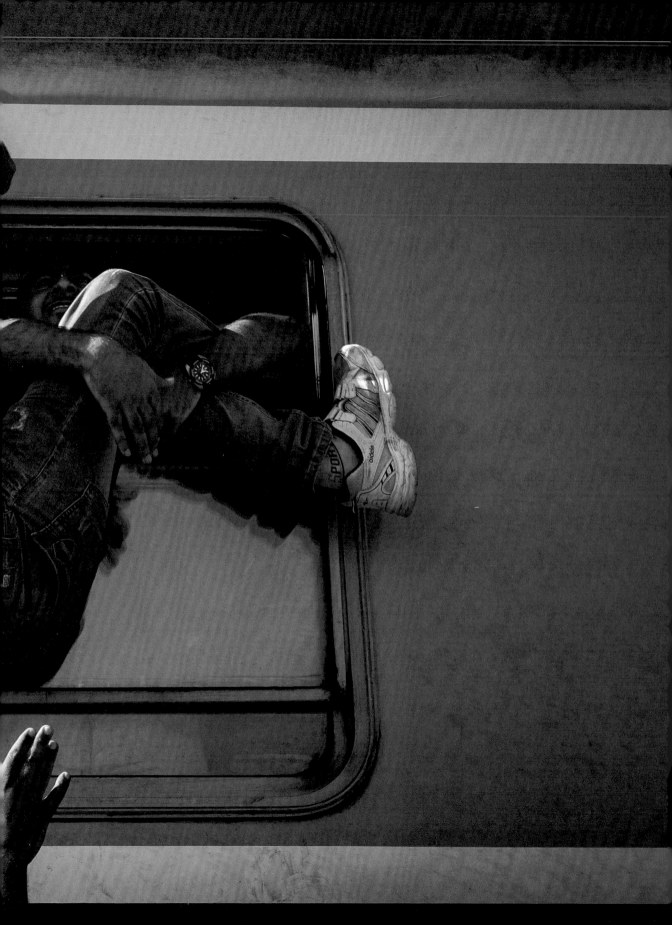

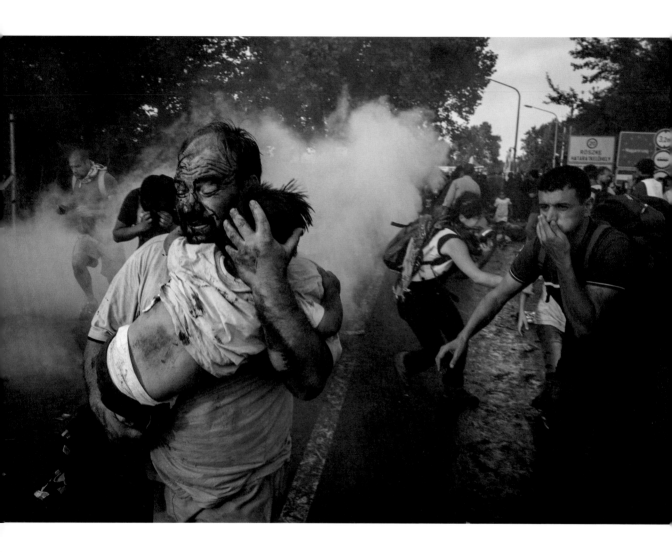

Over one million refugees entered Europe in 2015, the vast majority arriving by sea, through Greece and Italy. Many landing in Greece wanted to move on, through the Balkan countries, to enter the Schengen Area of the European Union, where movement between member states does not require a passport. Balkan countries tended to steer refugees towards the next border, in the largest movement of people on the continent since World War II. Hungary, to the north, closed its frontiers, first with Serbia, then with Croatia. *Two spreads back:* Refugees arrive by boat near the village of Skala Sikamineas, on the Greek island of Lesbos. *Previous spread:* A man strug-

gles to board a train headed to the Croatian capital Zagreb, in Tovarnik, a town near the border with Serbia. *This page:* A man carries his child as Hungarian police use tear gas, pepper spray and water cannon against people trying to cross into the country from Serbia, the day after Hungary closed its border with Serbia. *Facing page:* People wait in line at a refugee registration center in Preševo, Serbia. *Following spread:* A Slovenian police officer on horseback escorts refugees after they crossed from Croatia. *Two spreads forward:* People walk on to a registration camp outside the Slovenian town of Dobova, near the Croatian border.

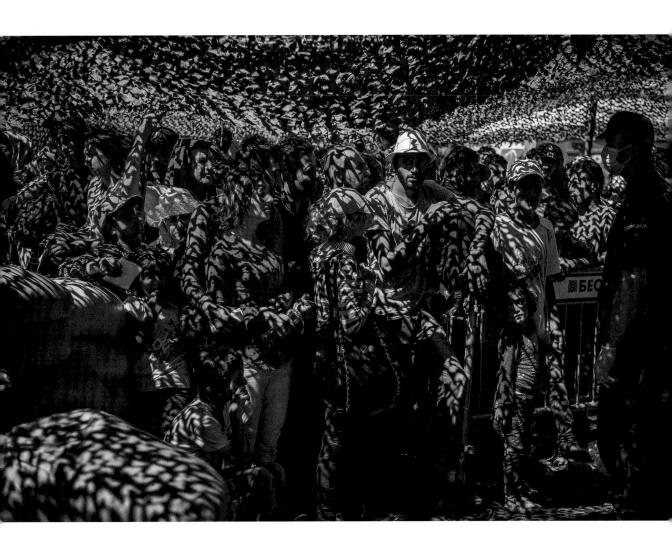

91

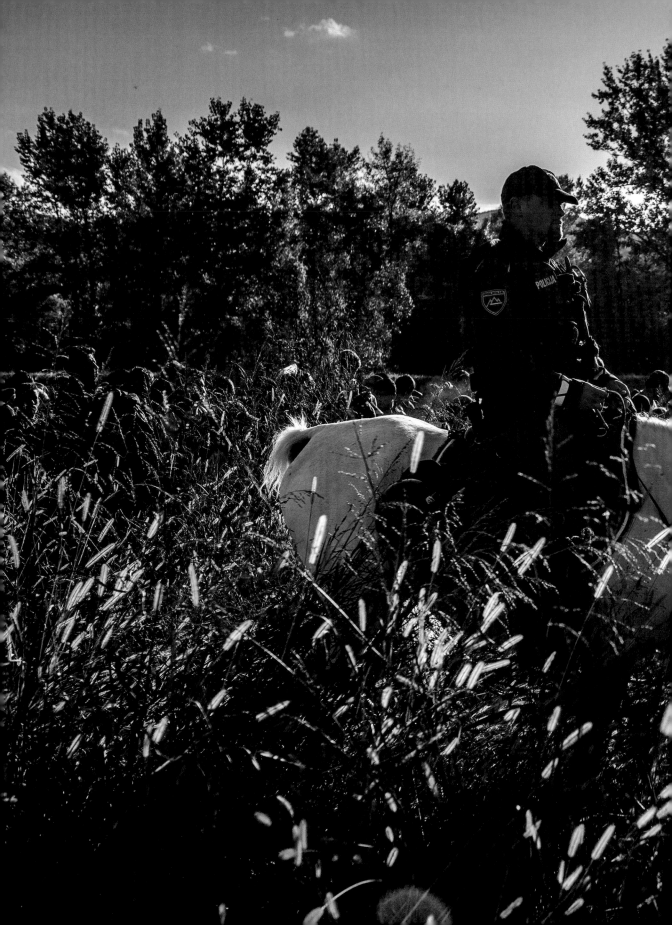

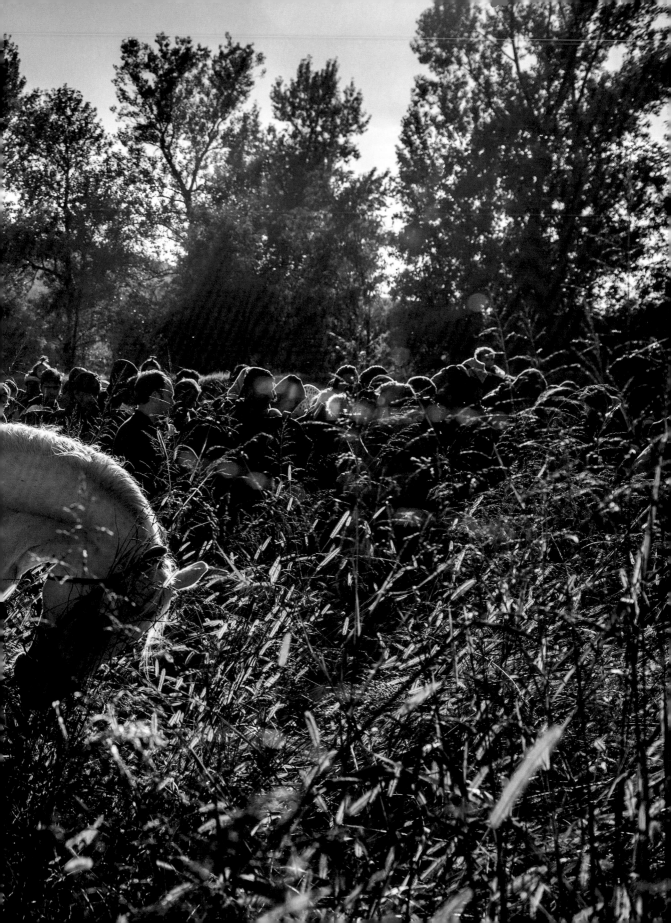

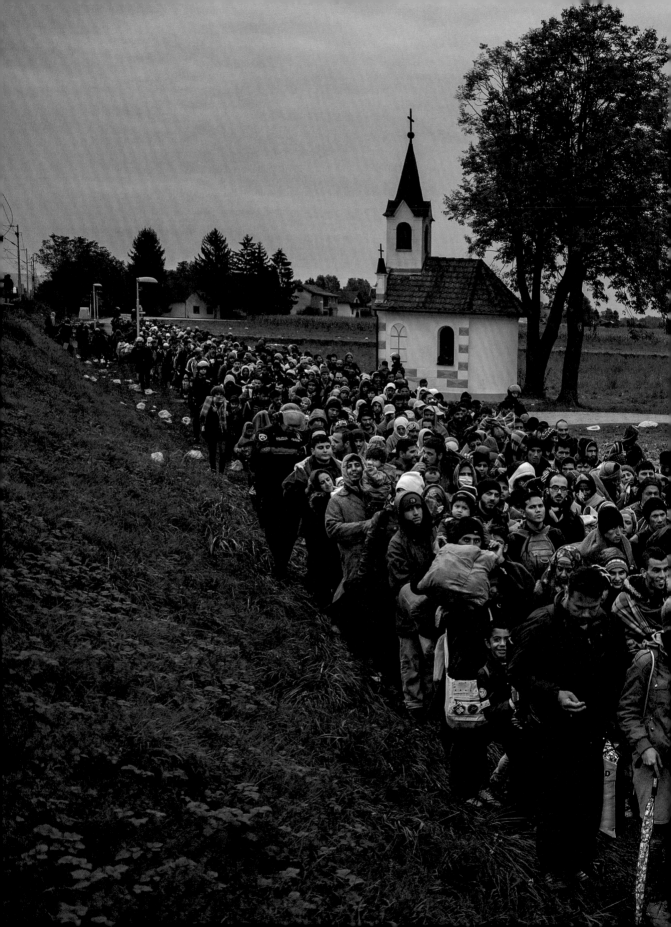

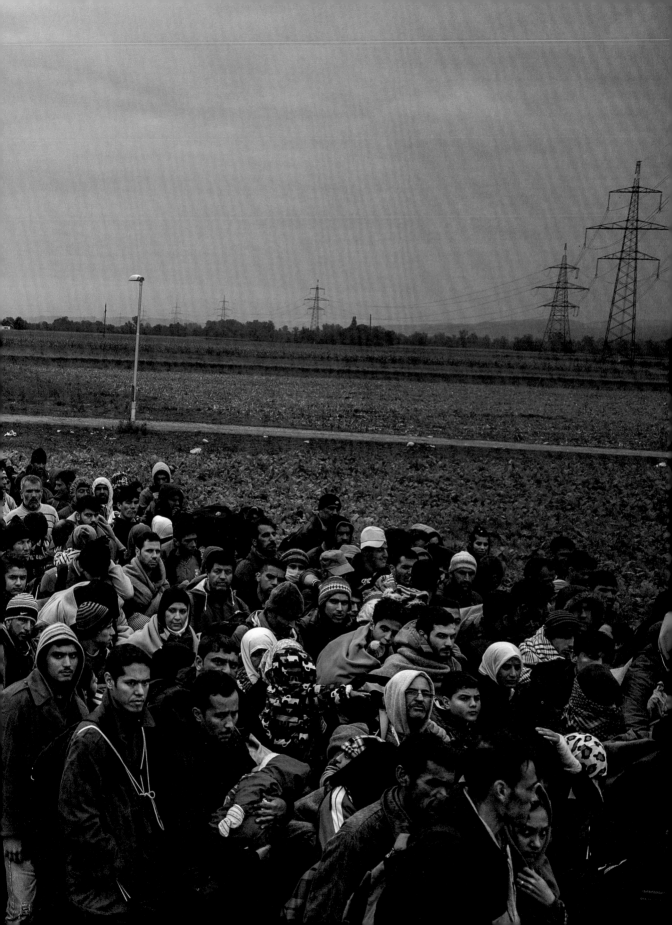

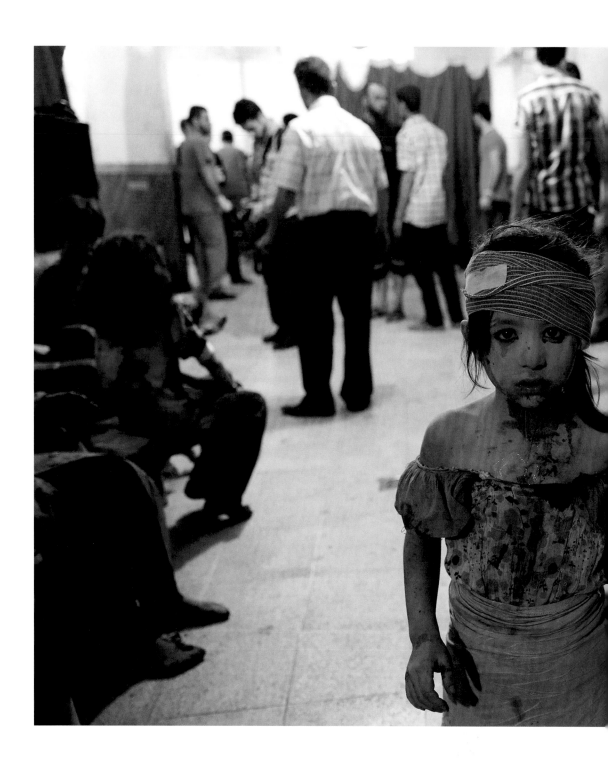

Abd Doumany
Syria, Agence France-Presse /
2nd Prize General News

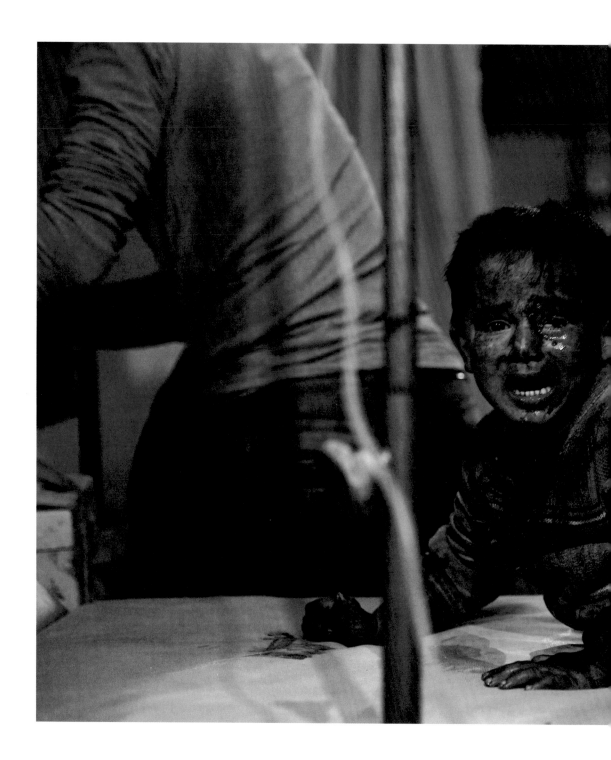

As the conflict in Syria entered its fifth year, the city of Douma, the largest opposition stronghold in Damascus province, was subject to sustained bombardment. The Violations Documentation Center in Syria (VDC), an independent NGO, puts civilian fatalities in and around Douma at 1,740 in the first half of 2015 alone. *Previous spread:* An injured girl stands in a makeshift hospital following shelling and airstrikes on 22 August. *This spread:* A wounded boy awaits treatment, following airstrikes on a market and a hospital, which, according to the Syrian Observatory for Human Rights (SOHR), were carried out by government forces. (continues)

(continued) Medical care in Douma deteriorated significantly, as government forces put the surrounding area under siege and restricted supplies, according to doctors in the area in touch with Amnesty International. Local hospitals struggled to cope with casualties. The SOHR said that government planes also attacked schools. *This spread:* A man cradles the body of his daughter, killed in an air raid on 24 August.

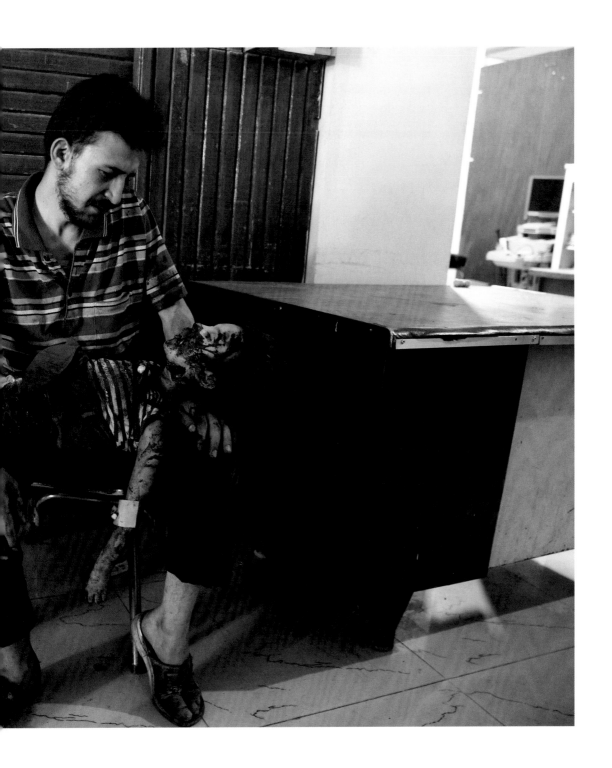

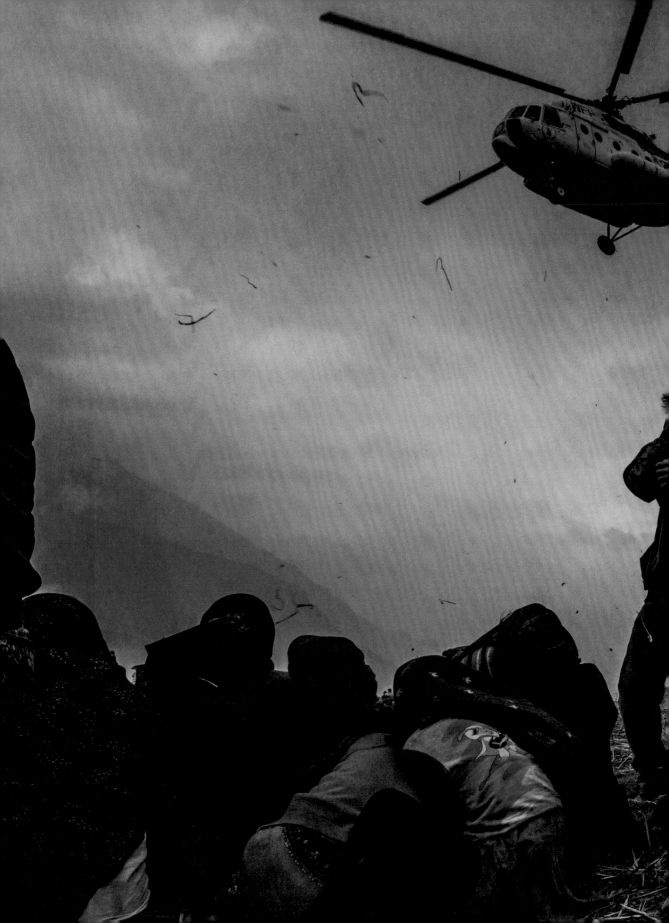

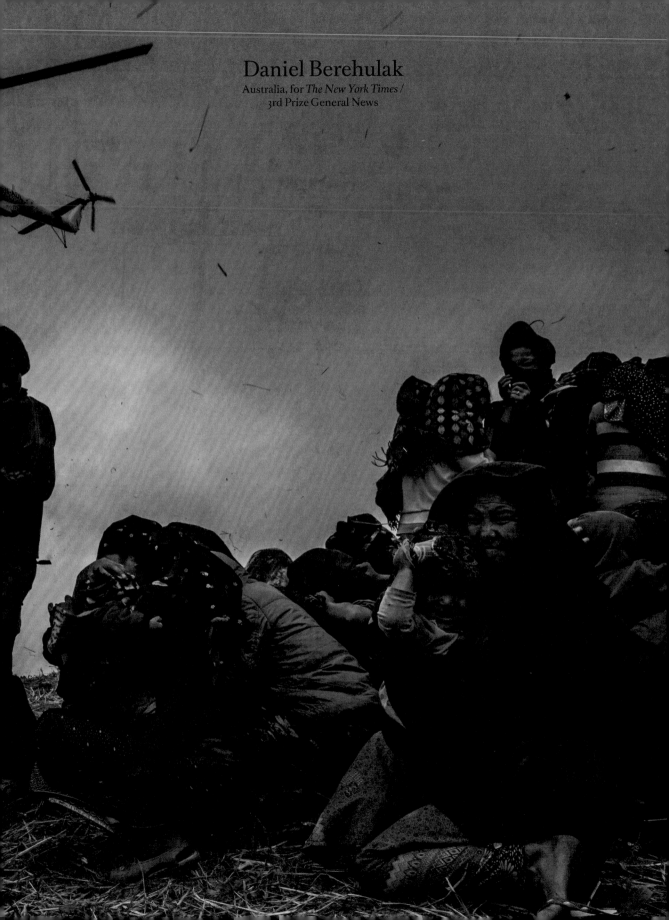

Daniel Berehulak

Australia, for *The New York Times* /
3rd Prize General News

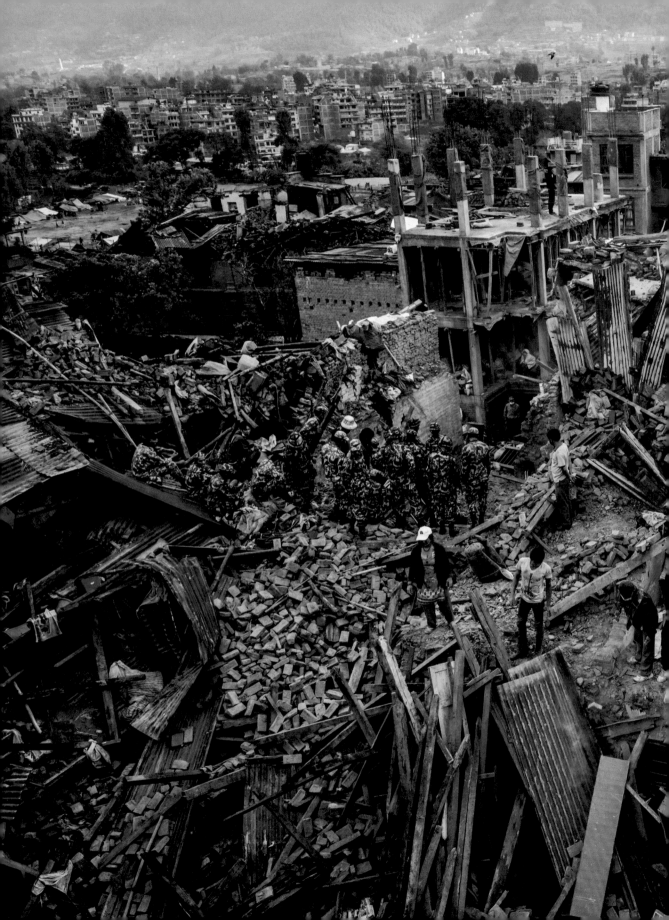

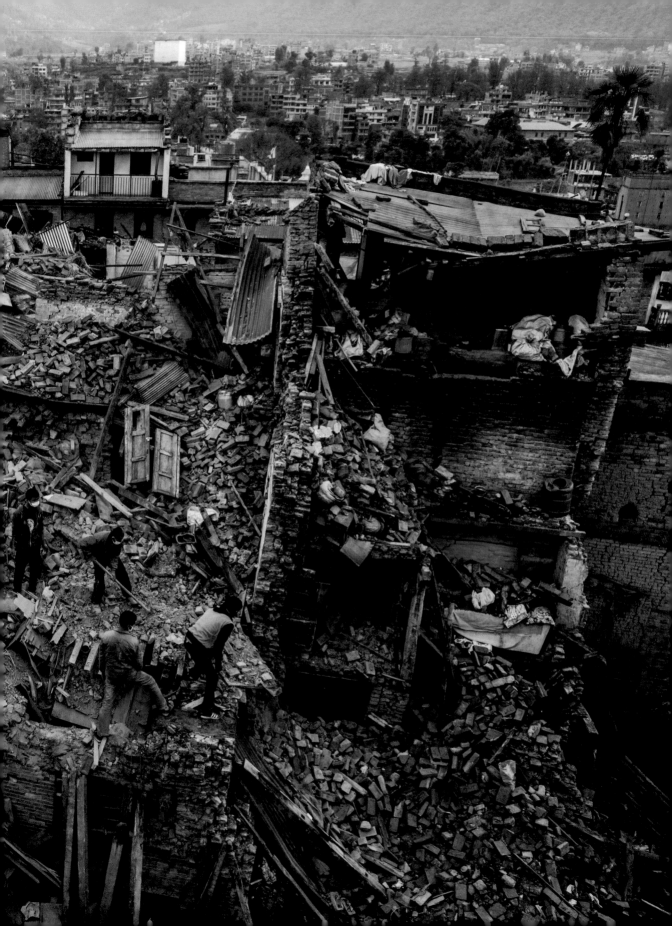

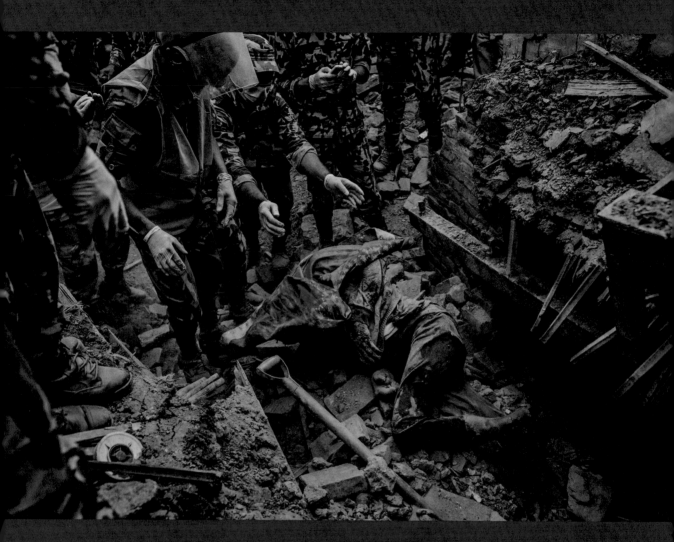

Just before noon on 25 April, a 7.8 magnitude earthquake struck northwest of the Nepalese capital Kathmandu, followed by a series of severe aftershocks. Over 8,000 people were killed, and some 21,000 injured. Homes, buildings and temples were destroyed in the capital, but rural mountainous districts were hardest hit. Although relief teams arrived from around the world to assist, people in remote villages, rendered inaccessible by the quake, had initially to fend for themselves. Across the region some 2.8 million people were made homeless. *Two spreads back:* A helicopter delivers aid to villagers in Gumda,

100 km northwest of Kathmandu, on 9 May. *Previous spread:* Residents forage through their destroyed homes, trying to salvage belongings, in the city of Bhaktapur. *This page:* Members of a rescue team in Bhaktapur retrieve the body of a man from the ruins of his home, on 29 April. *Facing page:* Bishnu Gurung (center) weeps as the body of her three-year-old daughter Rejina is recovered from the rubble of their family home, after a 13-day search, in the village of Gumda. *Following spread:* Flames rise from funeral pyres of earthquake victims, at the Pashupatinath temple, on the Bagmati River in Kathmandu.

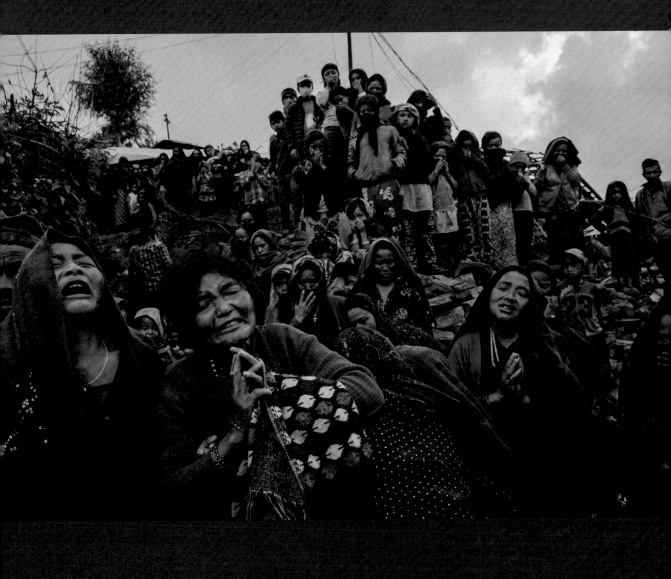

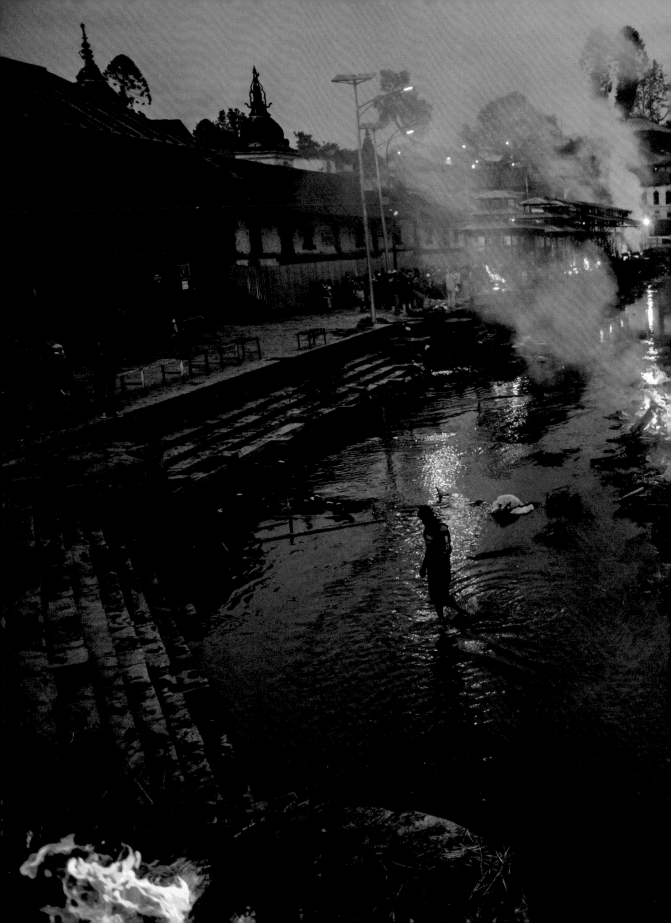

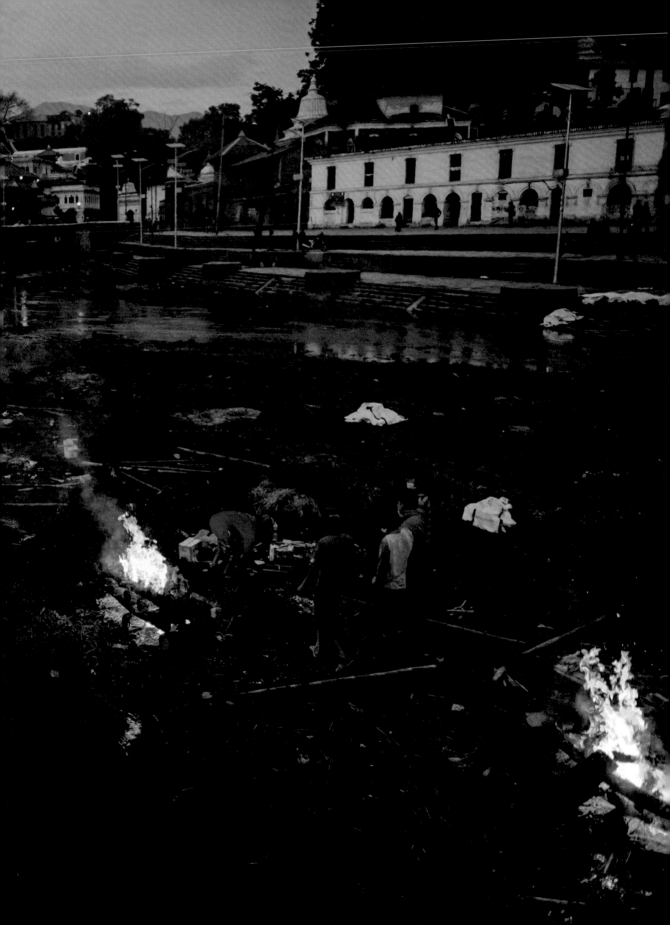

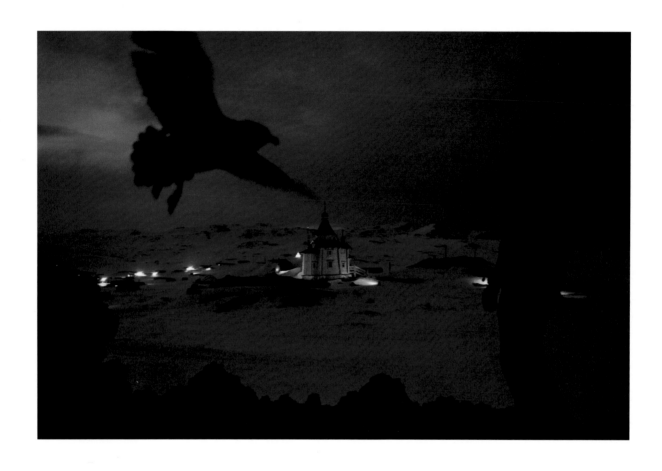

Daniel Berehulak

Australia, for *The New York Times* /
1st Prize Daily Life

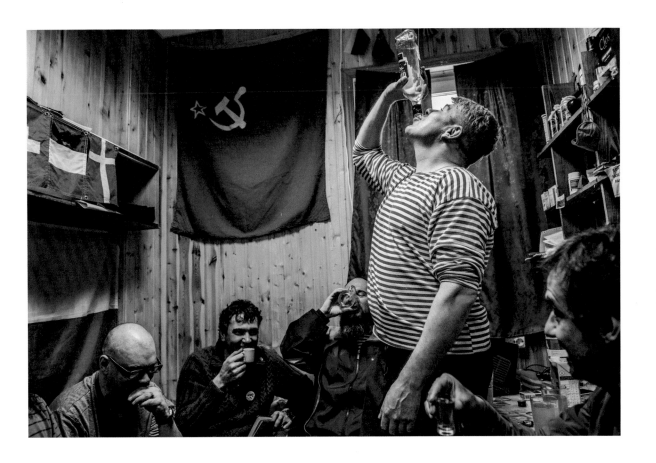

A number of countries, including Chile, Poland and Russia, have set up scientific stations on King George Island in the Antarctic. By the Antarctic Treaty, which came into force in 1961, Antarctica was set aside as a scientific preserve, with freedom of investigation and free intellectual exchange. No country may exploit mineral resources or exert territorial claims. *Facing page:* Dr Ernesto Molina, who is supported by the Chilean Antarctic Institute, walks by the Bellingshausen Russian Antarctic base, with its Orthodox Church of the Holy Trinity, in Fildes Bay, King George Island. *Above:* Dr Molina drinks home-made vodka with members of the winter expedition crew of the Russian research team, in a bedroom on the Bellingshausen base. *Next spread:* Father Benjam Maltzev, an Orthodox priest, looks out from the bell tower of his church. (continues)

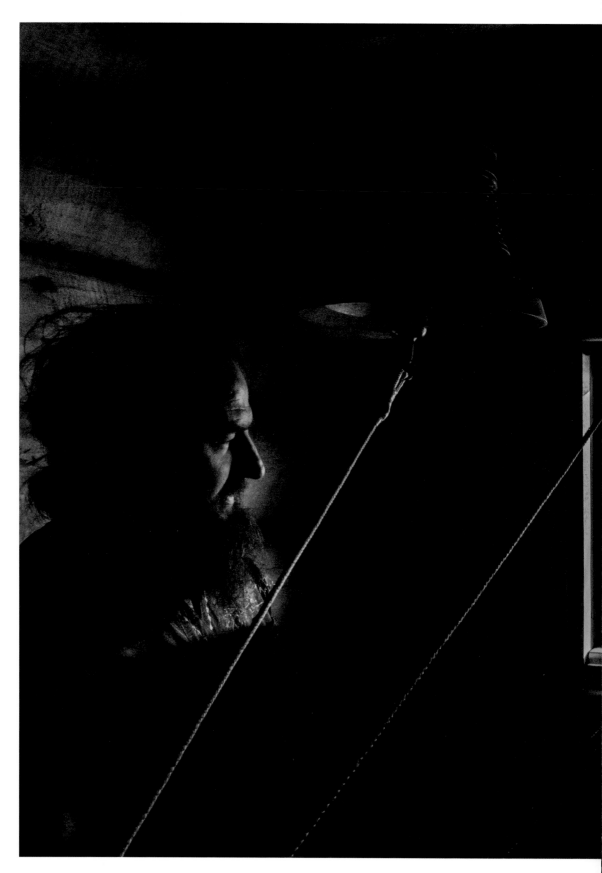

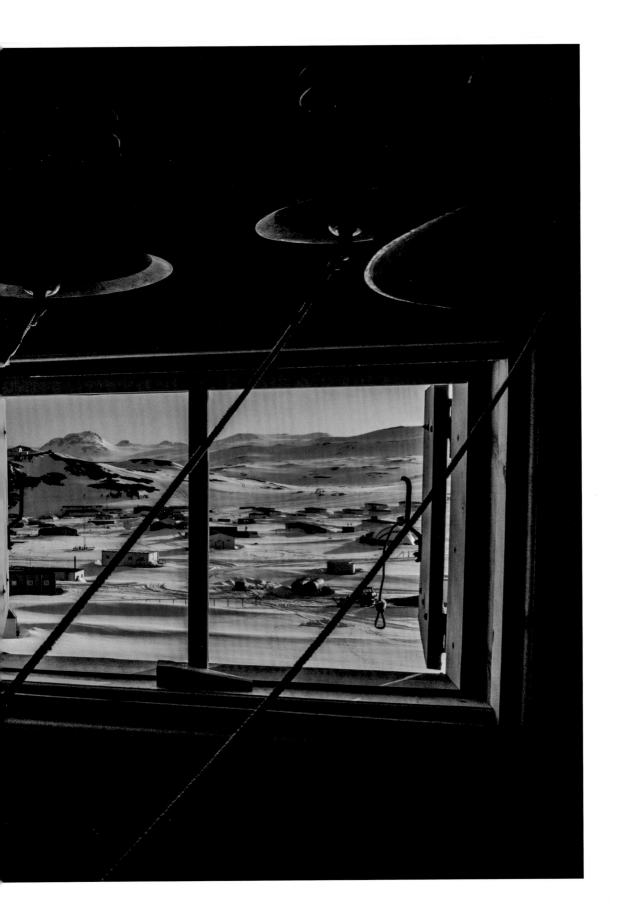

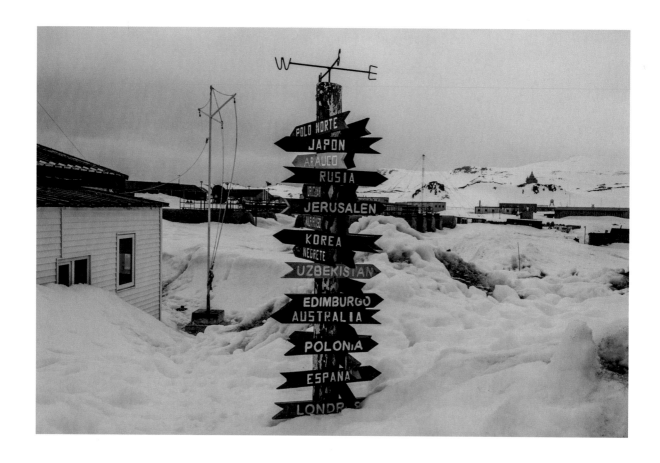

(continued) The Antarctic Treaty is currently in force until 2048, but a number of countries have an eye on asserting greater influence before the renewal date. Some countries are looking to strategic and commercial possibilities that exist right now, such as iceberg harvesting (Antarctica is estimated to have the biggest reserves of fresh water on the planet), krill fishing, and expanding global navigation abilities. *Above:* A signpost bearing the names of cities and countries around the world stands outside the Chilean base, on the Fildes Peninsula. *Facing page:* Russian engineer Nikolay Skripnik runs through the snow to cool down during a sauna session. *Next spread:* A member of a German research team counts penguin species and pairs, as part of ongoing research on Ardley Island, an Antarctic Specially Protected Area because of its bird life, on the Fildes Peninsula.

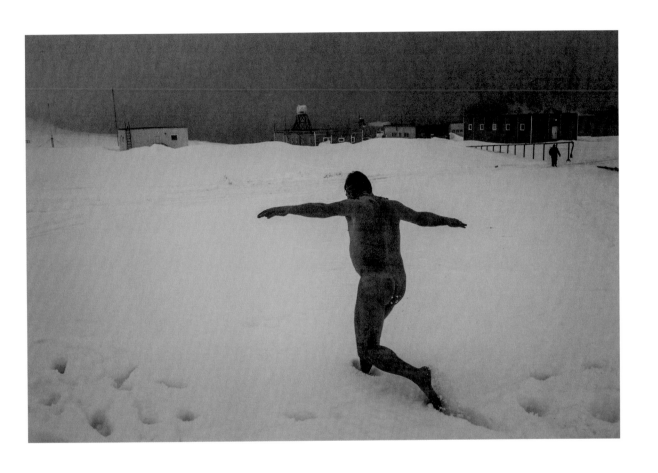

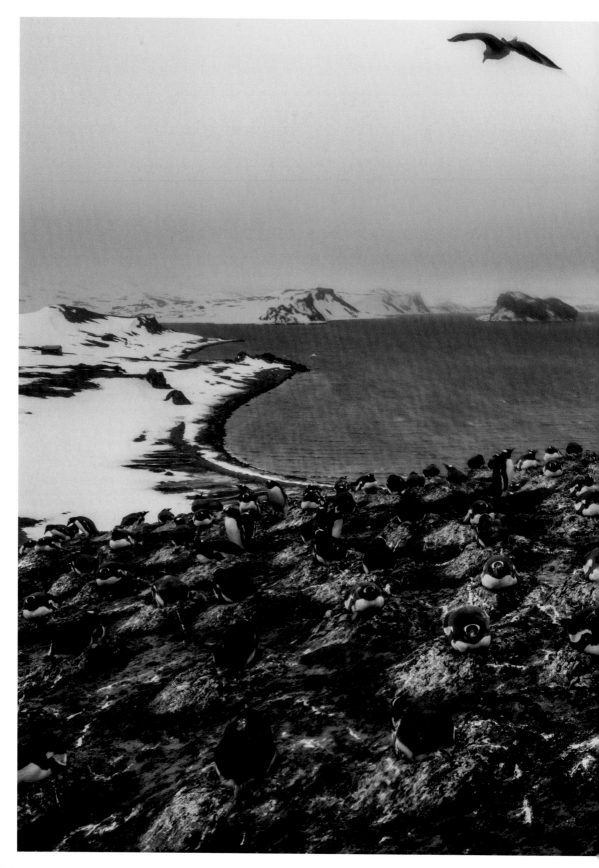

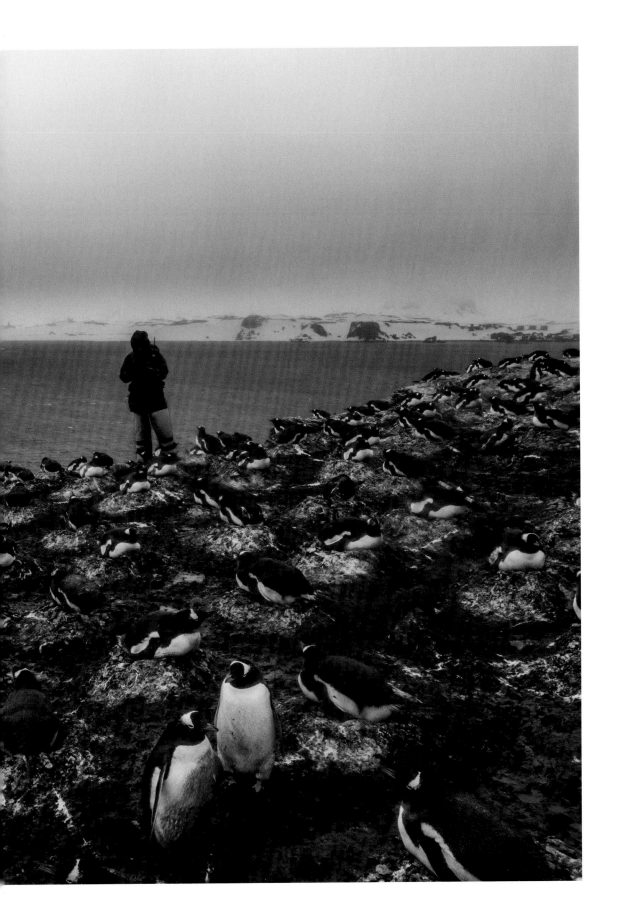

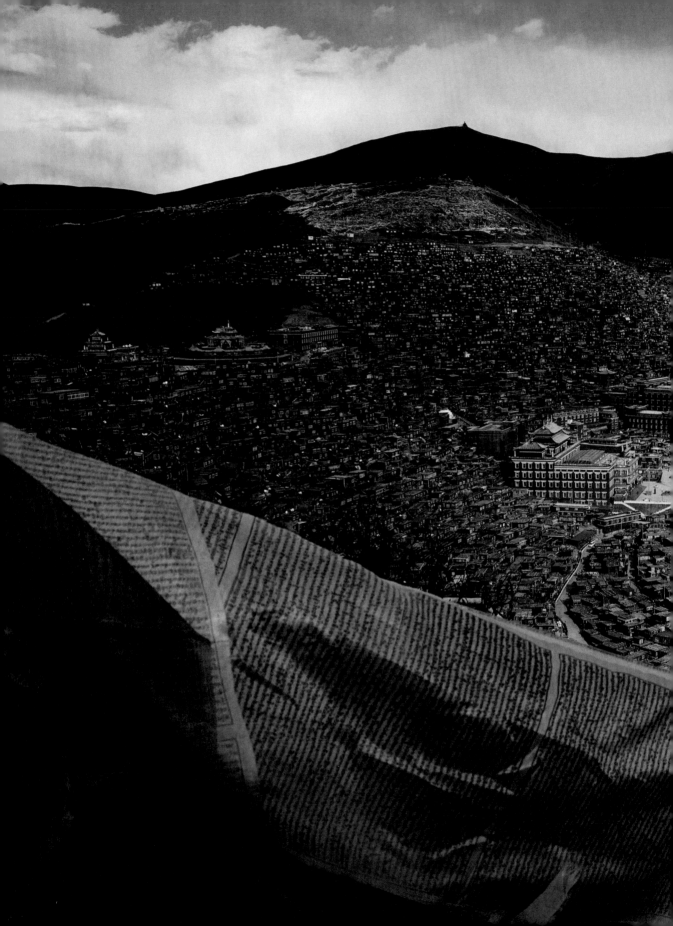

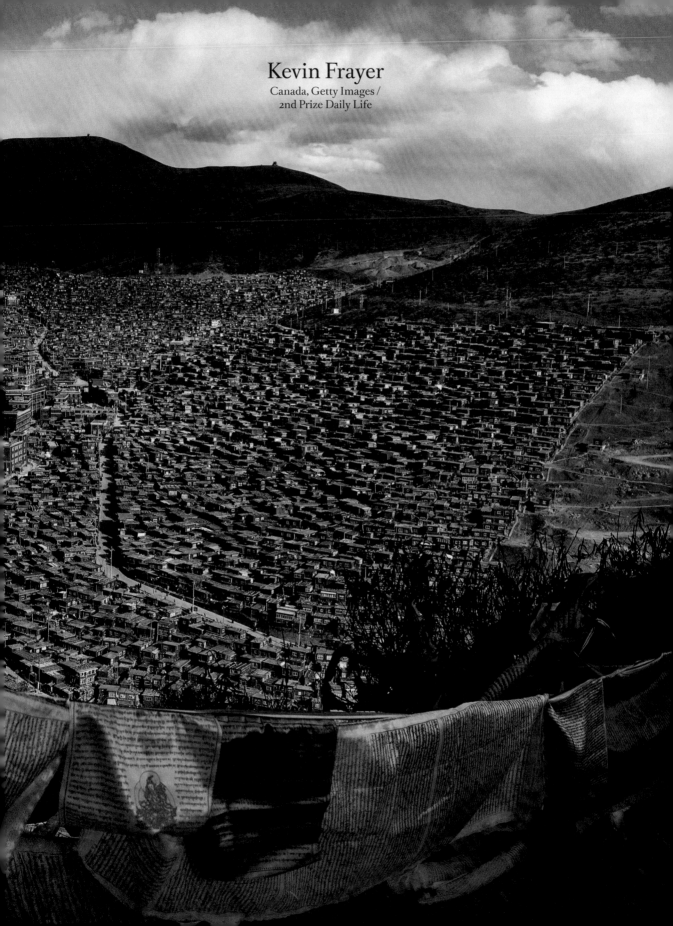

Kevin Frayer
Canada, Getty Images /
2nd Prize Daily Life

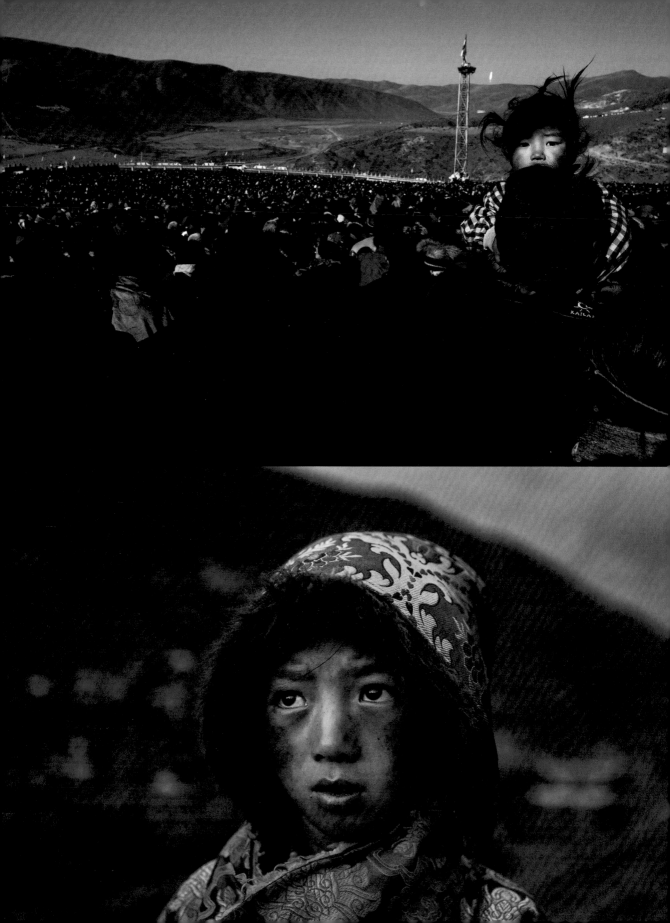

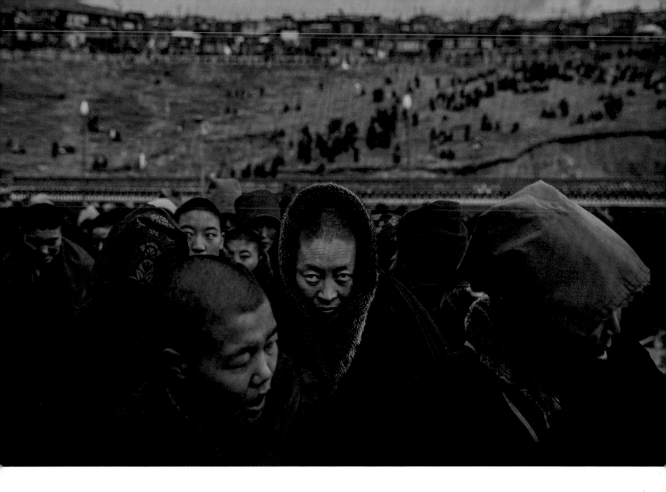

The Larung Gar Buddhist Academy is located in the remote Garze Tibetan Autonomous Prefecture, 4,000 meters above sea level in Sichuan, China. It was founded in 1980 by Jigme Phuntsok, a lama of the Nyingma tradition, the oldest of the four major schools of Tibetan Buddhism. The main academy buildings are surrounded by a multitude of small huts, home to some 40,000 monks and nuns, segregated by a road winding through the city. Thousands of Tibetan Buddhists come to Larung Gar for the week-long Bliss Dharma Assembly, an annual gathering that marks the Buddha's descent from heaven. *Previous spread:* Prayer flags flutter above the city. *Facing page, top:* A Tibetan Buddhist nomad carries his daughter in the crowd during the Bliss Dharma Assembly. *Below:* A nomad boy walks on a hillside during the assembly. *This page:* Nuns stand after a chanting session, during the assembly. *Next spread:* A nomad woman prepares tea at dusk, following a chanting session.

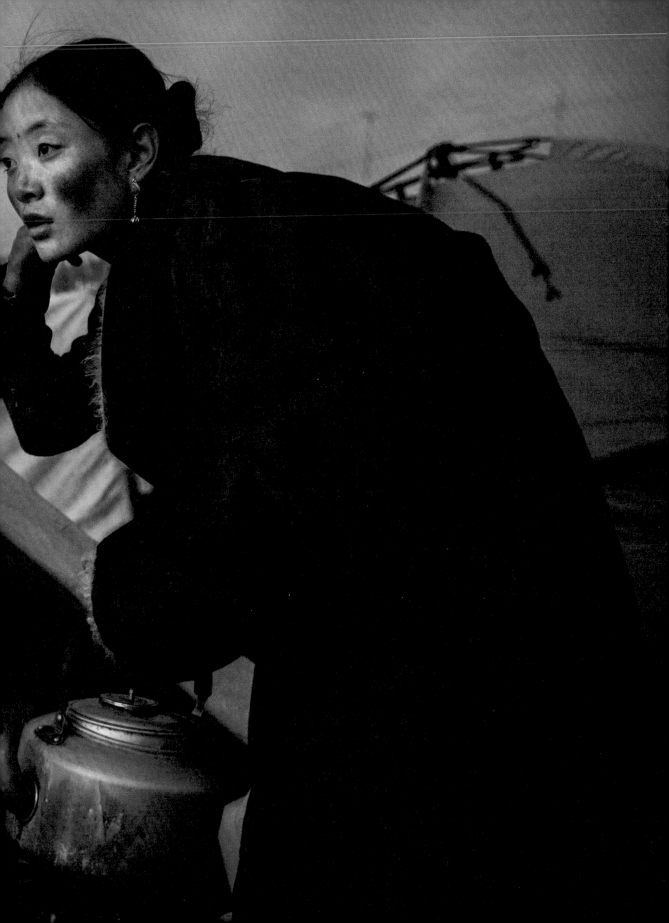

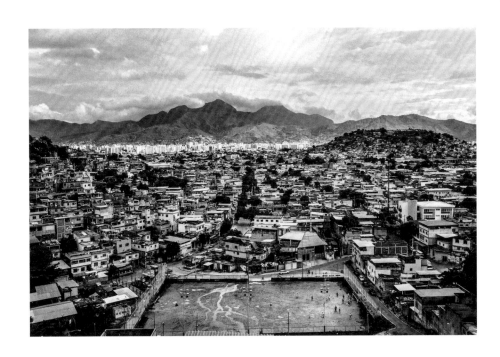

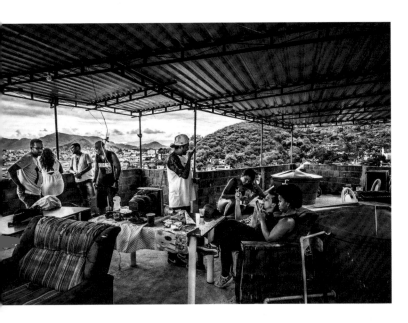

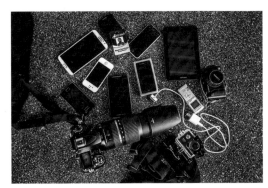

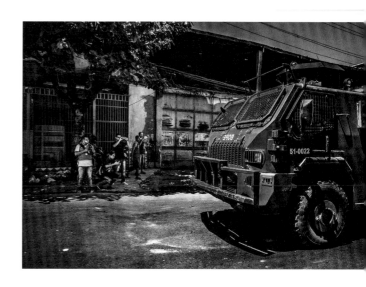

Police shootings in Rio de Janeiro's *favelas* (urban shantytowns) are so common that they are seldom reported. According to Amnesty International, around 2,000 people are killed every year by Brazilian police, often in a manner that resembles a planned execution. In Complexo do Alemão, one of the largest Rio *favelas*, residents, frustrated by the lack of traditional media coverage, have formed Papo Reto ('straight talk'), a collective of activists who collate and distribute images and reports through social media. *Previous spread:* Raul, from Papo Reto, photographs the scene where Diego da Costa Algavez, a mototaxi driver, was shot by police, in Vila Cruzeiro *favela. Facing page, top:* Complexo do Alemão, viewed from Papo Reto headquarters. *Middle:* Members of the collective at their headquarters. *Below:* Papo Reto equipment. *This page, top:* Papo Reto members photograph a Special Police Forces armored car patrolling the streets following the shooting. *Below:* Papo Reto is alerted to the shooting. *Following spread:* Police patrol the streets alert to possible confrontation, after Algavez had been shot.

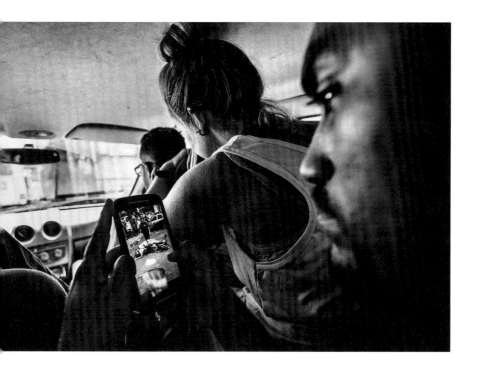

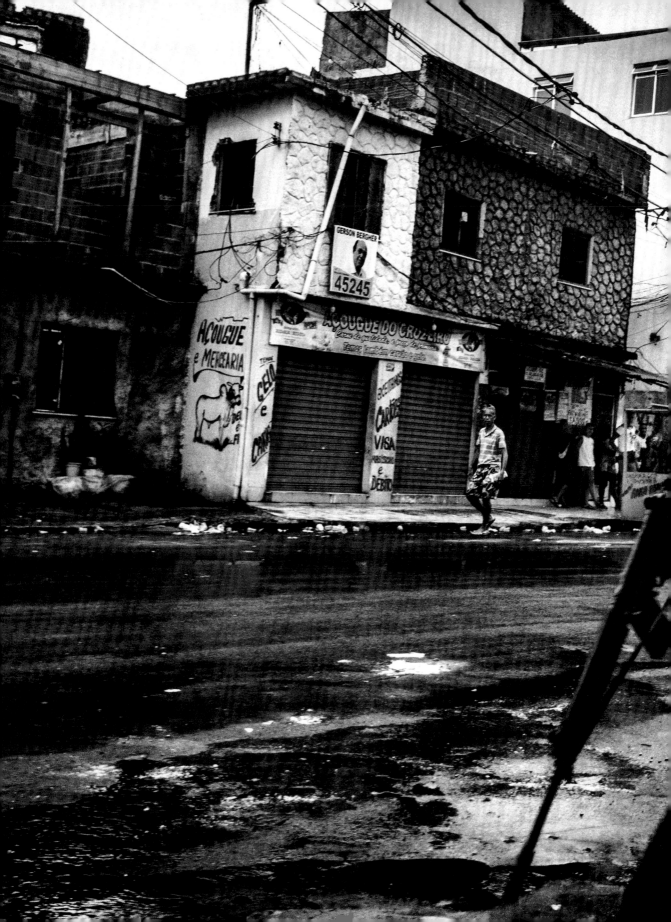

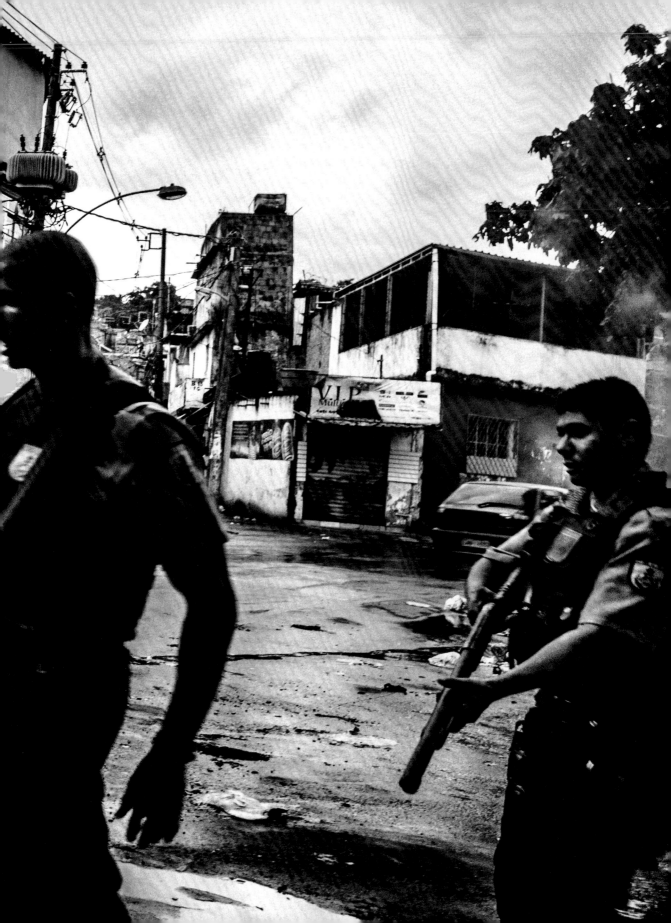

Kazuma Obara

Japan /
1st Prize People

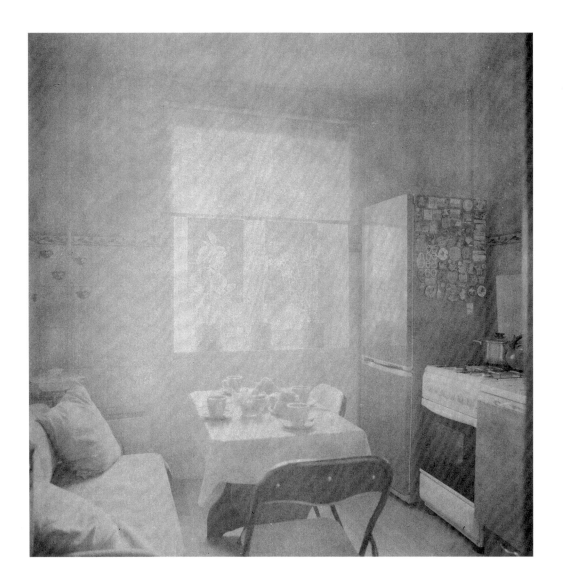

On 26 April 1986, a nuclear disaster at the Chernobyl Nuclear Power Plant, near the town of Pripyat, Ukraine, resulted in large amounts of radioactive material being released into the atmosphere. Radioactive particles—the contaminating effects of which can last for years—were carried downwind through much of the western USSR and Europe. Five months after the disaster, a girl named Mariya was born in Kiev, 100 km south of Chernobyl. She grew up suffering from chronic thyroiditis, one of the results of radiation poisoning. These images represent 30 years of her life.

In April 2015, the photographer's assistant discovered 20 rolls of unused color film in Pripyat, with a 1992 expiry date. The photographer set about shooting images taken in places which related to the Chernobyl accident: the apartment of somebody displaced by the accident, a hospital treating people with radiation illnesses, an apartment where nuclear workers were living at the time of the accident, a school for children whose parents used to live in the restricted zone around Chernobyl, and current pictures of the plant.

When it came to processing the negatives, the photographer had to improvise and experiment. The chemicals he needed for developing the old Ukrainian color film were no longer available, but he found that using black-and-white chemicals on over-exposed film gave a result that suited his purposes. He wanted to capture the current situation, but also to help people imagine the invisible problems, such as those experienced by Mariya.

Mariya was admitted into an intensive care unit soon after being born. Much of her childhood was spent in different hospitals, without receiving a diagnosis. She feels that so much time lying in hospital without her mother has had a long-term effect on her character.

When Mariya was 19, her symptoms grew more acute. Her heart rate accelerated to 120–130 beats a minute, and she developed a severe tremor, which put an end to her studies to be an architect. She could not understand what was happening, and found the whole experience frightening. She says that it bothered her to be branded as 'disabled', that she had the feeling the word would bury her. She also felt in some way guilty for her predicament.

It took Mariya many years to work through these emotions, but she no longer feels guilty, nor does she blame anyone. She needs a lot of medication, but her heart rate is more under control. After re-establishing contact with her estranged parents, she feels like she has been reliving much of what she missed in her childhood. And she has been embarking on new ventures, such as travel, and taking up painting. She says she no longer feels overwhelmed by life.

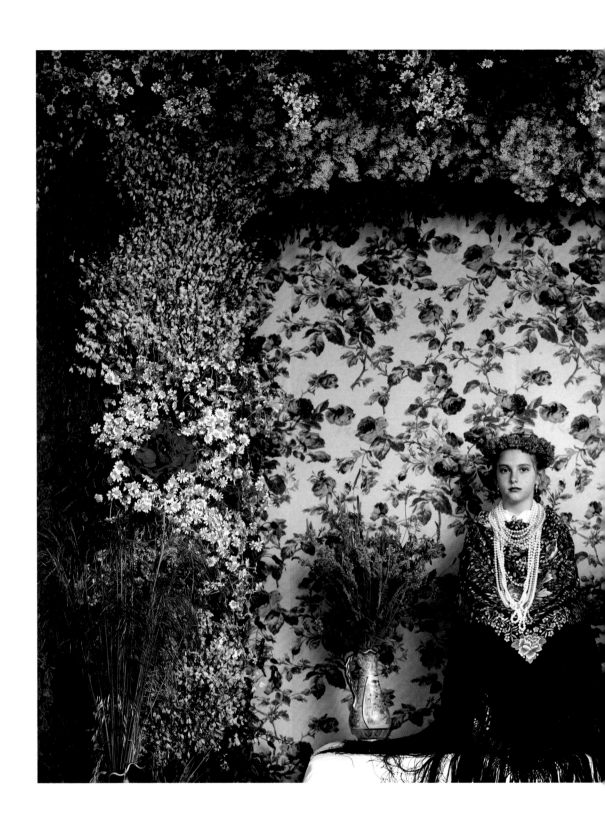

Daniel Ochoa de Olza
Spain, The Associated Press /
2nd Prize People

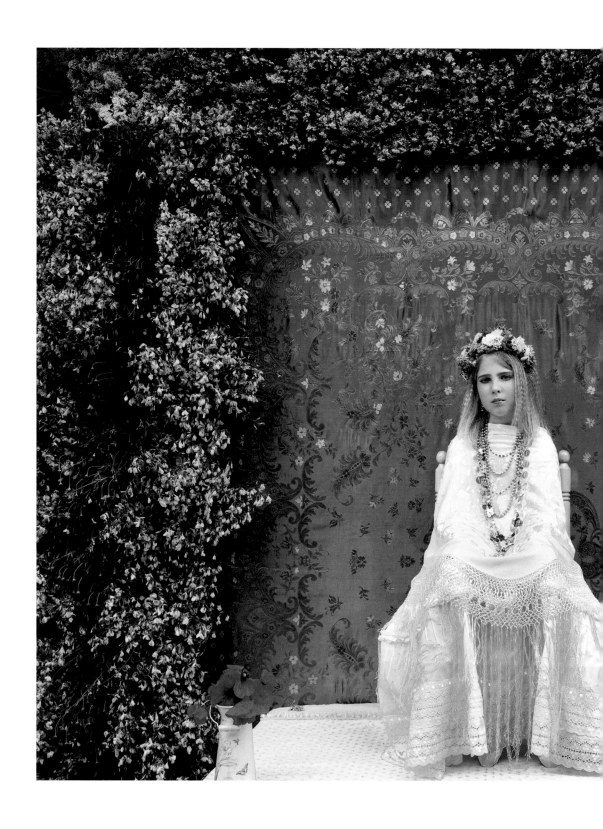

The feast of Las Mayas, in Colmenar Viejo, on the outskirts of Madrid, Spain, has its origins in pagan ritual. It is held annually at the beginning of May, to celebrate spring. Five or six groups create altars adorned with plants and flowers on the main town square and adjacent streets, and each selects a young girl between the ages of six and 15 to be a 'Maya'. She must then sit on the altar—very still, silent and serious—wearing a white blouse and skirt, and a Manila shawl.

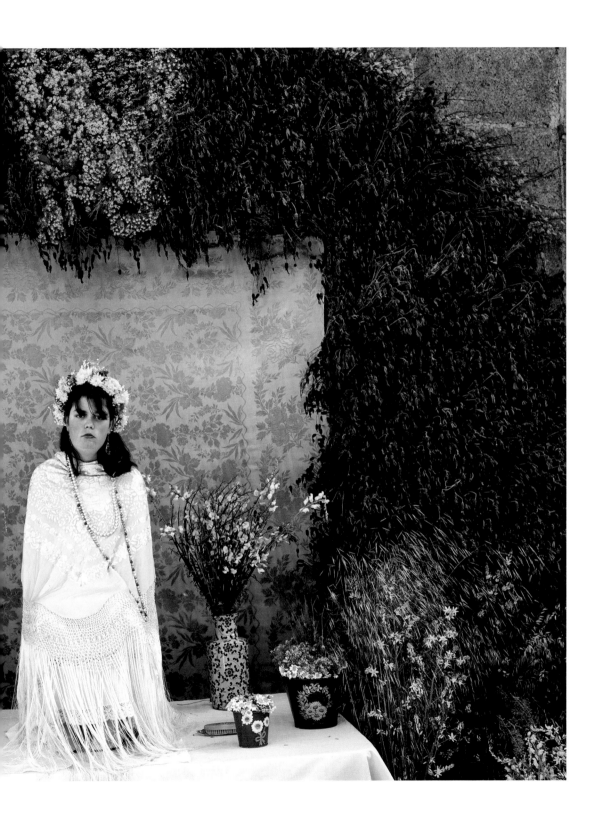

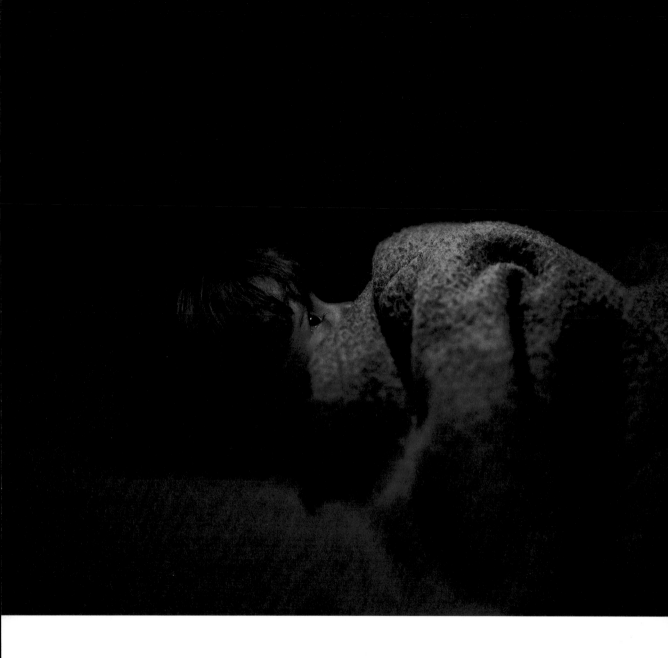

Magnus Wennman

Sweden, *Aftonbladet* /
3rd Prize People

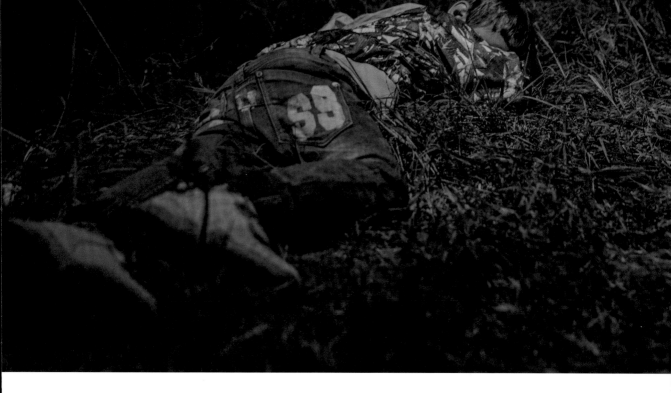

Refugee children, on their long journey to a new home, sleep where they can along the route. *Facing page:* Fara (2) loves soccer. Her father tries to make balls for her by crumpling up anything he can find, but they don't last long. *Above:* Ahmed (6) falls asleep in the grass after midnight, in Horgoš, Serbia. He carries his own bag on the stretches of the journey that the family covers on foot. His uncle, who has taken care of him since his father was killed in their hometown, says Ahmed is brave and cries only occasionally, in the evenings.

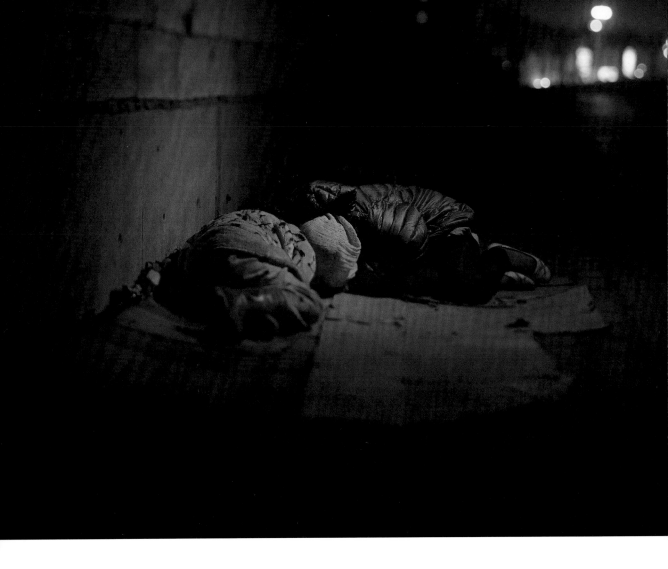

Refugee children, on their long journey to a new home, sleep where they can along the route. *Above:* Ralia (7) and Rahaf (13) sleep on the streets of Beirut, Lebanon. A grenade killed their mother and brother in Damascus. They are with their father, and have been sleeping outside for a year. *Facing page:* Mohammed (13) dreams of being an architect. He used to enjoy walking around Aleppo, looking at houses.

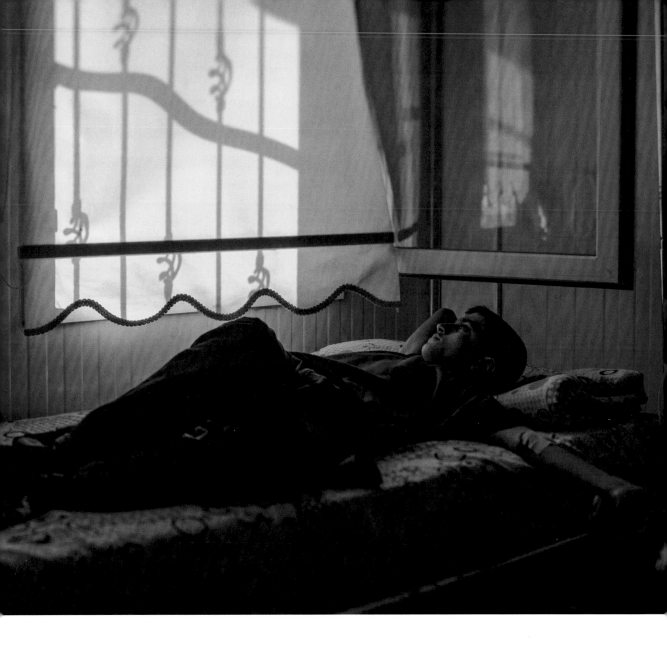

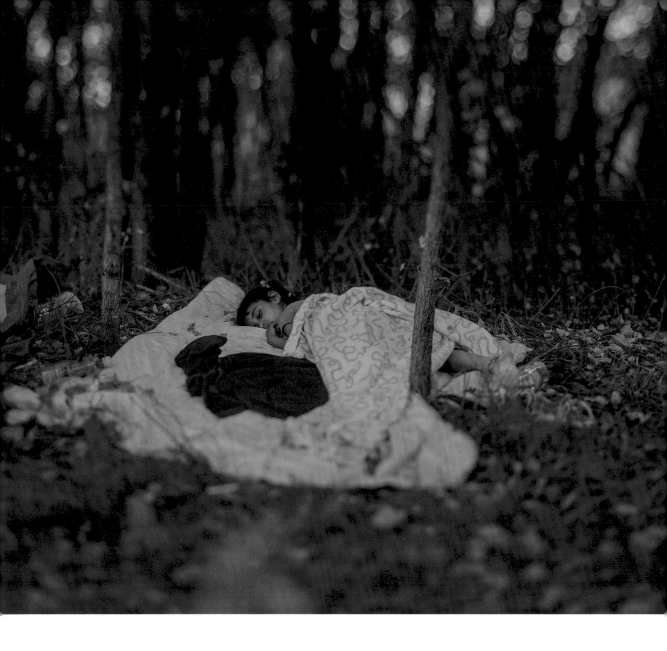

Refugee children, on their long journey to a new home, sleep where they can along the route. *Above:* Lamar, from Baghdad, sleeps on a blanket in a forest in Horgoš. After two attempts at crossing the sea from Turkey in a small dinghy, her family has come as far as Serbia to find the border with Hungary closed. *Facing page:* Walaa (5), in a refugee camp in Lebanon, is distressed at night, because that is when attacks happened when she was at home in Aleppo.

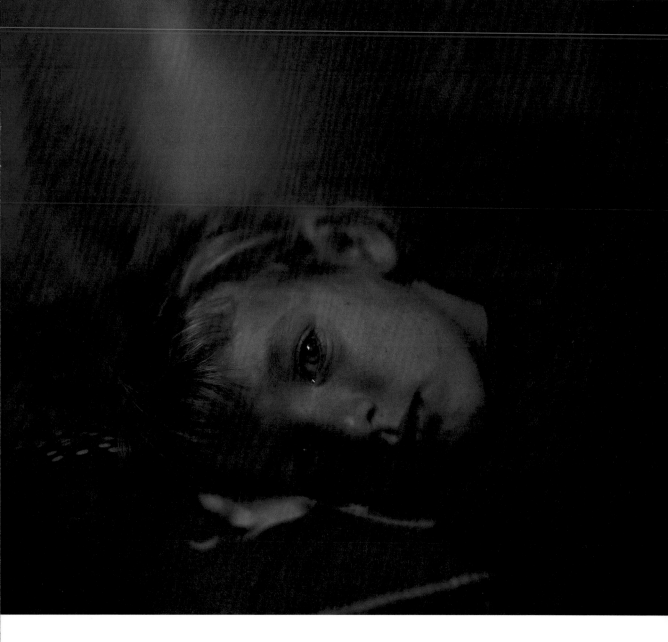

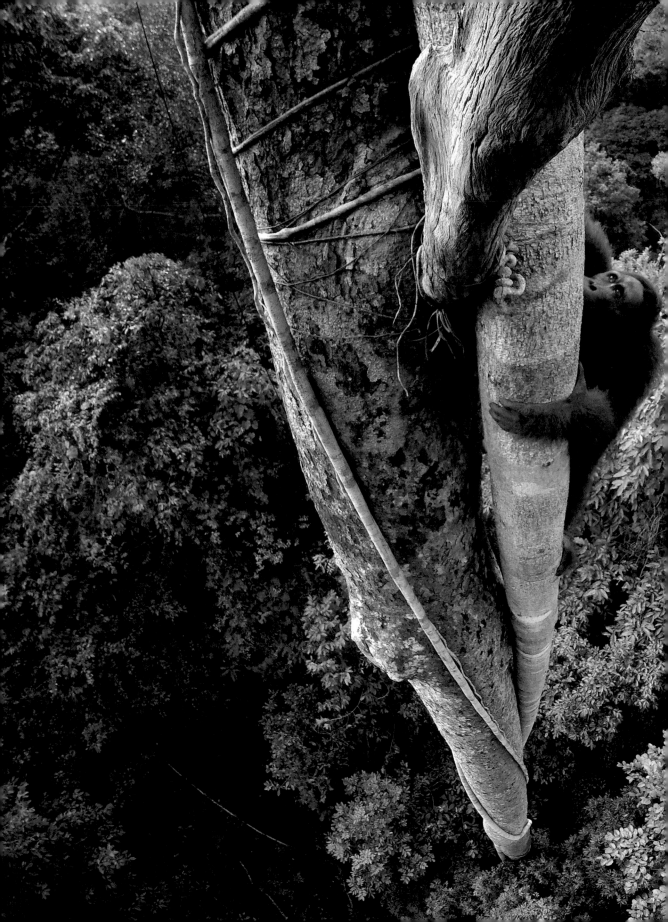

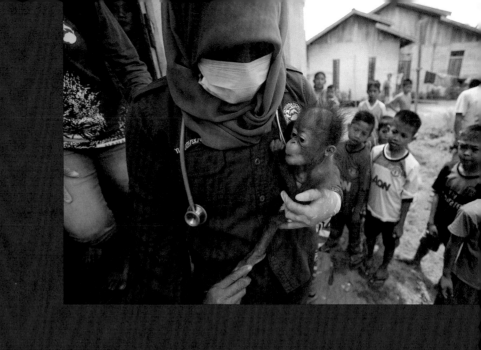
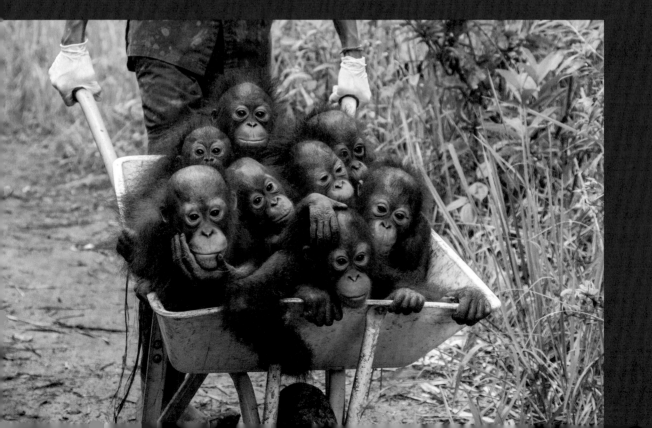

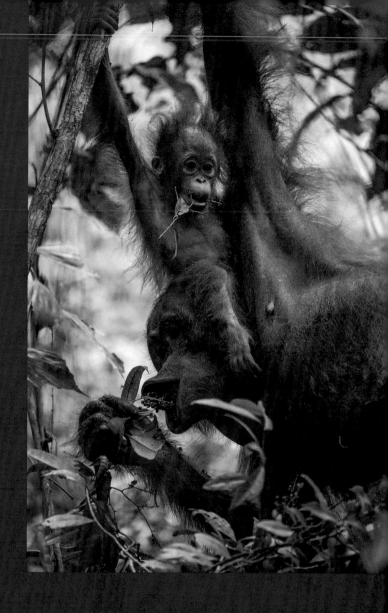

Orangutans are facing a crisis in habitat, as logging activity, conversion to agriculture, and fires consume their forests. They are also poached for the illegal pet trade. In 2015, wildfires—spurred by drought and the effects of El Niño—devastated vast areas of rainforest in Borneo, driving out orangutans and putting them in increased danger from poachers, and into conflict with farmers as they searched for food. *Previous spread:* A young male Bornean orangutan climbs 30 meters up to the crown of a fig tree to feed, in Gunung Palung National Park, West Kalimantan, Indonesian Borneo. *Facing page, top:* A member of International Animal Rescue carries a baby Bornean orangutan out of a house where it was being kept illegally as a pet, in Sungai Besar. *Below:* Orphan baby orangutans get a ride from their night cages to a patch of forest where they can play for a day, at the International Animal Rescue facility, in Ketapang. *This page:* A wild female and baby feed on Ardisia fruit, in the Mawas Conservation Area, Central Kalimantan. *Next spread:* A young male Sumatran orangutan threatens another male, in Batang Toru Forest, Sumatra, Indonesia. *Two spreads forward:* An orangutan is forced to the forest's edge by fire.

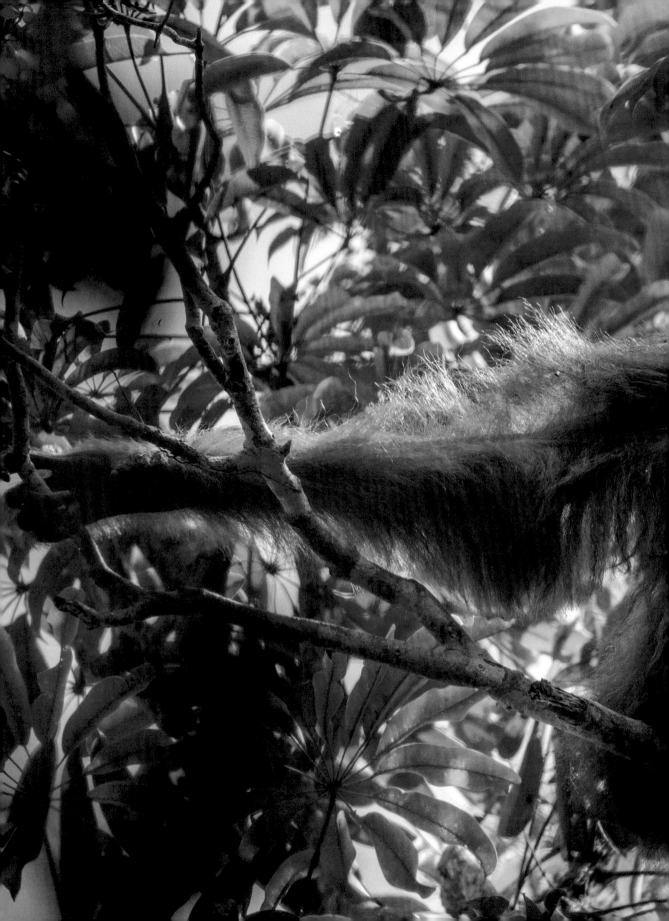

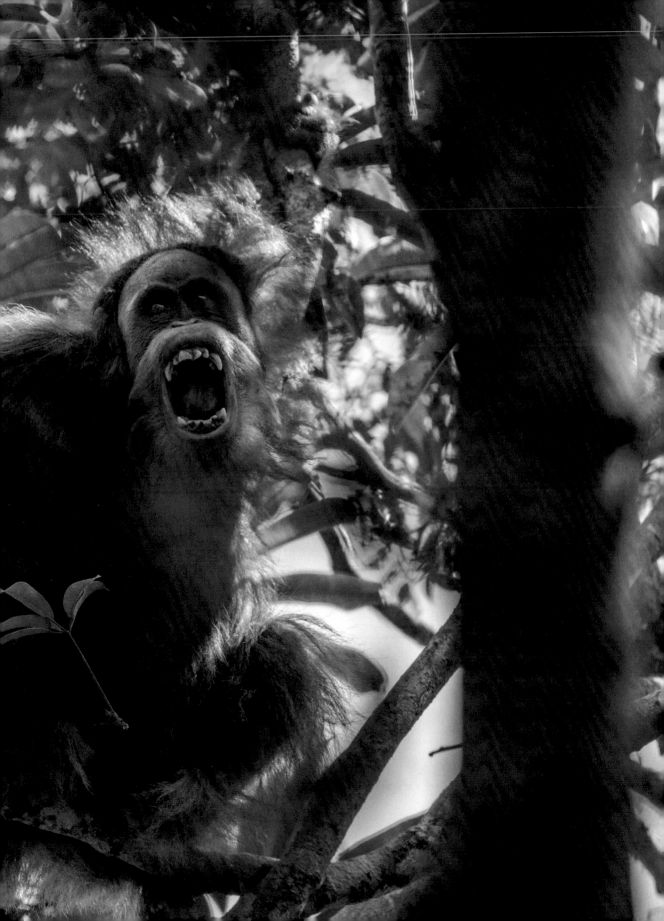

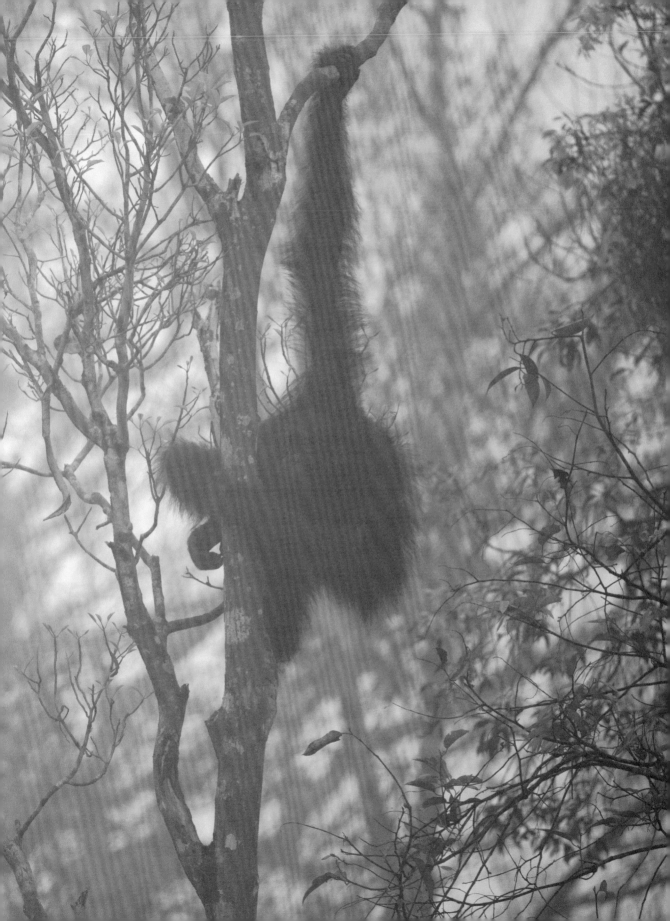

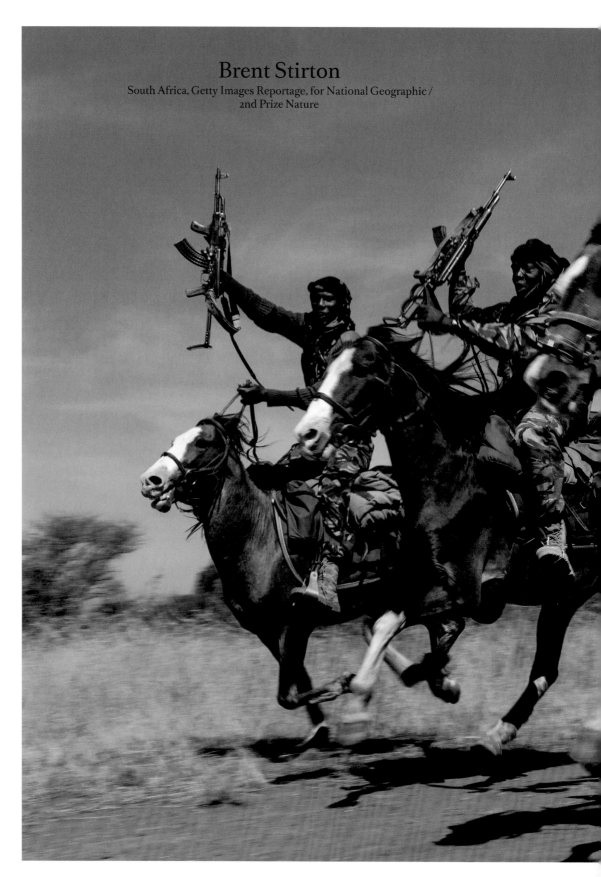

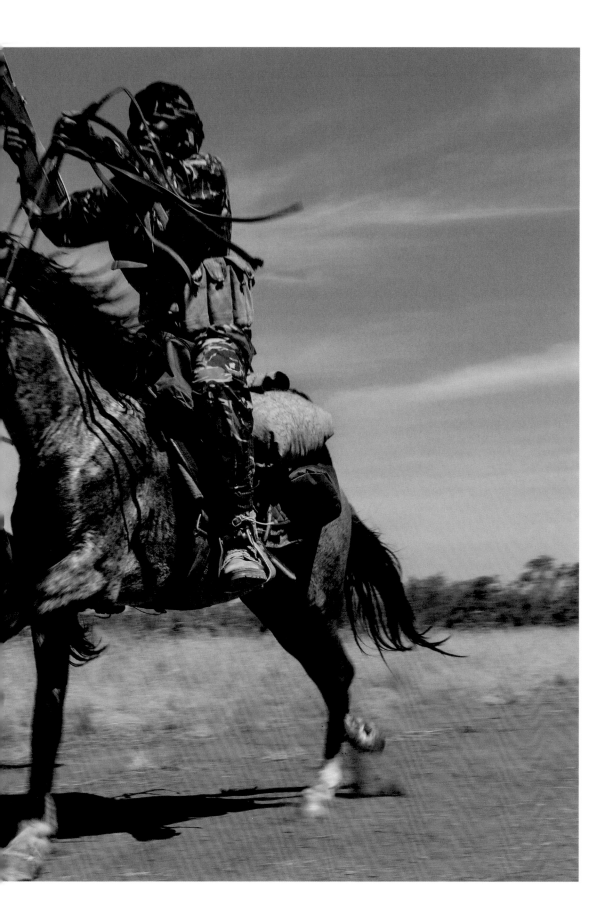

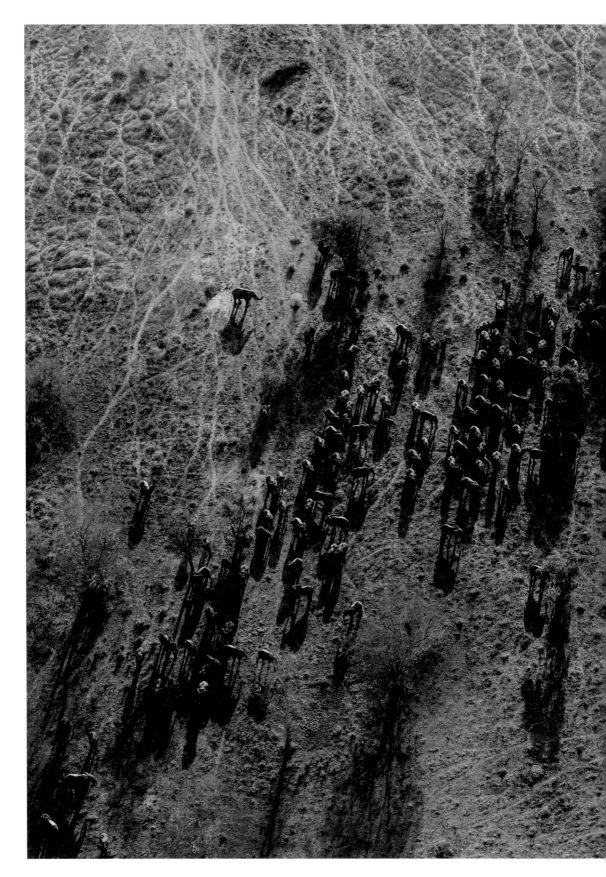

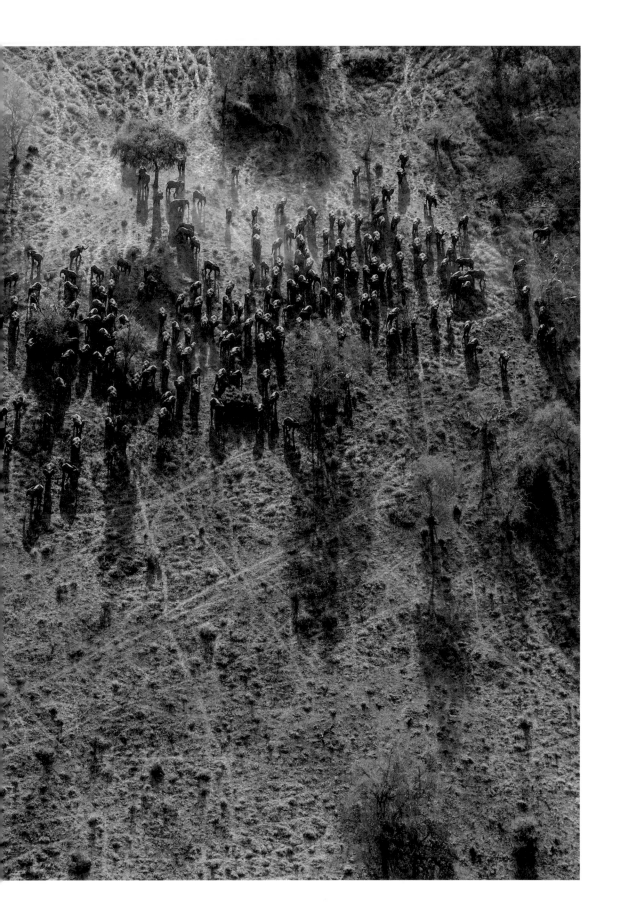

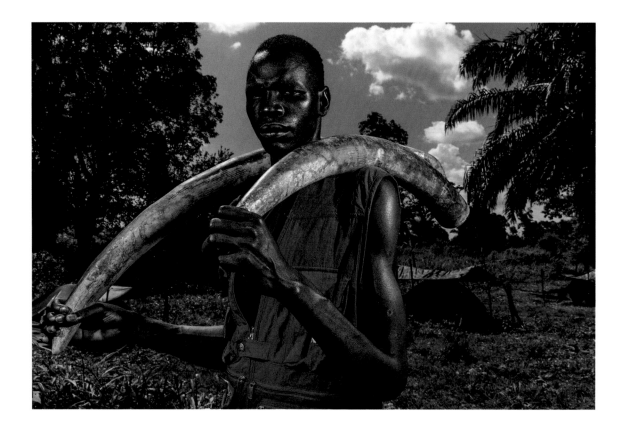

The trade in poached ivory is financing armed rebel militia across Africa. Various national armies actively trade with these groups, and centuries-old Sudanese poaching cartels participate in sending large bands of armed men across borders to kill elephants. Patrols of dedicated rangers around the continent are on the frontline of attempts to thwart the trade. *Two spreads back:* Rangers exhibit their riding skills as they return to base at Zakouma National Park, Chad, after weeks on elephant patrol. The park lost nearly three quarters of its elephants in the decade up to 2011, due to raids by Janjaweed rebels and poachers from Sudan. Since then, Zakouma rangers, helped by intelligence from nomad groups, have eliminated poaching almost completely. *Previous spread:* Zakouma National Park is home to the largest remaining herd of elephants in the world. *This page:* Michael Oryem (29) poached elephant with the Lord's Resistance Army (LRA). He says the LRA

trades the ivory to the Sudanese Army. Oryem defected from the LRA and helped take Ugandan forces through the border into the Central African Republic (CAR) to retrieve a stash of ivory he had previously hidden. *Facing page, top:* Ranger Dieudonné Kumboyo Kobango stands with his son Genekpio, in Garamba National Park, Democratic Republic of Congo (DRC). Genekpio escaped soon after being abducted from his village near the park by the LRA. *Below:* Margret Acino (32) was abducted from a field in Gulu, Uganda, by the LRA, who accused her of informing on them to the Ugandan Army. She was mutilated before being released. *Next spread:* A shipping container stands open in the port at Lomé, Togo, after customs officers had seized four tonnes of illegal ivory, found using new container-scanning technology. DNA evidence linked the ivory to an elephant massacre perpetrated by Seleka rebels in Dzanga Bai, CAR, in 2013.

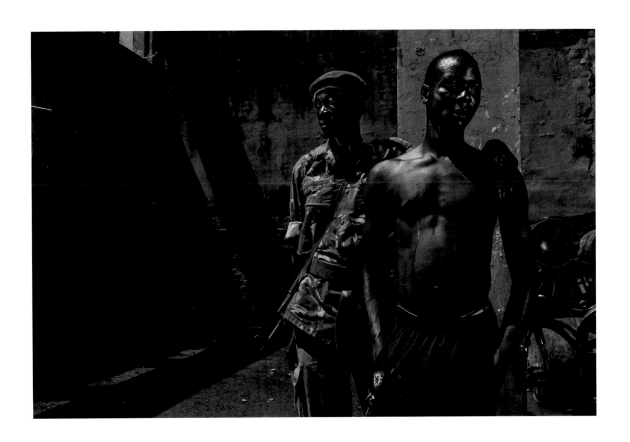

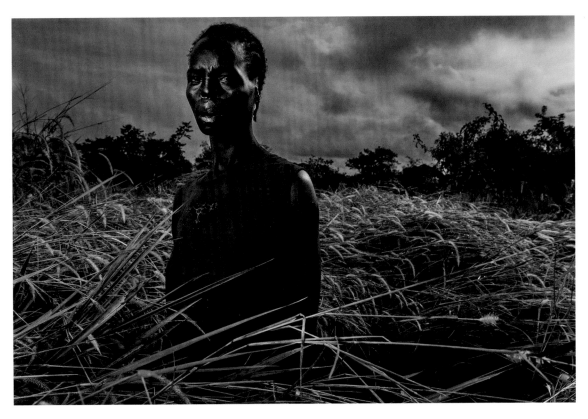

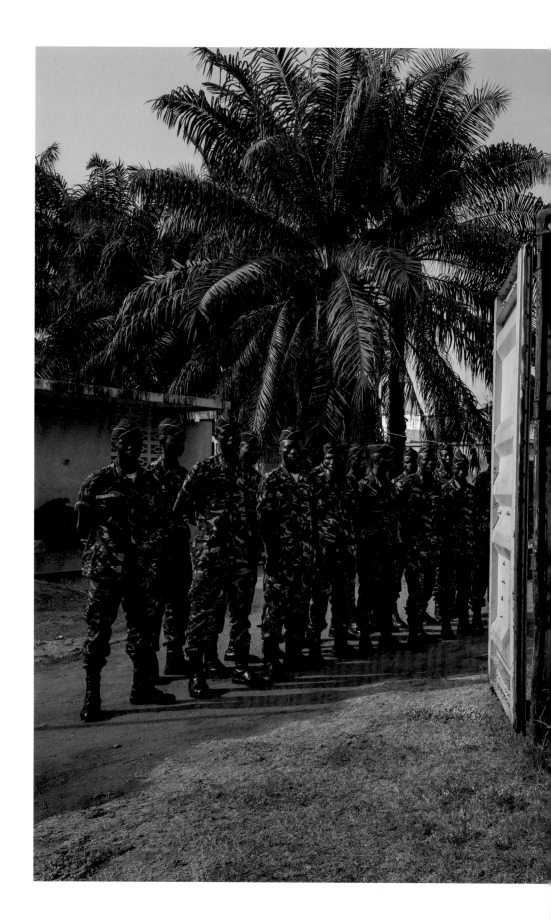

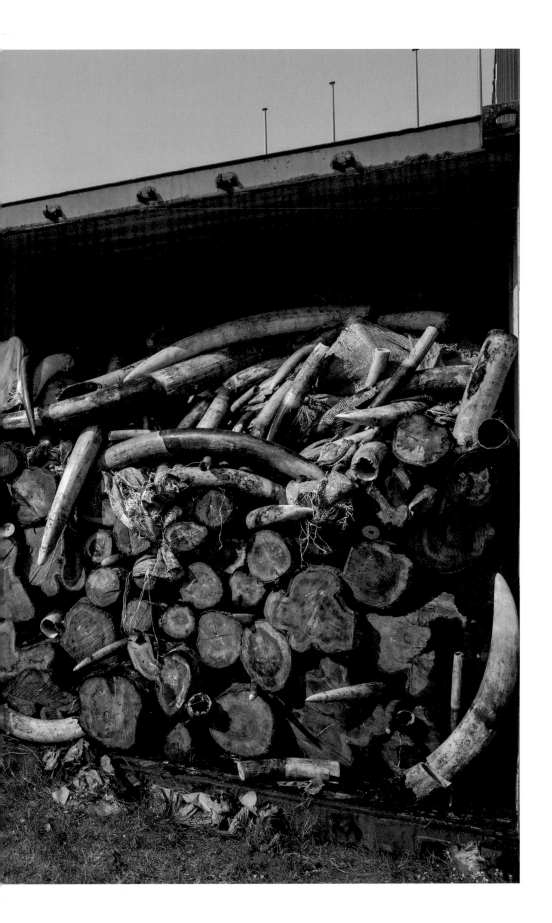

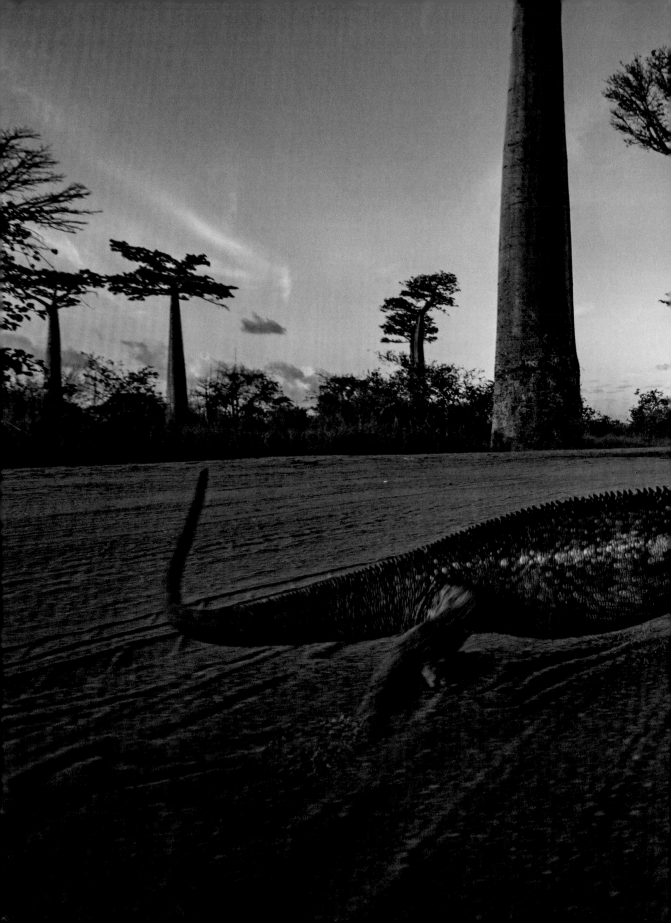

Christian Ziegler

Germany, for National Geographic /
3rd Prize Nature

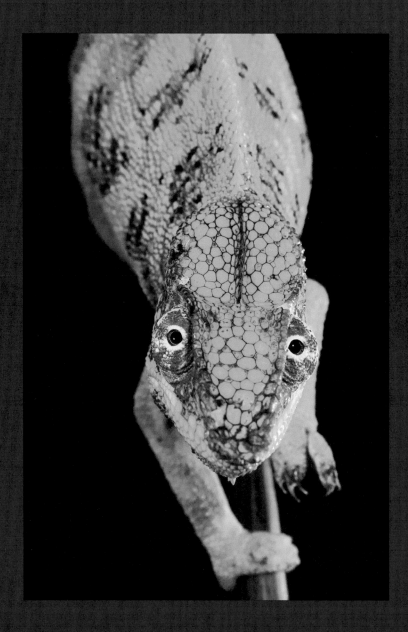

Chameleons are an ancient group of lizards, with more than 170 described species, living in habitats that range from rainforests to deserts, and from sub-tropical coastlines to 4,000-meter-high mountains. According to the Species Survival Commission's Chameleon Specialist Group, over a third of the world's chameleon species are threatened with extinction. *Previous spread:* A Malagasy giant chameleon crosses Baobab Alley, in Kirindy Mitea National Park, Madagascar. *This page:* A dominant male of a rare turquoise form of panther chameleon displays its colors. *Facing page, top:* Orange panther chameleons, from northern Madagascar, fight. Pictured here in captivity, they are very rare in the wild. *Below:* Two Decary's leaf chameleons sit in perfect camouflage in the leaf litter of a dry forest in Ankarafantsika National Park. *Next spread:* A female *Calumma ambreense* captures an insect.

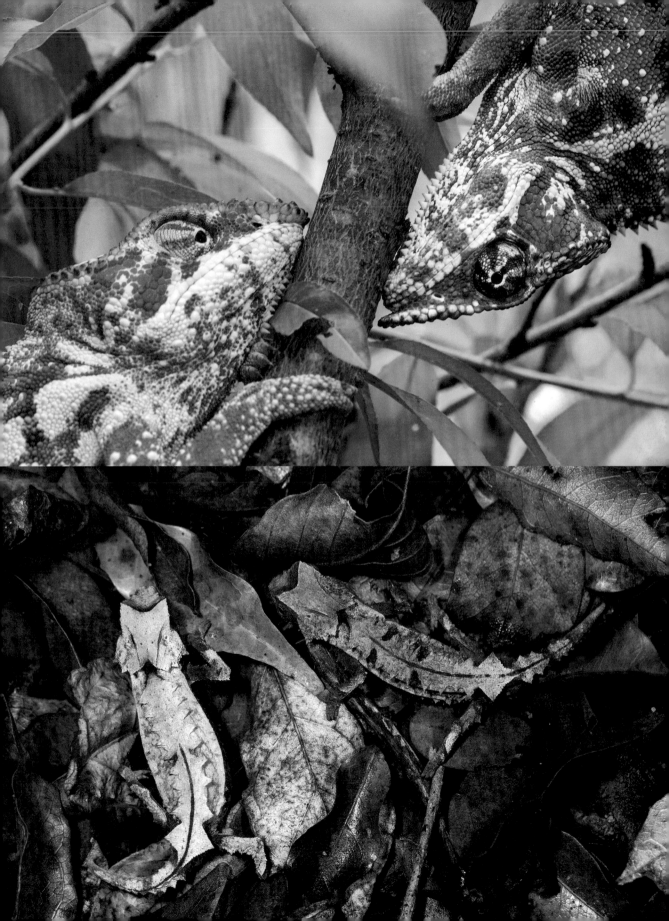

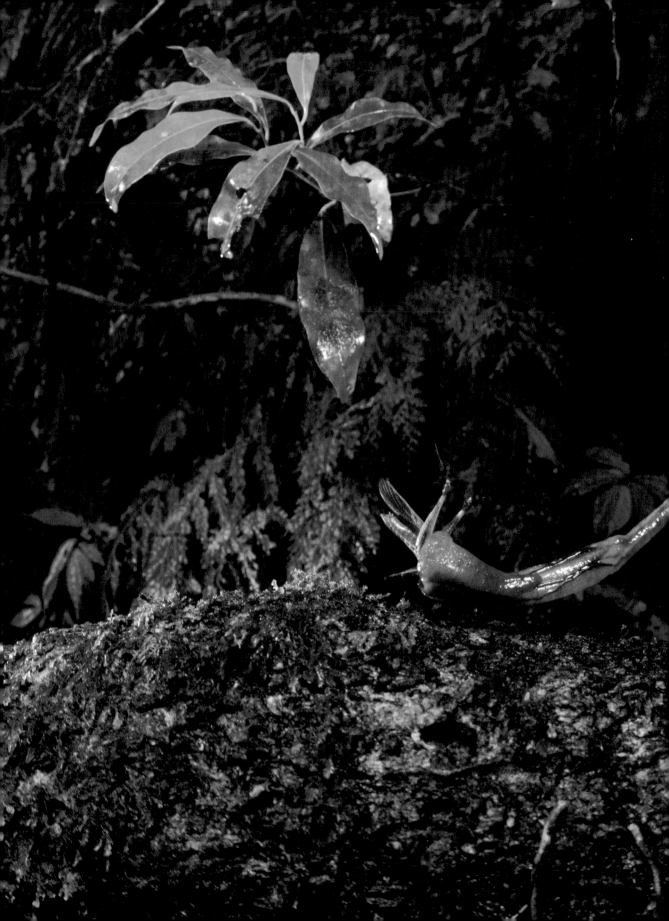

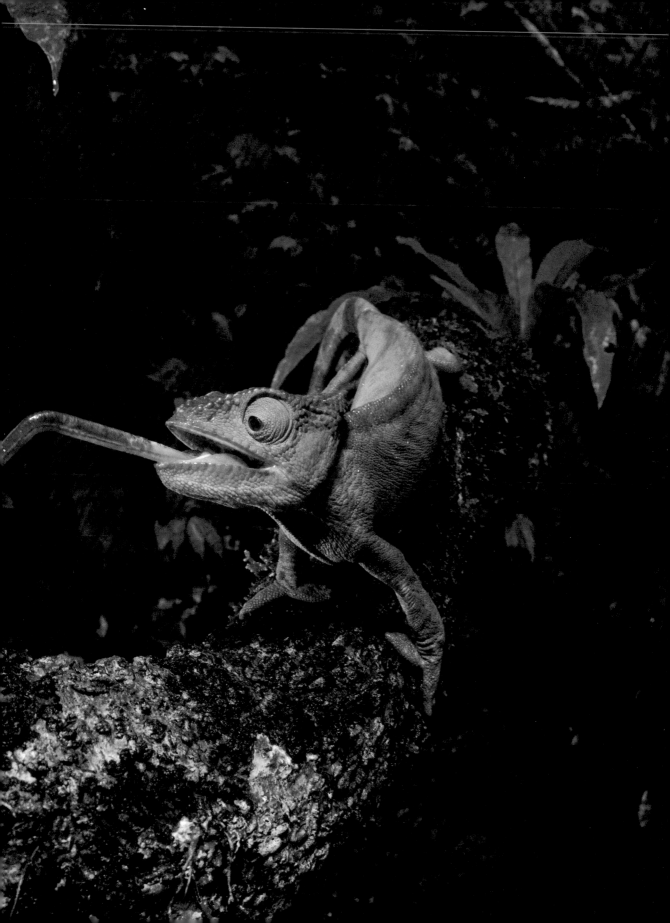

Vladimir Pesnya

Russia, Sputnik /
1st Prize Sports

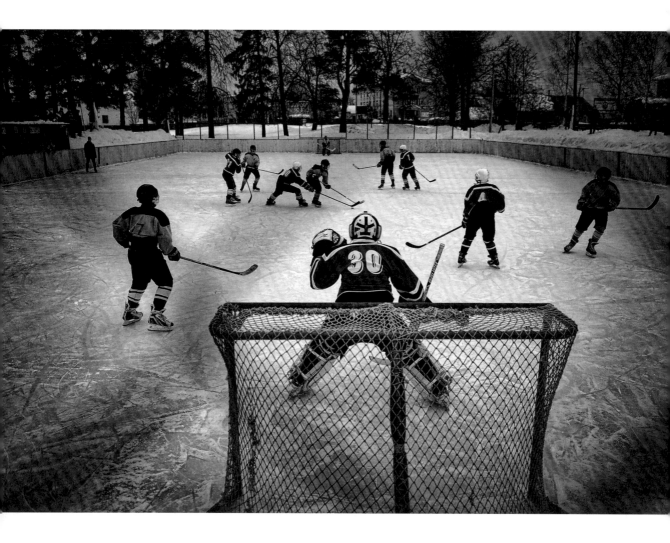

HC Vetluga is an amateur ice-hockey team in the small town of Vetluga, some 230 km north of Novgorod, in Russia. The team participates in regional championships. The players' stadium is simply a fenced-off area of ice in the open air. *This page:* A match takes place between junior teams from Vetluga and the neighboring village of Sharanga. *Facing page:* Michael Chukino, HC Vetluga's goalkeeper, leaves home for a match. (continues)

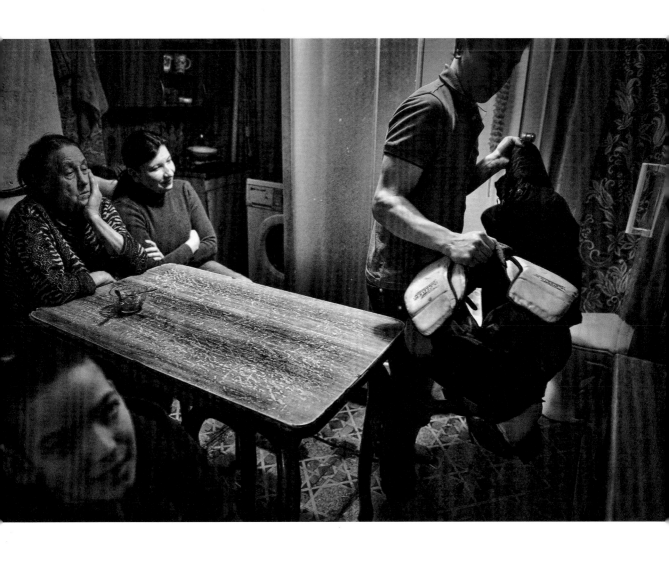

(continued) HC Vetluga comprises people of all ages, from school-children to pensioners. *Previous spread:* Team coach Evgeny Solovyov prepares the stadium for a match. *This page:* Players get ready for a match against the town of Tonshaevo. *Facing page:* The match with Tonshaevo takes place.

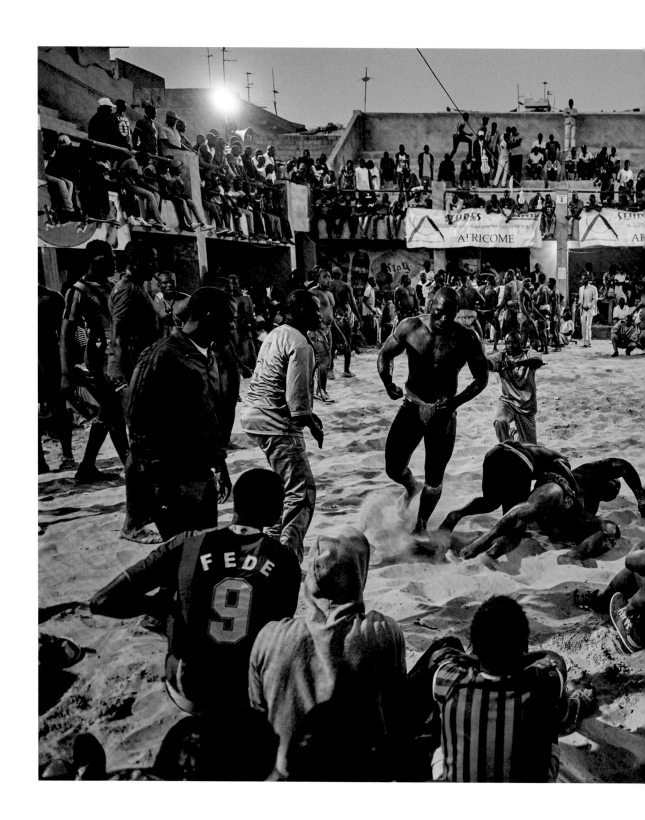

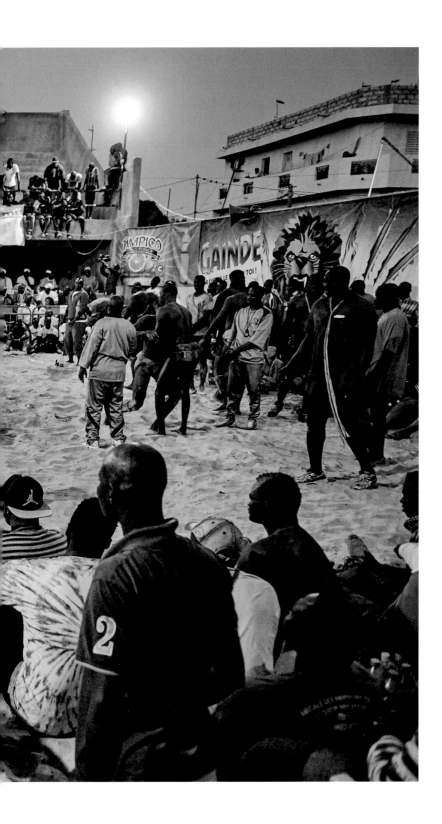

Christian Bobst
Switzerland /
2nd Prize Sports

Senegalese wrestling is the most popular sport in Senegal, attracting major sponsors and wide media coverage. Wrestlers can become national stars and extremely wealthy, with top prizes reaching hundreds of thousands of euros. The sport is part of a larger West African form of traditional wrestling, but differs in that the Senegalese version allows blows with the hands. It has its historical roots in preparations among warrior classes for battle, and is still seen as an indication of masculine strength and ability. Tournaments involve drumming and dance, and wrestlers practice a range of rituals—such as the presentation of amulets, and rubbing with lotions—to increase their chances and ward off bad luck. *Previous spread:* A tournament in the Adrien Senghor Arena in Dakar nears its end. *This page:* Superstar wrestler Omar Sakho (known as Balla Gaye 2) releases a dove for good luck, before a match with Eumeu Sène, in Dakar. *Facing page, top:* An assistant prepares a sacrifice to bring luck, at a wrestler's family shrine. *Below:* People watch a match held as part of Independence Day celebrations.

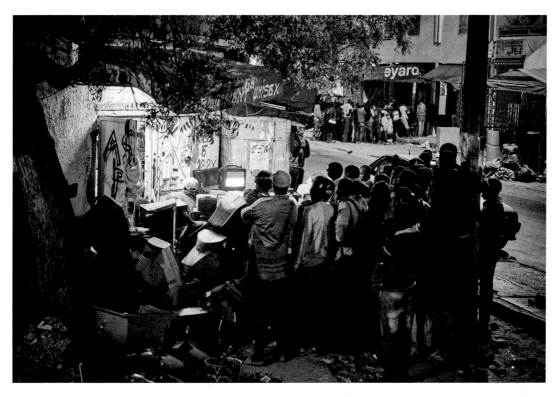

Tara Todras-Whitehill

USA, for *The New York Times* /
3rd Prize Sports

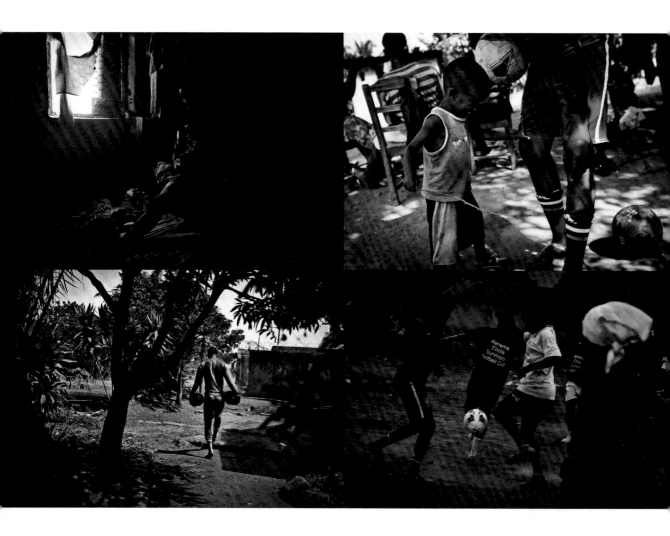

The Ebola Survivors' Football Club provides a
support network for survivors of the disease and
helps battle negative stigmas in the community.
It was founded by Erison Turay, who lost 38
members of his own family to Ebola, in his home-
town of Kenema, 300 km east of Freetown, Sierra
Leone. *Top row:* Erison puts on his football kit, at
home in Kenema. Erison plays with a member of
his extended family. Men wear club kit to prac-
tice. Women members of the club practice a
sudden-death penalty shoot-out. *Bottom row:*
Erison walks to practice. Erison referees a
women's match. Bandu Turay (second row from
top, fourth from right), Erison's mother, watches
him play. Women celebrate after winning a
penalty shoot-out.

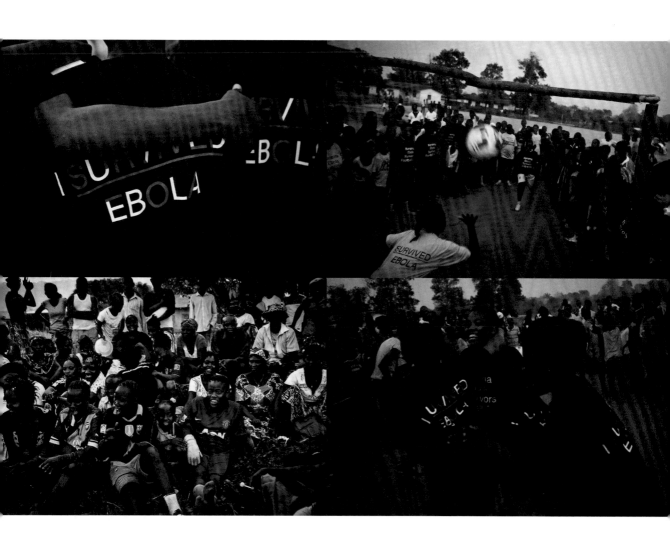

The 2016
Long-Term Projects

Mary F. Calvert

USA, ZUMA Press/Alexia Foundation /
1st Prize

The Battle Within: Sexual Assault in America's Military

The incidence of sexual assault on women by their colleagues in the US Armed Forces is high. Many women see reporting attacks to their commands as difficult or futile. Very few sexual assaults are reported and only a fraction of those get to court. The trauma of a sexual assault, and the ensuing emotional distress, may lead to long-term personal issues. The effects of Military Sexual Trauma (MST) include drug and alcohol dependence, homelessness, and an increased risk of suicide. Challenges for women veterans are not always met by existing vet programs. Women veterans form the fastest-growing segment of the homeless population of the US, and are four times more likely to be homeless as other women.

The photographer, who comes from a military family, made it her mission to document the lives of MST survivors, and to keep the issue talked about. She learned that they formed a network of support for each other, but that homeless survivors were a hidden population, who rarely spoke to others about their experiences.

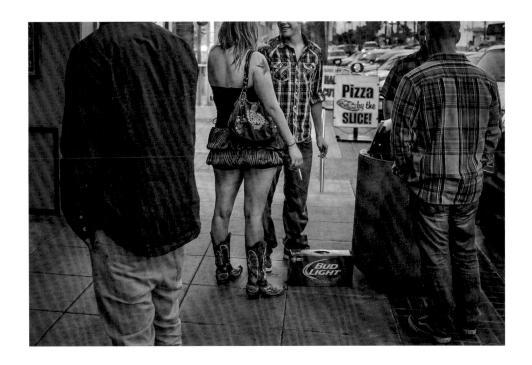

Top: Off-duty servicemen meet women at local bars outside Camp Pendleton in Oceanside, California. Drinking culture is strong in the US Armed Forces. *Below:* Connie Sue Foss was raped three times during a seven-year military career. She bears scars from punching a window during a Post Traumatic Stress Disorder (PTSD) episode, and holds a molar she lost from grinding her teeth at night.

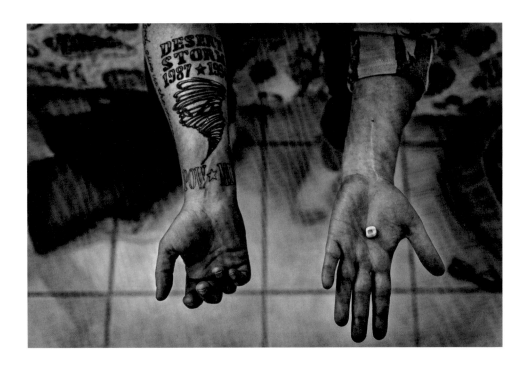

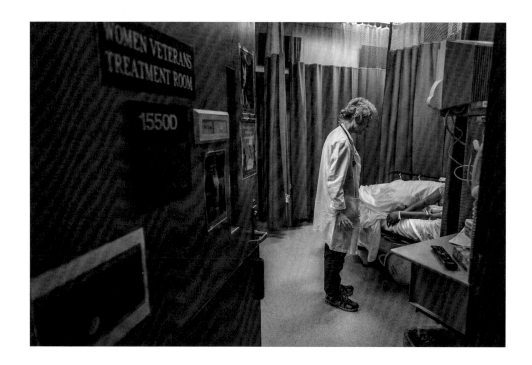

Top: Dr Nancy Lutwak, a Veterans Affairs (VA) emergency room physician in New York City, began screening patients for military sexual assault, and has opened a safe room for women to reveal their MST, and receive support and counselling. *Below:* Elisha Morrow and Tiffany Berkland were sexually harassed by the same company commander during basic training for the coastguard. They did not report it for fear of being kicked out, but came forward when they met a third victim. At the trial, they met a fourth, who had been raped.

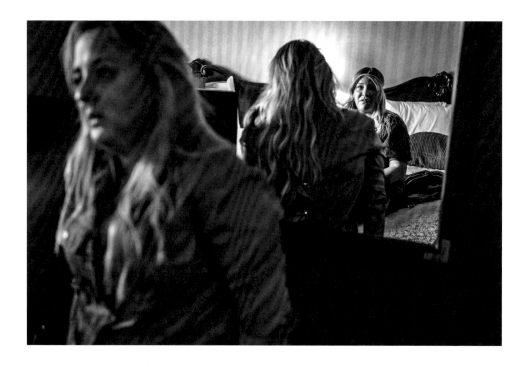

Top: Connie Sue Foss went to sleep after a Christmas party at her National Guard unit. She woke to find a fellow guardsman had tied her down and was assaulting her. *Below:* Jennifer Norris was drugged and raped by her recruiter after joining the Air Force. *Next spread:* Natasha Schuette was sexually assaulted by her drill sergeant during basic training, and was harassed by other sergeants after reporting it. Staff Sergeant Louis Corral was sentenced to four years in prison for assaulting her and four other trainees.

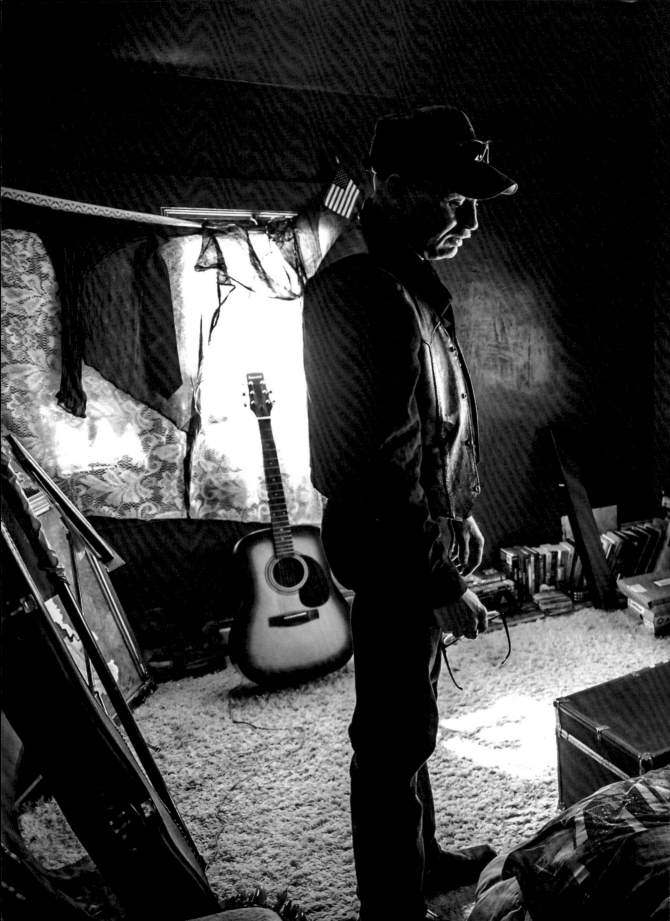

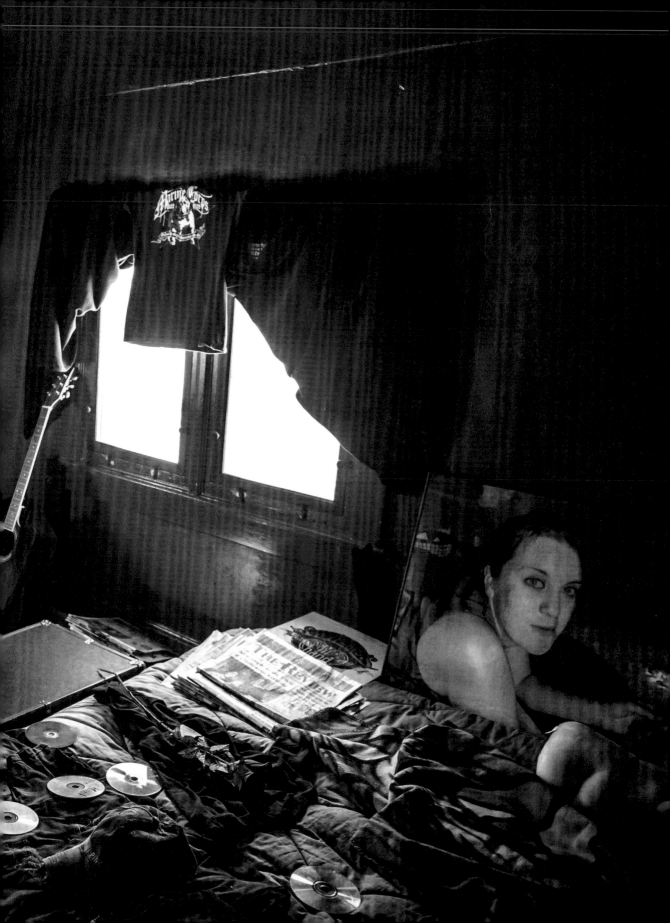

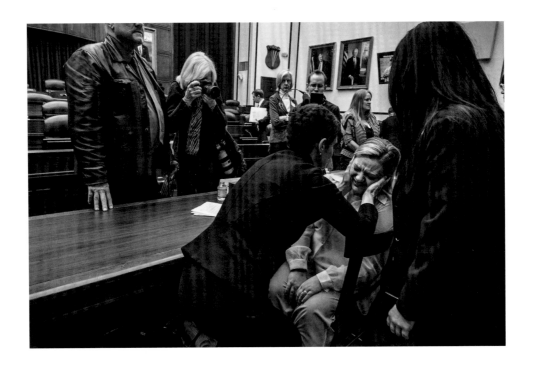

Previous spread: Gary Noling stands in his daughter Carrie's bedroom in Alliance, Ohio. She drank herself to death following severe retaliation after reporting her rape to superiors. *Top:* Jennifer Norris is comforted after testifying before a sparsely attended Housed Armed Services Committee hearing on Capitol Hill discussing sexual misconduct. *Below:* Melissa Bania hangs a banner inscribed with the story of her rape on a footbridge across from Naval Station San Diego, in California.

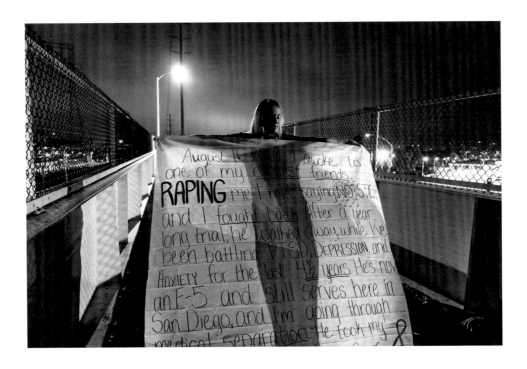

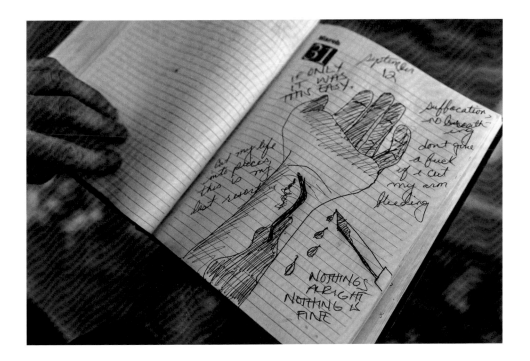

Top: Gary Noling holds his daughter Carrie's diary, on the anniversary of her suicide. *Below:* Sandra Sherman had been in the army only a few weeks when she was drugged and raped at a party. She was also raped by a fellow soldier at her next duty station. After leaving the army she felt emotionally numb, began to hallucinate, could not work and became homeless, eventually calling a crisis line and finding help. *Next spread:* Veteran Darlene Matthews has been living in her car for more than two years.

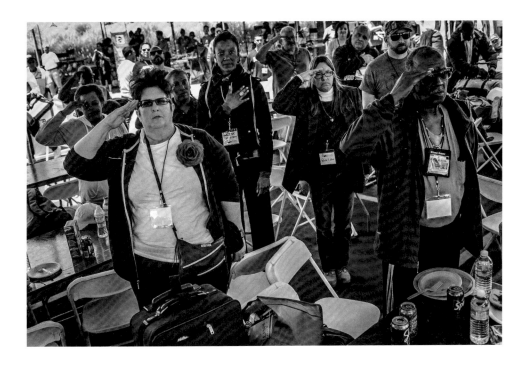

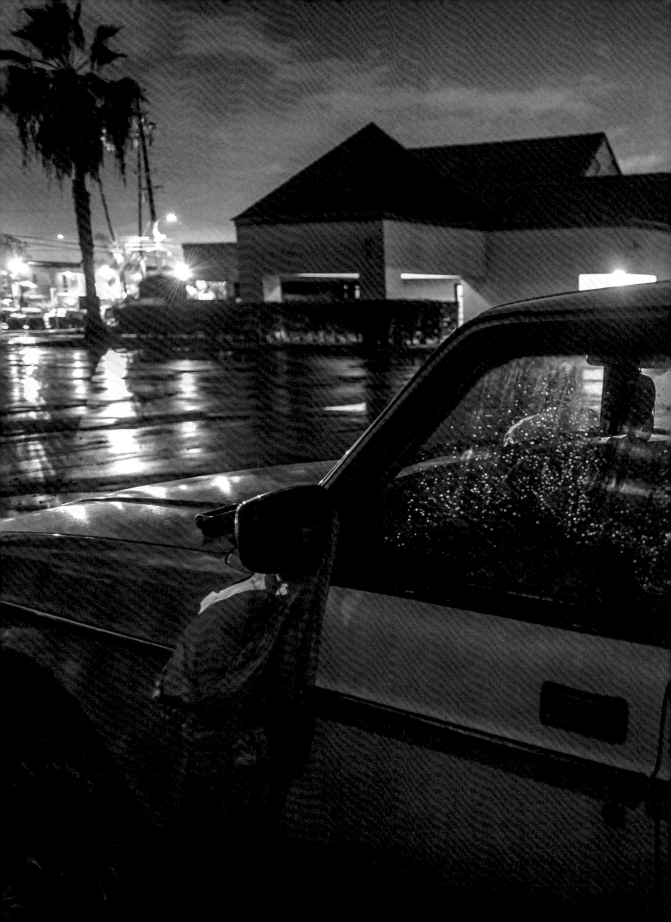

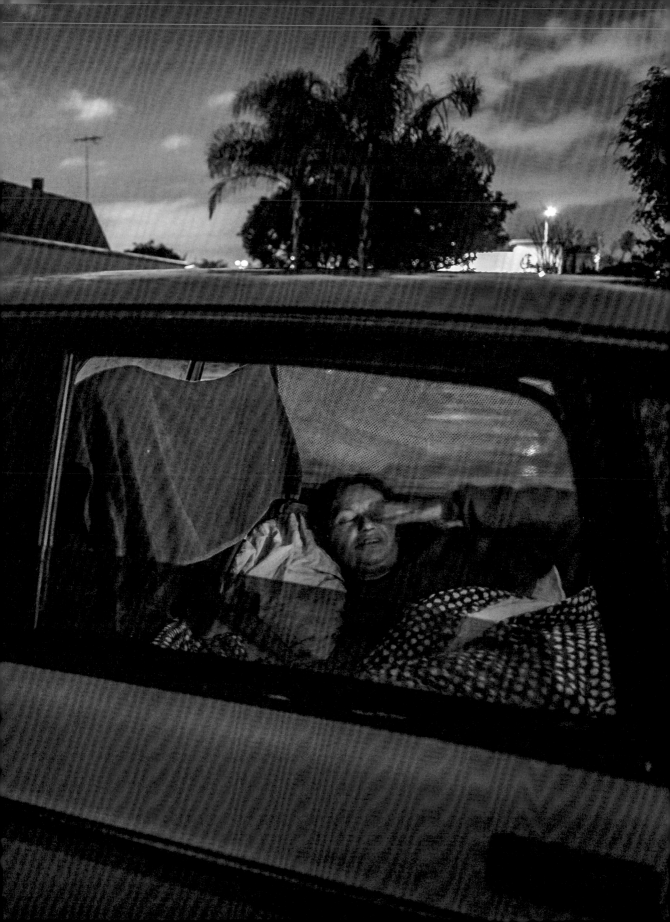

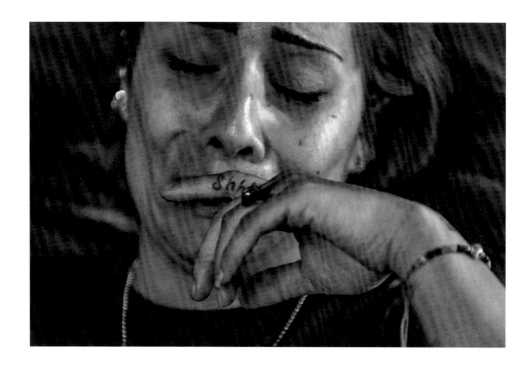

Top: Melissa A. Ramon spent nine years in the Air Force, and suffers from MST and PTSD after sexual abuse from her training instructor and fellow airmen. Since her discharge, she has frequently been homeless and has trouble finding shelter because women's refuges don't allow boys over 12, and she has a 13-year-old son. *Below:* Karen Scott was raped several times on active service and sexually harassed. She was later given a personality disorder discharge, became homeless, and now lives in rent-assisted housing.

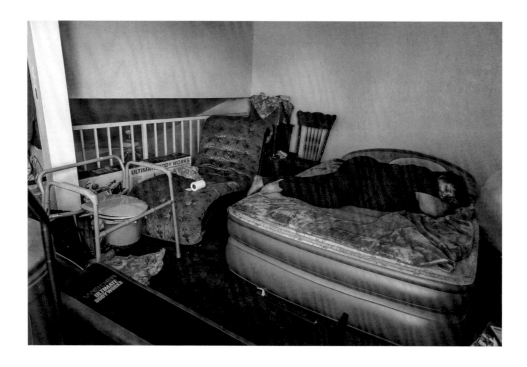

Top: Former US Marine Sarah Jenkins, under the influence of drugs, accepts a food parcel from a National Veterans Foundation outreach van. *Below:* Melissa A. Ramon and her son move into a motel she calls 'The Jungle'. *Next spread:* Debra Filter was raped with several other recruits at a boot camp graduation party they were forced to attend in 1978. For a long time she suffered from PTSD, and eventually left the army. She has been homeless for ten years and wrangling with Veterans Affairs for benefits for decades.

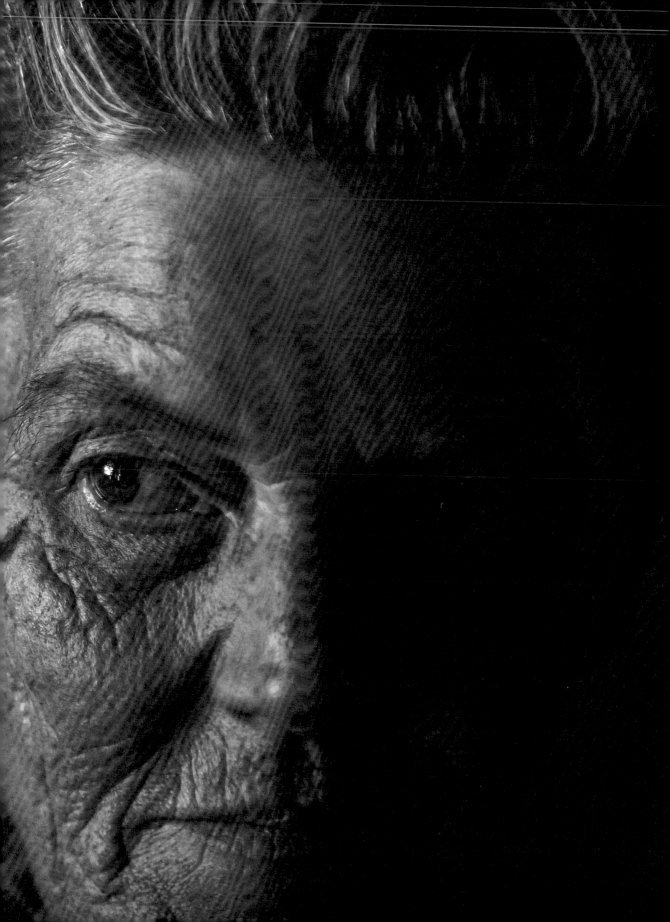

Nancy Borowick

USA /
2nd Prize

A Life in Death

Laurel and Howie Borowick lived out the final year of their 34-year-long marriage fighting cancer together. Laurel had been diagnosed with breast cancer some 17 years earlier, Howie was told he had terminal pancreatic cancer in December 2012. They chose to spend their last months creating new memories, rather than becoming preoccupied with their troubles. Their family used the time they all had left together to the fullest. Howie died on 7 December 2013, a year and a day after his cancer was discovered. After that, Laurel's cancer worsened and she passed away on 6 December 2014.

The photographer is Laurel and Howie's daughter. She chose to document her parents' final chapters in order to hold on to their memory, and to capture their essence and strength in a trying time. She wanted to focus on their love, both individually and for each other. She says that everyone wants to find purpose in their lives, and that Laurel and Howie's final purpose was found in this moment, in the gift they gave her of allowing her to tell their story. This is their legacy.

Facing page, top: Howie and Laurel get their weekly chemotherapy treatment, in what Howie calls 'his and hers chairs', in January 2013. *Below:* The couple embrace in their bedroom at home. *Next spread:* Wearing a playful wig, Laurel does the dishes in the family kitchen, in Chappaqua, New York.

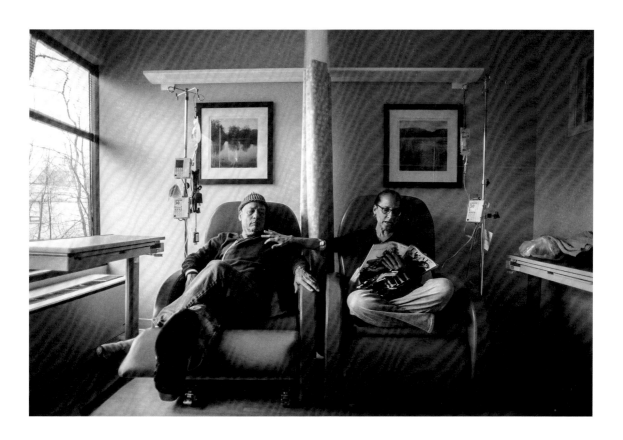

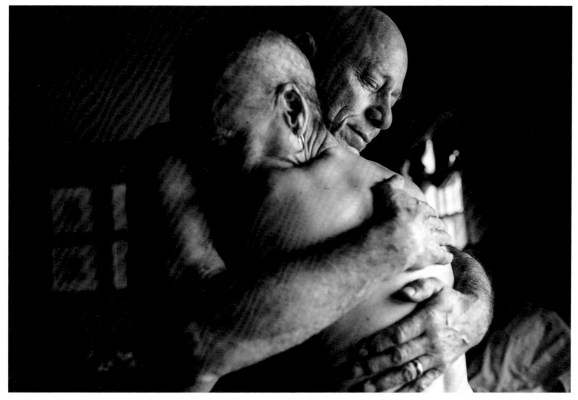

Howie raises a smile from Laurel by breaking into a bouncing dance in the kitchen.

Howie speaks on the bathroom telephone to their oncologist, in March 2013.
The news is good for both of them: scans reveal that their tumors are shrinking.

Laurel and Howie plan for their funerals, to make the process easier for their children.

The couple walk their daughter Nancy down the aisle on her wedding day, on 5 October 2013.
Nancy photographed the occasion herself by rigging a camera in a tree.

OPEN AFTER I L

but before my FUNERAL

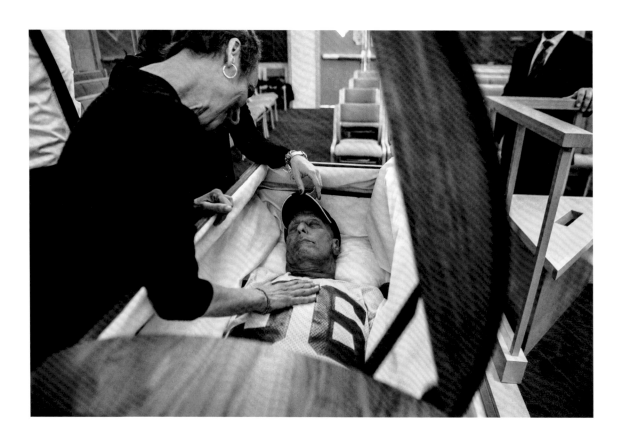

Previous spread: Howie, who always had the last word in any conversation, characteristically wrote his own eulogy, which he left in an envelope with his daughter. *Above:* Laurel spends her last moments with Howie before his casket is closed, on 10 December 2013.

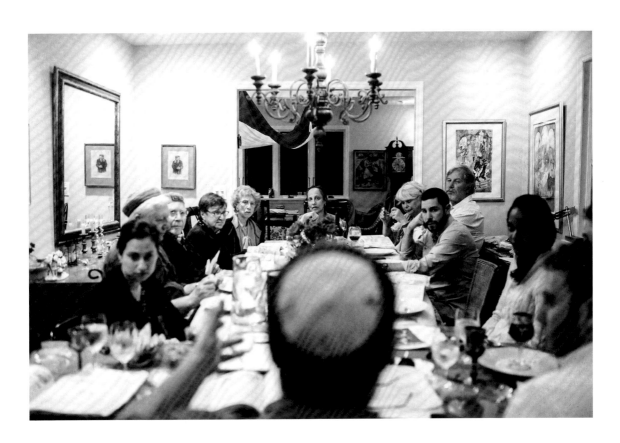

Above: At her first Passover meal since her husband's death, Laurel sits alone at the head of the table. *Next spread:* By November 2014, Laurel is no longer in treatment and has begun home hospice care. Her tumors are growing, she struggles to breathe, and uses an oxygen machine.

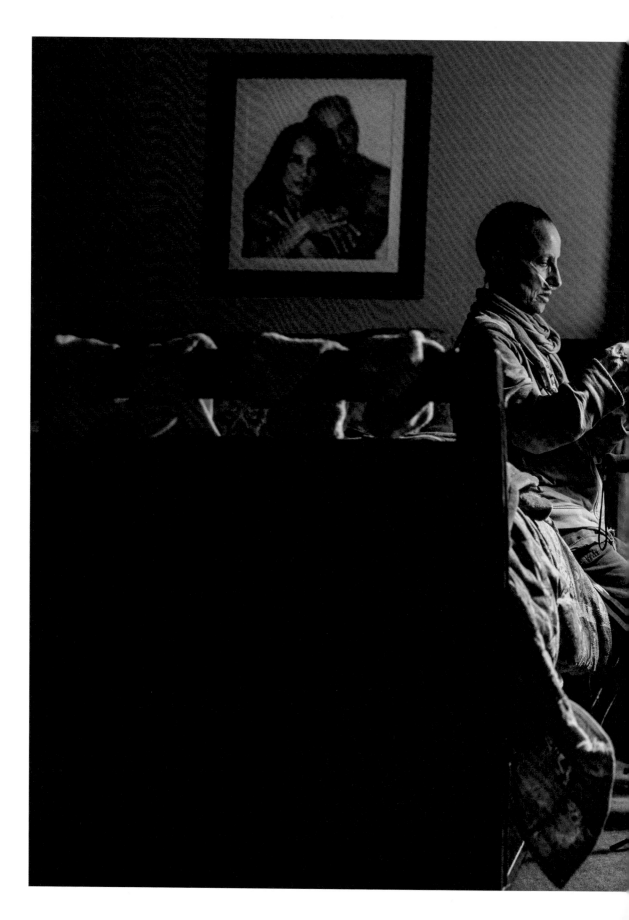

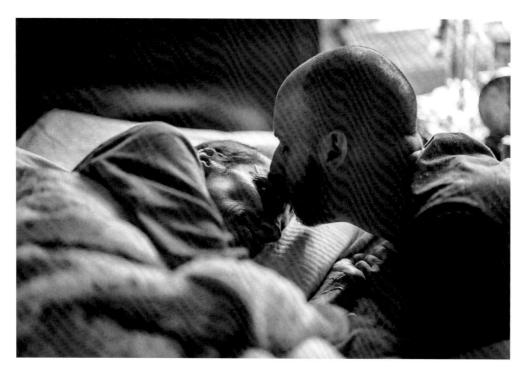

Laurel's son Matthew gives her a kiss on the forehead, but she barely responds.
She can hardly get out of bed, and speaks only in a low whisper.

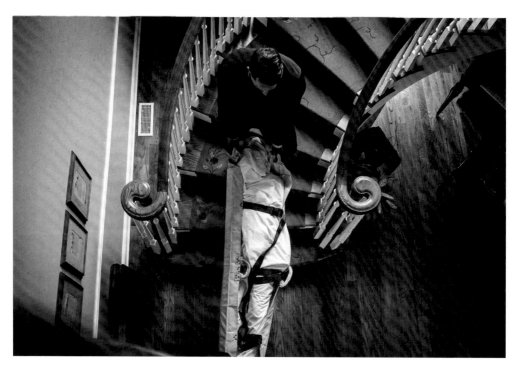

Wrapped on a stretcher, Laurel's body is carried downstairs and from the family home, on 6 December 2014.

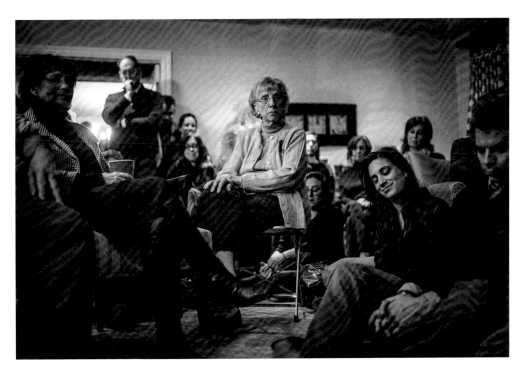

Members of the community gather in support for Laurel's children and her 87-year-old mother, Marion (center), during *shiva* (the Jewish period of mourning).

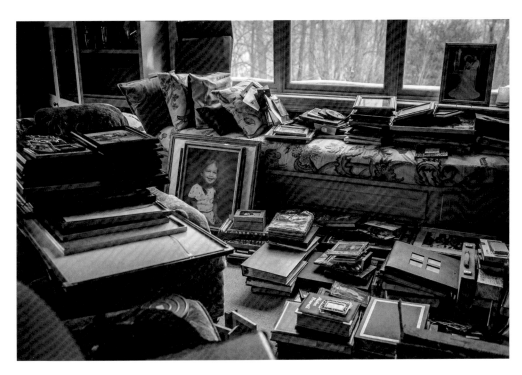

A lifetime's worth of photographs piles up, as the family home is cleared. Howie and Laurel's children plan to sell the house, and close the chapter.

David Guttenfelder

USA, for The Associated Press/*The New York Times*/National Geographic /
3rd Prize

North Korea: Life in the Cult of Kim

North Korea emerged in the upheaval following the end of World War II and the Korean War, and for six decades has been one of the most isolated and secretive nations on earth. Its history is dominated by the founding president, Kim Il-sung, known as the Great Leader. He shaped political affairs for almost half a century, establishing a totalitarian state which shut itself off from the outside world. A leadership cult has grown around the Kim dynasty, passing from Kim Il-sung to his son Kim Jong-il (the Dear Leader) and grandson, the current supreme leader Kim Jong-un.

The country is run along rigidly state-controlled lines. Local media are strictly regulated, and the foreign press largely excluded. The photographer was granted rare access, visiting North Korea on some 40 occasions between 2008 and 2015. He photographed not only large state-orchestrated events, but also everyday rural life.

Facing page, top: The curtain rises on a group of singers about to entertain visiting VIPs at the Mansudae Art Theater, in the capital Pyongyang, in February 2008. *Below:* A traffic policeman stands at the center of an intersection in Pyongyang. *Next spread:* Dusk falls over central Pyongyang, in April 2011.

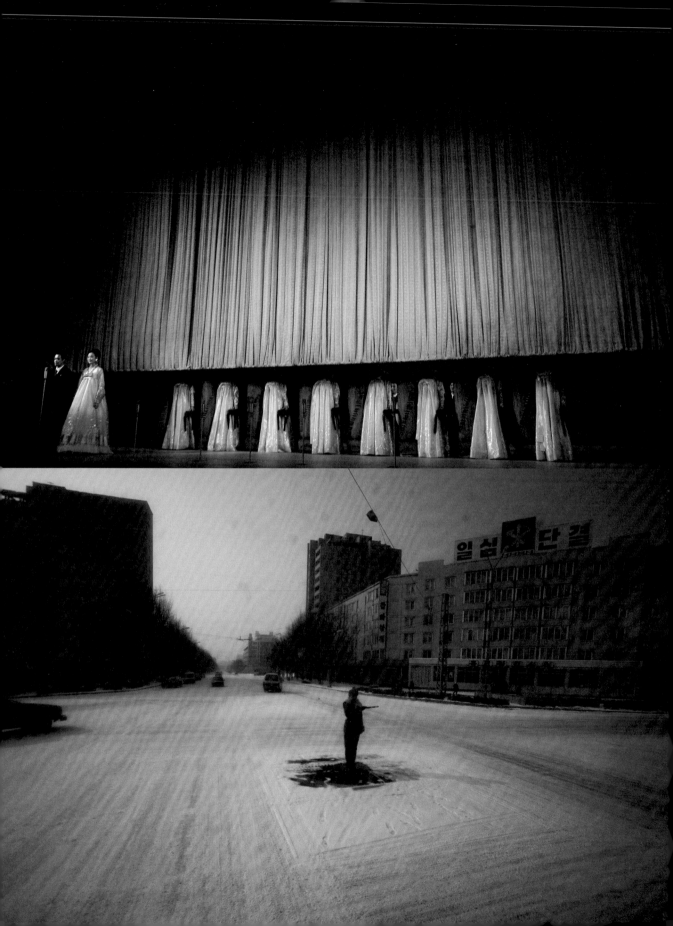

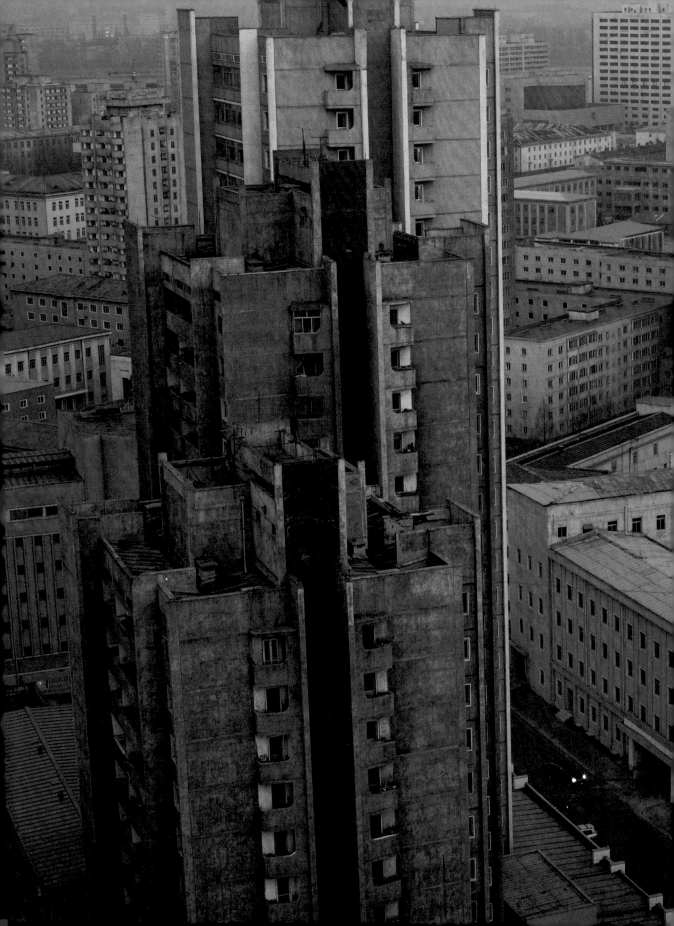

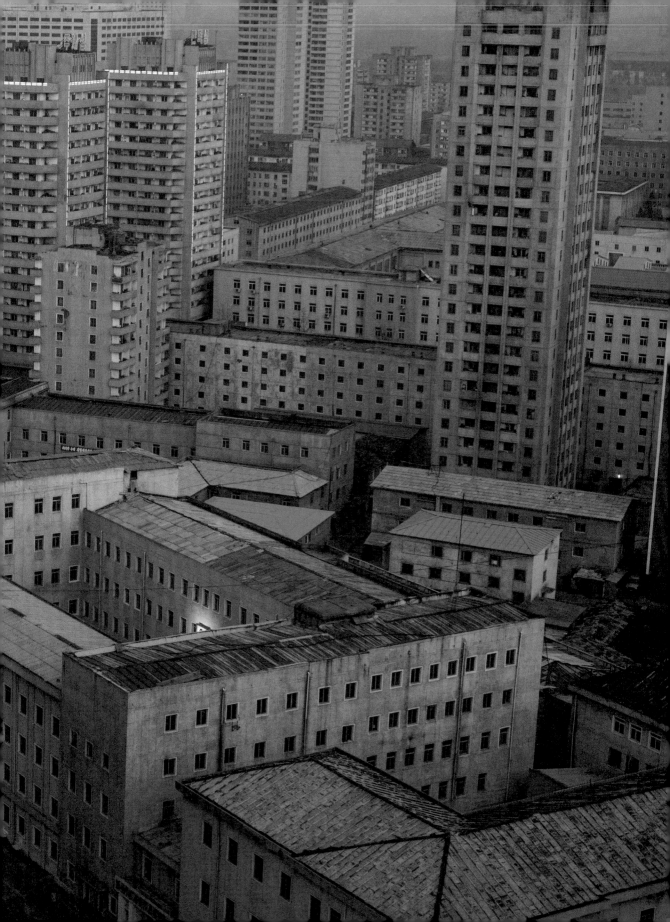

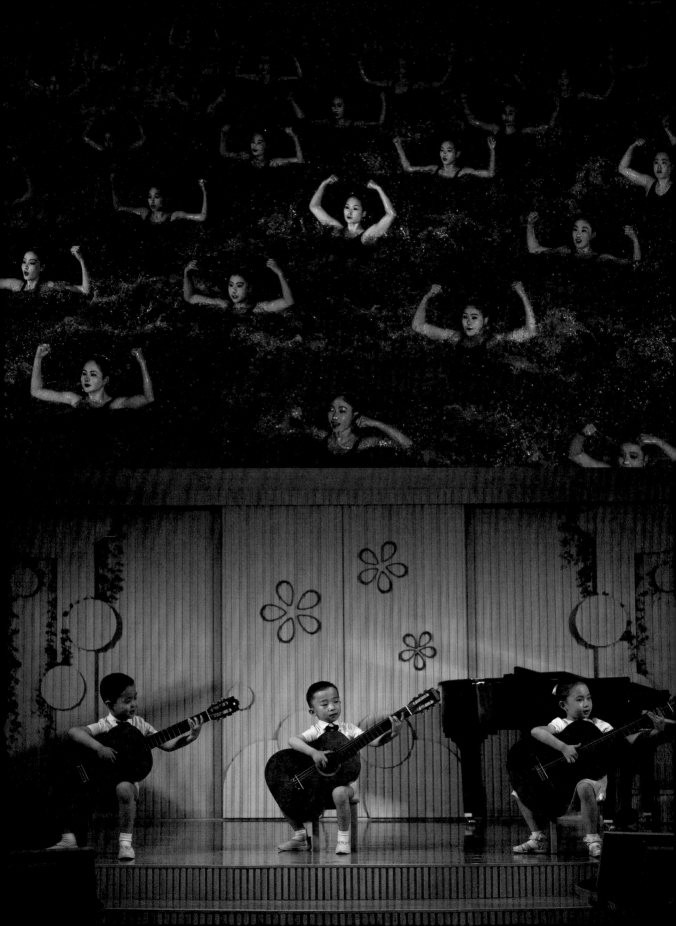

Facing page, top: Women perform in a massed synchronized swimming show to commemorate the birthday of the late leader Kim Jong-il, on 16 February 2012, the day before he would have turned 70. As a grand finale they performed to the song, 'We Will Defend General Kim Jong-un at the Risk of Our Lives'. *Below:* Children perform at the Pyongyang Kyongsang Kindergarten. *This page, top:* A frilly cover protects a computer monitor at an office in the capital. *Below:* A soldier working as a guide walks through a forest said to have been the campsite where the Great Leader spent the night while leading a battle against the Japanese, at the foot of Mount Paektu. *Next spread:* Thousands of people turn colored placards to depict a saluting child, during mass games at a stadium in Pyongyang, on 19 September 2008.

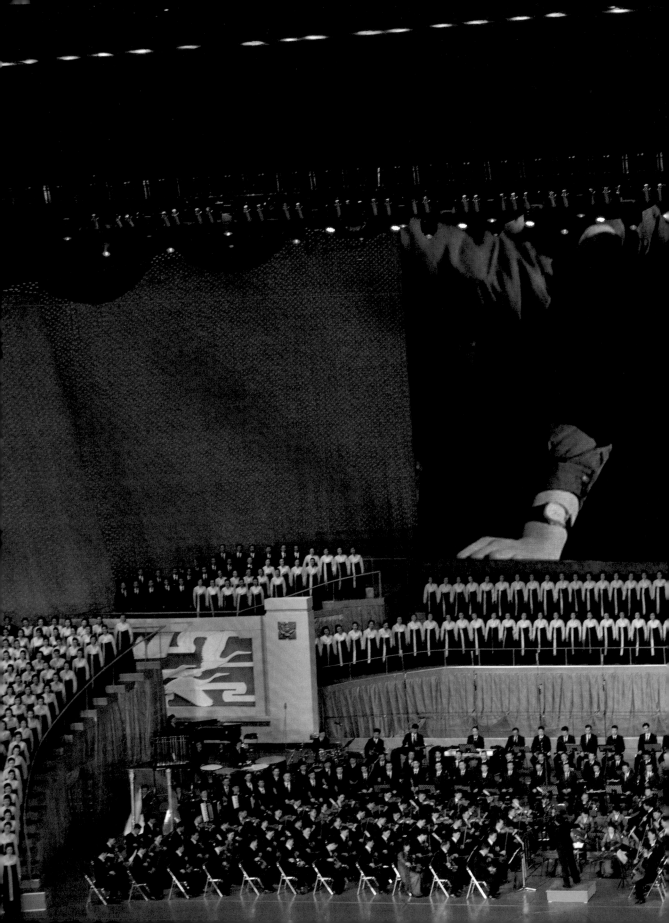

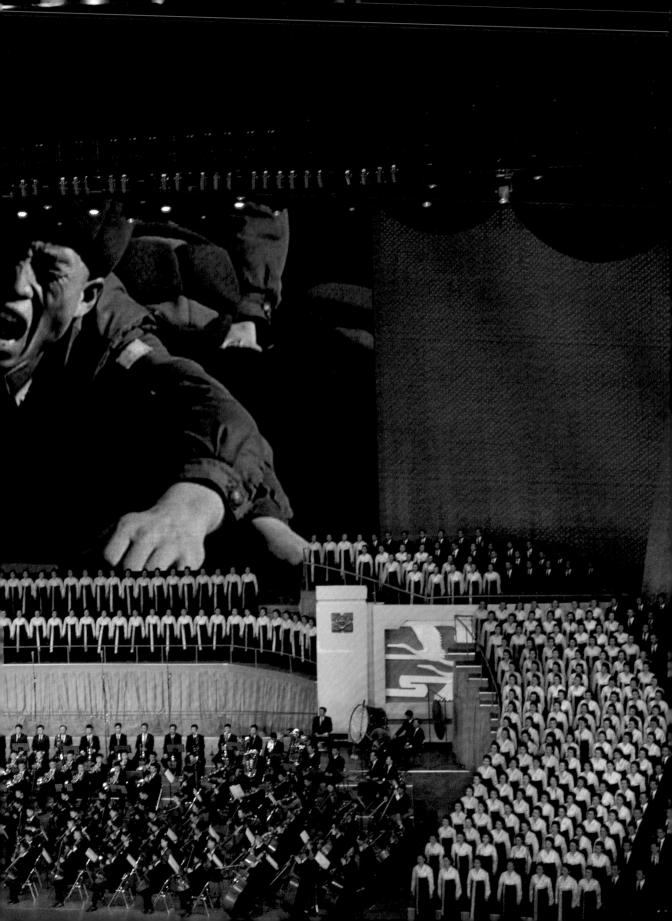

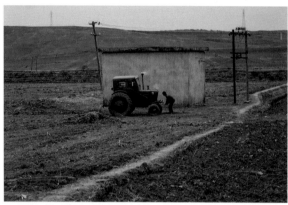

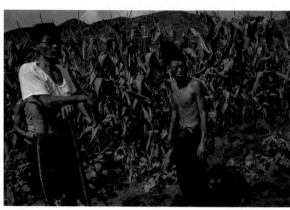

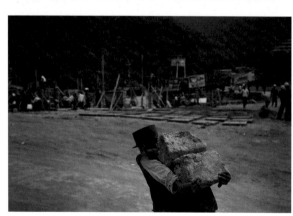

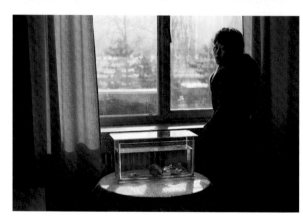

Previous spread: A video shot during the mourning period for the late Kim Jong-il screens during a concert celebrating what would have been his 70th birthday. *This page, top left:* People dance to popular local music in a Pyongyang park. *Top right:* A student learns to drive a tractor on a computerized driving simulator at the Samjiyon Schoolchildren's Palace, in the north of the country. *Middle row, left:* A farmer cranks up his tractor in a field north of the city of Kaesong. *Middle row, right:* Men work in a field in Songchon County, in the center of the country. *Below, left:* A soldier carries stones at a building project at the Masik Pass, in the south. *Below, right:* An office building in Pyongyang. *Facing page, top:* North Korean and South Korean soldiers face each other over the demarcation line that separates the two halves of the peninsula, in the demilitarized zone at Panmunjom, North Korea. *Below:* A woman walks along a road south of Pyongyang. *Next spread:* A man checks his bicycle beside a propaganda billboard, at Kaesong, north of the demilitarized zone.

The 2016 Jury

Participants

In 2016, 5775 photographers from 128 countries submitted 82,951 images in the photo contest. The participants are listed here according to nationality, as filled in by them in the entry registration system.

Afghanistan
Rada Akbar / Barat Ali Batoor / Ishaq Anis / Mujtaba Jalali / Aref Karimi / Ahmad Masood / Naseer Turkmani / Farshad Usyan

Albania
Arben Bici / Enri Canaj / Petrit Kotepano / Armend Nimani / Gentian Shkullaku / Valdrin Xhemaj

Algeria
Zohra Bensemra / Ferhat Bouda

Argentina
Enrique Abbate Pinaud / Rodrigo Abd / Lujan Agusti / Humberto Lucas Alascio / Sebastian Ambrossio / Paul Amiune / Facundo Arrizabalaga / Walter Astrada / Diego Azubel / Juanma Baialardo / Carlos Barria / Néstor J. Beremblum / Nicolás Bravo / Nicolás Carvalho Ochoa / Gustavo Cherro / Mario De Fina / Pablo DiZeo / Emmanuel Fernandez / Nikolas Galuya / Ileana Andrea Gómez Gavinoser / Jeremias Gonzalez / Anibal Greco / Daniel Jayo / Alejandro Kirchuk / Andres Kudacki / Andrés Larrovere / Gabriel Luque / Fabian Marelli / Sophie Starzenski / Juan Medina / Daniel Merle / Lucia Merle / Patricio Michelin / Emiliana Miguelez / Luciana Demichelis / V. Notarfrancesco / Juan Obregon / Atilio Orellana / Gabriel Pecot / Patricio Peñalba / Pablo Ernesto Piovano / Natacha Pisarenko / Héctor Rio / Gabriel Rossi / Matias Sarlo / Mario Sayes / Eduardo Soteras Jalil / Juano Tesone / Pablo Tosco / Gonzo Vega

Armenia
Nazik Armenakyan / Anush Babajanyan / Vahran Baghdasaryan / Adis Easagholian / Eric Grigorian / Karen Mirzoyan

Australia
Matthew Abbott / Conor Ashleigh Ashleigh / Michael Aw / Nicolas Axelrod / Daniel Berehulak / James Brickwood / Patrick Brown / David Caird / Aletheia Casey / Rémi Chauvin / Steve Christo / Robert Cianflone / Warren Clarke / Brett Costello / Paul Crock / Tim Georgeson / Morne de Klerk / Perry Simon Duffin / Stephen Dupont / Alex Ellinghausen / Brendan Esposito / Mark Evans / Adam Ferguson / Andrea Francolini / Alex Frayne / Kate Geraghty / Ashley Gilbertson / Tash Gillespie / Craig Golding / Steve Gosch / Philip Gostelow / David Gray / Toni Greaves / Mathias Heng / Phil Hillyard / Ian Hitchcock / Lisa Hogben / Chris Hopkins / Chris Hyde / Eddie Jim / Bradley Kanaris / Theo Karanikos / Daily Telegraph / Dallas Kilponen / Adam Knott / Nick Laham / Tanya Lake / Sylvia Liber / Glenn Lockitch / Dominic Lorrimer / Brendan McCarthy / Ted McDonnell / Chris McGrath / Cam McLaren / Justin McManus / Andrew Meares / Paul Miller / Palani Mohan / Nick Moir / Mike Moores / Dean Mouhtaropoulos / Chris Peken / Martine Perret / Edwina Pickles / Ryan Pierse / Jeremy Piper / Adam Pretty / Andrew Quilty / Gary Ramage / Asanka Brendon Ratnayake / Warren Richardson / Quinn Rooney / Raphaela Rosella / Jayne Russell / Dean Saffron / Dean Sewell / Russell Shakespeare / Marko Sommer / Cameron Spencer / Adrian Steirn / Dave Tacon / Patrick Tombola / Darrian Traynor / Louise Whelan / Clifford White / Lisa Maree Williams / Tracie Williams

Austria
Heimo Aga / Heinz-Peter Bader / Peter Berger / Michael Biach / Christian Fischer / Helmut Fohringer / Martin Valentin Fuchs / Helmut Graf / Peter Granser / Johann Groder / Gerald Henzinger / Kurt Hoerbst / Rudolf Klaffenböck / Kopp Christian / Herbert Kratky / Miro Kuzmanovic / Simon Lehner / Mario Marino / Eugenia Maximova / Lisi Niesner and Georg Hochmuth / Christine Ebenthal / Josef Polleros / Florian Rainer / Mafalda Rakoš / Bernhard Riedmann / Erwin Scheriau / Alexander Schmidjell / Yann Schreiber / Christian Schuetz / Heinz Stephan Tesarek / Elisabeth Mena Urbitsch / Aram Voves / Sebastian Wahlhuetter / Christian Walgram / Michael Winkelmann / Ronald Zak / Claudia Ziegler / Martin Zinggl

Azerbaijan
Orxan Azim / Rena Effendi / Ilgar Jafarov / Javid Mammadov

Bahrain
Hamad Mohammed / Mohammed Al-Shaikh

Bangladesh
A.M. Ahad / Kaisar Ahamed / Parvez Ahmad Rony / Sumon Yusuf / Salahuddin Ahmed / Ahmed Firoz / Monirul Alam / Mushfiqul Alam Tanvin / K. M. Asad / Khandaker Azizur Rahman / Abdul Malek Babul / Ripon Barua / Wahid Adnan / Rasel Chowdhury / Turjoy Chowdhury / Zakir Hossain Chowdhury / Suvra Kanti Das / Faiham Ebna Sharif / Emdadul Islam Bitu / F Omar / Saydul Fateheen / Ismail Ferdous / Indrajit Ghosh / Mohammad Rakibul Hasan / Khaled Hasan / Mohammad Ponir Hossain / Momena Jalil / Banglar Chokh / Fahad Kaizer / Reshad Kamal / Kazi Riasat Alve / Masudur Rahman Khan / Md Rafayat haque Khan / Khan Naymuzzaman Prince / Md. Shahnewaz Khan / Abu Taher Khokon / Zakirul Mazed Konok / Alamin Leon / Masud Alam Liton / Sourav Loskar / Yousuf Tushar / Shantanu Majumder / Mamunur Rashid / Maruf Hossain / Md.Ibrahim Khalil / Zaman Mehede / Saikat Mojumder / Nirob Hossain Mukit / Naima Perveen / Al-Mashud Nepun / Tapash Paul / Abdur Rahman / Reza Shahriar Rahman / Mustafiz Mamun / Anik Rahman / Sony Ramany / Probal Rashid / Mohammad Fahim Ahamed Riyad / MD Tanveer Hassan Rohan / Avijit Roy / Sudeepto Salam / Sarker Protick / Shafayet Hossain Apollo / Shadman Shahid / Shariful Islam / Md. Khalid Rayhan Shawon / Din Muhammad Shibly / Rahul Talukder / Hadi Uddin / Shehab Uddin / Md. Akhlas Uddin / Jashim Salam / A.N.M ZIA

Belarus
Dmitry Brushko / Anton Dotsenko / Sergei Gapon / Uladz Hrydzin / Hudzilin Siarhei / Vadim Kachan / Dmitrij Leltschuk / Searhei Liudkevich / Eugene Reshetov / Maxim Sarychau / Volha Shukaila / Alexander Vasukovich

Belgium
Layla Aerts / Claire Allard / Pauline Beugnies / Philippe Braquenier / Koen Broos / Frederik Buyckx / Filip Claus / Isabel Corthier / Johannes De Bruycker / Eleonore Henry De Frahan / Patrick De Roo / De Tollenaere Marc / Peter de Voecht / Sanne De Wilde / Nic Declerq / Anthony Dehez / Colin Delfosse / Bieke Depoorter / Oscar Dhooge / Karoly Effenberger / James Arthur / Gregory Heirman / Tina Herbots / Yves Herman / Roger Job / An-Sofie Kesteleyn / Jimmy Kets / Frédéric Lecloux / Nicolas Maeterlinck / Wendy Marijnissen / Mashid Mohadjerin / Virginie Nguyen Hoang / Olivier Papegnies / Jonas Roosens / Frederik Sadones / Alice Smeets / Gaël Turine / Liza Van der Stock / Katrijn Van Giel / Tomas van Houtryve / Sébastien Van Malleghem / Kristof Vadino / Filip Van Roe / Robbe Vandegehuchte De La Porte / Thomas Vanden Driessche / Ingrid Vekemans / Eva Vermandel / Dirk Waem

Bolivia
Gonzalo Contreras del Solar / Patricio Crooker / Eduardo Franco Berton / Juan Karita / David Mercado / Marcelo Pérez del Carpio / Dico Veimar Solis Rocha / Wara Vargas lara

Bosnia and Herzegovina
Haris Calkic / Armin Durgut / Amel Emric / Ziyah Gafic / Sljivo Husein / Sam Yordam / Haris Memija / Almir Panjeta / Dado Ruvic / Damir Sagolj

Brazil
Jose Carlos Alexandre / Alinne Rezende / Wagner Almeida / Leonardo Almeida / Raphael Alves / Rodrigo Chadí / Paulo Amorim / Keiny Andrade / Eduardo Anizelli / Carolina Arantes / Alberto César Arúujo / Alexandro Auler / Avener Prado / Anderson Barbosa / Nário Barbosa / Taba Benedicto / Guilherme Bergamini / Thiago Bernardes / Daniel Botelho / Mateus Bruxel / João Luiz Bulcão / Daniel Kfouri / Luciano Candisani / Rubens Cardia / Alisson Gontijo / Leonardo Carrato / Ricardo Chicarelli / Rodrigo Coca / Tiago Coelho / Weslei Barba / Julio Cordeiro / Leo Correa / Carlos Fonseca / Fernanda Luz / Andre Silva / Felipe Dana / Lalo de Almeida / Marcelo Andrade / Joao Castellano / Diego Padgurschi / André Teixeira / Eduardo Lima / Douglas Magno / Mastrangelo Reino / Francisco de Souza / Juca Rodrigues / Ricardo DeArantha / Thiago Dezan / Marcio Pimenta / Guilherme Dionizio / Gustavo Oliveira / Rafael Duarte / Antonio Emygdio / Alan Marques / Bobby Fabisak / Cristiane Mattos / Marcelo Ferrelli / Felipe Fittipaldi / Rogério Florentino Pereira / Márcia Foletto / Dado Galdieri / Apu Gomes / Fábio Seixo / Claudio Gonçalves / Cesar Greco / Érico Hiller / Paula Huven / Andrea Motta / Bruno Kelly / Antonio Lacerda / Luisa Dörr / Odair Leal / Claus Lehmann / Mauricio Lima / André Liohn / Edson Lopes Jr. / Benito Maddalena / Ueslei Marcelino / Daniel Marenco / R. Martinelli / Alice Martins / Paulo Pinto / Alexandre Meneghini / Henry Milléo / Ricardo Moraes / Marta Nascimento / Gualter Naves / Michael Patrick O'Neill / Lili Okpis / Paulo Pampolin / Amanda Perobelli / Fernanda Peruzzo / Juliana Spinola / Mauro Pimentel / Ricardo Beliel / Marcelo Prates / Tiago Queiroz Luciano / Marcos Ramos / Sergio Ranalli / Claudio Reis / Marcio RM / Murilo Ribas / Daniel Vilela Ribeiro / Ricardo Oliveira / Carlos Roberto / Jonne Roriz / Albari Rosa / Ale Ruaro / Werther Santana / Miguel Schincariol / Sandro Vox / Joá Souza / Jean Lopes / Rogerio Stella / Ricardo Stuckert / Fabio Teixeira / Ricardo Teles / Daniel Teobaldo / Gabriela Biló / Tadeu Vilani / Hans von Manteuffel / Jornal O Popular / Mônica Zarattini / Adriana Zehbrauskas /

Bulgaria
Mehmed Aziz / Minko Chernev / Dimitar Dilkoff / Tsvetomir Dimov / Nikolay Doychinov / Yanne Golev / Stoyan Iliev / Alexander Ivanov / Boryana Katsarova / Georgi Kozhuharov / Dimitar Kyosemarliev / Stoyan Nenov / Hristo Rusev / Iliyan Ruzhin / Anastas Tarpanov / Vlado Trifonov / Victor Troyanov / Hristo Vladev / Boris Voynarovitch

Cambodia
Vannarin Neou / Tang Chhin Sothy

Canada
Tamara Abdul Hadi / Carlo Allegri / Tyler Anderson / Berge Arabian / Terry Asma / Tobi Asmoucha / Alexis Aubin / David Barbour / Mathieu Belanger / Mehdi Maciej Benembarek / Tanya Kaur Bindra / Mark Blinch / Christopher Bobyn / Joseph Boltrukiewicz / Greg Bos / Samira Bouaou / Bernard Brault / Peter Bregg / Cole Burston / Kitra Cahana / Leyland Cecco / Yves Choquette / Andy Clark / Barbara Davidson / Etienne de Malglaive / Ivanoh Demers / Don Denton / Daniel Desmarais / Radu Diaconu / Bryan Dickie / Pascal Dumont / Darryl Dyck / Joel Ford / Pierre Fraser / Kevin

Frayer / Adam Gagnon / Rafal Gerszak / Gu Shixu / Brett Gundlock / Frank Gunn / Ramin Hashempour / Daniel Hayduk / Kiana Hayeri / Gary Hershorn / Richard Holmes / Michel Huneault / Sara Hylton / Marta Iwanek / Olivier Jean / Jim Chul-Ahn Jeong / Emiliano Joanes / Gavin Bryan John / Charla Jones / Jeremy Kohm / Nick Kozak / Esmond Lee / Roger Lemoyne / Ottawa Citizen / Douglas MacLellan / Rick Madonik / Liam Maloney / R. Jeanette Martin / Jo-Anne McArthur / Allen McInnis / Jeff McIntosh / Lance McMillan / Jaclyn McRae-Sadik / Kamal Mohammadizadeh / Brendan Montgomery / Christinne Muschi / Sierra Nallo / Guang Niu / Brennan O`Connor / Marlin Olynyk / Jen Osborne / Louie Palu / Ryan Pfeiffer / Renaud Philippe / Wendell Phillips / Andre Pichette / Edouard Plante-Fréchette / Geoff Robins / Norman Jean Roy / Steve Russell / Derek Ruttan / Matthew Sherwood / Jack Simpson / Sami Siva / David Maurice Smith / Tim Smith / Marilyn Smith / Adrienne Surprenant / Larry Towell / Michel Tremblay / Alexa Vachon / Kevin Van Paassen / Andrew Vaughan / Jimmy Vigneux / Christopher Wahl / Bernard Weil / Ian Willms / Scott A. Woodward / Adrian Wyld / Jim Young / Orna Zietman / Iva Zimova

Chile

Eric Allende / Ivan Alvarado / Javier Barrera / Jaime Barrera Durán / Alex Vidal Brecas / Ricardo De La Peña / Marcelo Diaz Espinoza / Javier Godoy / Raúl Goycoolea / Mariola Guerrero / Luis Hidalgo / Tomás Munita / Fernando Neira / Carlos Newman / Cristian Ochoa / Cristobal Olivares / Matias Recart / Hector Retamal / Amparo Rogel Cárdenas / Claudio Rojas Vargas / Mario Ruiz Ortiz / Luis Sergio / Ibar Felipe Silva Canales / Mario Tellez / Francisco Ubilla / Pedro Ugarte / Patricio Valderas / Elisa Verdejo / Alvaro Vidal / Carlos Villalon / Ernesto Zelada

China

Feifei An / Bai Shi / Xue Bai / Ying Bai / Jinhe Bai / Bao Tailiang / Bao Gang / Bao Bayasule / Bao Weidong / Yanchang Bi / Bian Shipeng / Gaopeng Bo / Ronghong Bu / Cai Tongyu / Cai Sheng Xiang / Ruiyun Cai / Guangwen Cao / Min Cao / Zhongyang Cao / Jun Cao / Cao Zhi Zheng / Cao Tong / Zhaoliang Cao / ZongwenCao / Junzhu Cao / Can Cao / Chai Jijun / Chang Gang / Chen Fan / Liduan Chen / Long Chen / Chen Qiang / Chen Ruishi / Yong Chen / Chen Wei / Tao Chen / YanjunChen / Guangchi Chen / Jianyu Chen / Chen Gang / Chen Youxin / Xiaowei Chen / Geng Sheng Chen / Chen Xiaodong / Kunlun Chen / Kunlun Chen / Ronghui Chen / Yongjun Chen / Xin Chen / Jianyuan Chen / Lei Chen / Chen Yaqiang / Baozhu Chen / Jianxin Chen / Xiurong Chen / Qituo Chen / Chen Xiao / Zhongqiu Chen / Zhenming / Chen Yin / Kunrong Chen / Zhuo Chen / Jian Chen / Yu xiao Chen / Chen Jie / Yongcheng Chen / Lanfeng Chen / Chen Jian Zhen / Chen Xiao Ming / Chen Qi Hui / Chen Qi Chuang / Chen Chang Rong / Chen Zhijian / Jianqiang Chen / Shaohua Chen / Cheng Xuliang / Cheng Yihui / Cheng Gang / Guimin Cheng / Lin Cheng / Cheng Gong / Cheng Bin / Li Cheng / Chi Haibo / Chi-ling Ching / Yongzhi Chu / Hu Cong / Gang Cui / Cui Heping / Ling Cui / Nan Cui / Jun Cui / Songge Cui / Zhishuang Cui / Chao Cui / Cui Xinyu / Cui maoyuan / Xiaogang Dai / Feie Dai / Jianming Dai / Jia DaiTengFei / Sun De Li / Liangming Deng / Weijian Deng / Deng Dongfeng / Guilun Ding / Huanxin Ding / Bingheng Ding / Xiang Dingkun / Dong Ning / Dong Baojun / Dong Boyu / Aimei Dong / Ren Dong / Hada Dong / Bing Dong / Yiming Dou / Shaolin Dou / Dugai / Jinen Du / Tiejun Duan / Xiaxia Fan / Fan Xianhai / Yulei Fan / Fan Liyong / Baosheng Fan / Ping Fang / Fang Sheng / Fang Qianhua / Jun Fang / LInming Fang / Tian Fei / Hui Feng / Feng Cheng Fa / Bing Feng / Wenjun Feng / Mubo Feng / Feng Yongbin / Qiang Fu / Zhiyong Fu / Fu Ding / Kuaili Fu / Fu Yongjun / Raymond Fung / Gan Lin / Pan Gan Ming / Linjie Gao / Gao Wenxiu / Chengjun Gao / Zheng Gao / Gao Yong / Gao Wei / Ge Xiaoming / QingFeng / Ge Yufei / Ge Yumin / Yaqi Ge / Hongjie Geng / Gong Lei / Gang Bencai / Gong Zhibing / Zijie Gong / Gongwenbin / Gou Bingchen / Rui Gu / Qingshi Gu / Jing Gu / Weiqiang Gu / Jia Gu /

Shan Hong Gu / Vincent Gu / Pengbo Gu / GuSong / Gu Yi / Ng Han Guan / Guo Chen / Guo Jijiang / Guo Jikai / Xiao Guo / XinGuo / Meixian Guo / ZhiHua Guo / Liliang Guo / Jizhou Guo / Guo Yong / Xiaolong Guo / Yongsheng Guo / Hongying Guo / Guo Guang Yu / Guangjie Guo / Jing Guo / Hao Guo / Meng Han / Zhiming Han / Yan Han / Hao Yi / He Yong An / Xiaodon He / Hehaier / Haiyang He / He Hui / He Chun Sheng / Zhongmin Hong / Hou Yu / Shaoqing Hou / Hu Shaofeng / Tingmei Hu / Hu Guoqing / Hu Lingyun / Jianhuan Hu / Hu Qing Ming / Hu Tiexiang / Kebin Hu / Weiguo Hu / Hu Wei-ming / Hu-weidong / Jian Hua / Xianbin Hua / Rongli Hua / Huangmo / Huang Zhe / Jin Huang / Huang Yue-Hou / Huang Qingjun / Songhe Huang / Jianming Huang / Fuqiang Huang / Huang Yangyang / Xi Huang / Yuyang Huang / Dongmei Huang / Yang Huang / Dewen Huang / Haiping Huang / Qijun Huang / Yunping Huang / Maokai Huang / Changbo Huang / HuangYan / Huang QiPeng / Huang Lun Qian / Huang Qing Dang / Huang Heng Ri / Haixin Ji / Xinhua Ji / Jia Yanan / JIA Ru / Jian Yin Jiao / Xu Jian / Tianze Jiang / Jiang Xinjun / jianghao / Ping Jiang / Zhizhou Jiang / Mingdeng Jiang / Yongxi Jiang / Hui Jiang / Donghai Jiang / Baocheng Jiang / Jiang Wenjie / Ning Jiang / Jiang Wen Hua / Peng Jiansheng / Sheng Jia Peng / Alani King / Yi Jin / Lidong Jin / Jin Xin / Jiehai Jin / Jin Liwang / Jin siliu / Zhen Qiang Jin / John / Lei Jing / Jinghua He / Chen Jinhai / Fan Jinyu / Rao Jun / Taisen Kang / Xu Kangping / Xiangming Kong / Huimin Kuang / Kuang Linhua / Kuangbingqi Kuang / Jing Lai / Xinlin Lai / Hongguang Lan / Yezuo Lan / Jiancheng Lang / Lang Shuchen / Xiping Lee / Guoyu Lei / Dong Lei / Li Xianjun / Suren Li / Leyuan Li / Li Yanan / Hongyuan Li / Quanhai Li / Dongli Li / Weiguang Li / Li Yang / Ge Li / Li Yalong / Jason Lee / Li Kun / Jibao Li / Li Li / Jiaping Li / Senliang Li / Qun Li / Junhui Li / Li Xin / Pin Li / Guanyu Li / Rongwei Li / Xiaolei Li / Chuan Li / Ling Li / Jiangang Li / Wenrui Li / Yun Li / Li Jinhe / Ga Li / Li Wei / Linlin Li / Ke Li / Xiang Li / Li Muzi / Lihao / Hua Li / Nuo Li / Li Feng / Tieqiang Li / Li Rui / Gang Li / Peng Li / Ming Li / Li Ming / Zhenyu Li / Alexvi Li / Davids Lee / Bin Li / Li Qiang / Qiang Li / Li Fan / Yao Li / Celiang Li / Peixian Li / Li Fang / Li Jing / Li Jin Tai / Li Songsen / Li Meng / Shuying Li / Zihong Li / Fukai li / Li Gang / Li Rongrong / Liang Zhentang / Hong Liang / Yilong Liang / Liang Meng / Zhenfeng Liang / Youquan Liang / Guo Liang / Jin liangkuai / Zhengyan Liao / Wenxiong Liao / Lulu Liao / Liao Pan / Liao Qiong / Liao Xiong / Xueming Liao / Shi Lifei / Chen Lin / Qishu Lin / Lin Ruiqing / Kun Lin / Kai Lin / Hanrong Lin / Hongxian Lin / Zuxian Lin / Lin Feng / Lin Qiao Sen / Lin Wu Wang / Lin Yun / Lin Wu Dan / Cul Lin / Zuo Lingren / Liu Debin / Jun Liu / Cun Yan / Yuyang Liu / Liu Song / Liu Kaida / Wenhua Liu / Liu Chenping / Liu Lei / Liu Ji / Yan Liu / Liqun Liu / Fengrui Liu / Xiaokun Liu / Guofeng Liu / Shuailiang Liu / Li Liu / Lin Liu / Jinbing Liu / Changming Liu / Changsong Liu / Qiang Liu / Liangjin Liu / Liu Aiguo / Xingzhe Liu / Jianhong Liu / Junyang Liu / Guoxing Liu / Mancang Liu / Shaolong Liu / Fusheng Liu / Guanguan Liu / Liu Weiqiang / Liu Youzhi / Zhang Ying / Liu Zheng / Liu Hang / Liu Dajia / Xiahong Liu / Xiaolan Liu / Liu Mei Hong / Liu Jie Zhi / Liu Zhiyu / Qi Liu / Feng Liu / Feiyue Liu / Liu Shutong / Wu Lixin / Wei Long / Hua Long / Long Yudan / He Long / Shidong Lou / Lu Lu / Ruguo Lu / Jing Lu / Lu Fan Jing / Mingjie Lu / Lu Guang / Minqiang Lu / Jiancheng Lu / Luan Zheng Xi / Shengjie Luan / Yu Lun / Hua Luo / Luohui Luo / Zhongbin Lv / Lyu Hao / Haiying Ma / Xiaobo Ma / Jie Ma / Chunbin Ma / Yuandong Ma / Mutailifu Maimaitiyiming / Mao Jinsong / Mao Yanzheng / Shangwen Mao / Fei Maohua / Meng Meng / Chun Meng / Ao Miao / Miao Jian / Jiwu Mu / Xinghai Na / Zhiping Nan / Xia Ni / Ni Li Xiang / Ning Zhouhao / Bo Niu / Chaoyue Pan / Jinming Pan / Pan Songgang / Yu Pan / Pan Cheng / Pan Haisong / Pan Siwei / Pan Deng / Zhengzheng Pang / Zhiqiang Peng / Peng ke / Liping Peng / Yong Peng / Changtong Peng / Ziyang Peng / Nian Peng / PingWei / Feng Pu / Pu Xiaoxu / Dan Yang / Qi JieShuang / Shihui Qi / Jin Qian / LuBin Qian / Xusheng Qian / Qianweizhong / Qiao Jianguo /

Qinbin / Dan Qin / Junxiao Qin / QinLing / Qin Qing / Ding QingLin / Wang Qisheng / Qiu Haochen / Qiu Yan / WenXiong Qiu / Taijian Qiu / Qiu Jianhua / Qiu Weirong / Qu Jinxiang / MengJunRan / Yongxia Rao / Xingwei Ren / Xiuting Ren / Ruan Fen / Ruan Jin Cheng / Sang Zhuo / Kangning Shan / Gen Shun Shang / Shang Huage / Rui Shang / Quanhai Shao / Xiao Xin Shao / Yalin Shao / She Jiahu / Shen Yu / Shen Hui / Shen Zhicheng / Yunfeng Shen / Bohan Shen / Youguo Shen / Guoqiang Sheng / Zhang Sheng / Yi Shi / Wei Shi / Bufa Shi / Minghui Shi / Shi Tao / Shi Linling / Cheng Shi / Yang Shiyao / Liming Shu / Wu Shuang / Song Shuang / Lian Yi Bao / Jinyu Song / Aly Song / Juqiang Song / Song Li / Xiepei Song / Guoqiang Song / Weihua Song / Kai Xuan / Xiqing Su / Yifan Su / Jixiang Su / Ying Su / Jason So / Qiaojiang Su / Hongwei Sun / Guanghuan Sun / Sun Jie / Sun Lin / Ning Dong Sun / Sun Jun / Sun Xiaoyi / TanQiuMin / Tan Qingju / Wendong Tan / Tang Yijun / Tang Jun / Mingzhen Tang / Tao Huan / Taoxiaofeng / Liu Tao / Deng Tao / Tian jieyan / Haiguang Tian / Tian He / Tian Yue / Jianming Tian / Li Tian / Weitao Tian / Baoxi Tian / Tian Ming / Tian Jian / Tian Yi / Zheng Tao / Minfeng Wang / Feng Wang / Shijun Wang / Zhijian Wang / Wang Ying Ying / Keji Wang / Wangyuheng / Wangjianwei / Zhendong Wang / Baifeng Wang / Wang Xiwei / Xiaoke Wang / Wang Keju / Ruobang Wang / Wang Nuo / Zicheng Wang / Shanyuan Wang / Mianli Wang / Fengxiang Wang / Wang Xiao / Zirui Wang / Aimin Wang / Ming Wang / Yanggang Wang / Wangchen / Wang Weiwei / Wang Shi Jun / Wangjie / Wang Pan / Wang Huo Yan / Di Wang / Qingfu Wang / Hao Wang / Xinsheng Wang / Changshu Wang / Wang Qibo / Gongke Wang / Liqiang Wang / Zhipeng Wang / Shen Wang / Wang Cheng / Zhengping Wang / Xiangyang Wang / Wang Ye / Guorong Wang / Yong Wang / Wang Jianing / Wang Ying Chao / Kun Wang / Wang He / Hui Wang / Wangyunliang / Lili Wang / Wang Xiaoming / Yixuan Wang / Wei Wang / WangWei / Wang Qin / Jianbao Wang / Huisheng Wang / Shijie Wang / Zhenyu Wang / Weitao Wang / Wang Qi / Wang Zhendong / Wang Jun / Wang Jing / Tiejun Wang / Wang Bo / Jing Wei / Yongguang Wei / Xue Min Wei / Wei Xiaohao / Liang Wei / Wei Gesheng / Weizhiyang / Wei Hai-Zhou / Wu Wei / Zheng Wei / Cao Weisong / Jianjun Wen / Lieming Wen / Shuncheng Weng / Weng Zili / Qiyu Weng / Chen Wenjin / Qiang Wu / Wu Jingli / YongGang Wu / Changqing Wu / Bin Wu / Wu Bowei / Fan Wu / Zhicheng Wu / Wu Yue / LinHong Wu / Wu Jiang / YunXuan Wu / Anbiao Wu / Wu Zhiyi / Wu Junsong / Jiaxiang Wu / Guangqing Wu / Fang Wu / Wu Xiao Rong / Duanhong Wu / Tingxue Wu / Huang Wu / Kai Wu / Kaibiao Wu / Zhen Wu / Di Wu / Wu Chuan Ming / Hao Wu / Wu Xiaoling / Wu Hong / Wenbing Wu / Wu Yuanfeng / Wu Jie / Lixin Wu / Wu Hailang / Wu Dengcai / Wu Wujiedi / Wuyina / Xia Yang / Zhaoxu Xia / Xia Shiyan / Xuejun Xia / Zhonghai Xia / Pengfei Xia / Deyi Xia / XiaoJunwei / Yijiu Xiao / Muyi Xiao / Zheng Xiaoliang / Xie Hui / Xie Kuangshi / Lin Xie / Dacai Xie / Minggang Xie / Jiujiang Xie / XieHua / Xing Xiaoyan / Xing Shujuan / Xiong Ming / Xiong Shengwen / Liang Xu / Xuhao / Shaofeng Xu / Xu Jiye / Junwen Xu / Xu Minhao / Kai Yan Xu / Xu Jingxing / Xu Jianlong / Fuxiang Xu / Shiweixu / Yinghong Xu / Ping Xu / Tiantong Xu / Limin Xu / Xiaochen Xu / Haifeng Xu / Congjun Xu / Xu Bin / Jianyong Xu / Xiaohong Xu / Juelin Xu / Bin Xu / Xu Cong / Xuran / Gangqiang Xuan / Xiuli Xue / Ning Gang Xue / Yan Yang Ming / Yue Yan / Xiang Yan / Bailiang Yan / Jing Yan / Han Yan / Xu Yancheng / Yang PengWei / Yang Haipeng / Yang Xinyu / Yaoye Yang / Bo Yang / Xiaojunyang / Xudong Yang / Jinyan Yang / Chenglong Yang / Qianfu Yang / Yang Kuan / Jie Yang / Dengfeng Yang / Yang Da / Shao Kun yang / Yang Fang / Liming Yang / Shunpi Yang / Zhonghua Yang / Xiaoning Yang / Jian Yang / Yongdong Yang / Wenbin Yang / Shenlai Yang / Ming Yang / Yang xiao ning / Ning Yang / Youde Yang / Yang Kejia / Fu Yang / Zhiguo Yang / Chang Yang / Yang Hui / Fan Yang / Yang Fan / Yang Yang / Yang Yifan / Donghui Yang / Feng Yang / Deryck Yang / Huabei Yao / Qiangyao / Yao Dong / Jianpin Ye / Pingfan Ye / Zhen Ye / Wei Ye / Yuanhong Ye / Shuyong Ye / Yin Quanlin / Yonghong Yin / Haimin

Yin / Xiulian Yin / Li Yong / You Sihang / Xiao Yu / Yu Yonghua / Yu Jiarui / Yu Jie / TongYu / Yu Hua Qiang / Ying Yu / Chunshui Yu / Yuesheng Yu / Changrong Yu / Mingjian Yu / Yu Hongchun / Yu Ye / Ningtai Yu / Junjieyu / Yu Ming / Yu Ping / Liu Yuan / Liyang Yuan / Jialin Yue / Yuewei Yue / Hongjun Yue / Yun Hongbo / Mu Zang / Nipeng Zeng / Wei Zeng / Yan Zeng / Lidong Zeng / Zeng Junshang / Wenfeng Zeng / Zhai Jianfeng / Jianlan Zhai / Yujia Zhai / Zhanyan / Zhanyu / Zhan Xin Min / zhan You Bing / Zhang Deng Wei / Zhang Lide / Meiyong Zhang / Hongxin Zhang / Wengliang Zhang / Chuansong Zhang / Zhang Shibo / Zhang Mao / Xia Zhang / Zhang Chengbin / Yujie Zhang / Zhang Hao / Guangyu Zhang / Zhang Qiang / Zhang xinghai / Youqiong Zhang / Ting Zhang / Tianming Zhang / Chloe Zhang / Zheng Zhang / Libo Zhang / Aiwu Zhang / Junjie Zhang / Kexin Zhang / Chaohui Zhang / Shougguo Zhang / Chenglin Zhang / Zhang Lei / Ronghua Zhang / Cuncheng zhang / Hong Zhang / Qiaoling Zhang / Peijian Zhang / zhangzihong / Zhang Jinqi / Hongguang Zhang / Renfeng Zhang / Lijie Zhang / Yifu Zhang / Zhang Wei / Zhang Shuguang / Zhang Xiaodong / Jin Zhang / Xiaoyu Zhang / Zhang Xiaoyu / Huoshun Zhang / Zheren Zhang / Yongchao Zhang / Yuan Zhang / Zhang Jin / Tao Zhang / Jian Zhang / Zhiming Zhang / Yan Zhang / Zhang Di / Cheng Zhang / Oliver Zhang / Zhang Tao / Zhanghongwei / Kui Zhang / Zhang Changming / Zhao Siheng / Zhao Qing / Xiao Ming Zhao / Zhao Heting / Xiaoguang Zhao / Wei Zhao / Jiangning Zhao / Zhao Jingdong / Pengfei Zhao / Zhao Linfeng / HongZhao / Zuemin Zhao / Zhao Jianwei / Guanjun Zhao / Zhao Kang / Zhao Chongyi / Wang Zhao / Di Zhao / Zhao Tianrui / Zhao Jie / Zhao Enhui / Jie Zhao / Yinshu Zhao / Wenjian Zhao / Zhao Hui / Xuebao Zhen / Xiaoqun Zheng / Zheng Yang / Zheng Yong Sheng / Zhenglindong / ZhengLiang / Yuqing Zheng / Xiang Zheng / Zhibo Zheng / Qi Zhi Qiang / Zhitang Zhong / Shan Zhong / Zhong Huan / Zhou Na / Pinglang Zhou / Zhou Ren / Zhou Lei / Cunyun Zhou / Zhou Yanming / Jianyong Zhou / Qing Zhou / Yunchang Zhou / Guoqiang Zhou / Gukai Zhou / Guomiao Zhao / Baofu Zhou / Lichun Zhou / Runsheng Zhou / Zhou Xin / Zhou Yong / Zhu Zhiren / ZhiHui Zhu / Zhu Jialei / Jun Zhu / Jianguo Zhu / Chongping Zhu / Xiyong Zhu / Haiwei Zhu / Hongbo Zhu / Vego Zhu / Zhuang Xinmin / Zhuang Yingchang / Zibohong / Tianshu Zou / Zou Zheng / Zou Hong

Colombia
Henry Agudelo / Juan Arredondo / Juan Barrero / Carlos Andrés Bernate Martínez / Kena Betancur / Jose Isaac Bula Urrutia / Nelson Cárdenas / Abel E. Cardenas O. / Jonathan Carvajal / Juan Pablo Cohen / Camilo Diaz / Milton Diaz / Christian EscobarMora / Salym Fayad / Daniel Garzon Herazo / Jose Miguel Gomez / Víctor G. Carreño / Guillermo José González Pedraza / Ovidio Gonzalez Soler / Iván Herrera / Marcelo Londoño / W. Martinez / Angel Mauricio Morales / Andrea Moreno / Eduardo Munoz / Ernesto Navarro / Jorge Eliecer Orozco Galvis / Jaime Pérez Munevar / Sandra Ramírez G. / Luis Ramirez / Federico Rios Escobar / Luis Robayo / Henry Romero / Vanexa Romero / Camilo Rozo / Manuel Saldarriaga / Joana Toro / Ivan Valencia / Javier Vanegas / John Vizcaino / Héctor Fabio Zamora

DR Congo
Justin Makangara / Ley Uwera

Costa Rica
Jeffrey Ar / Jose Diaz / Mayela López / Priscilla Mora Flores / Gabriela Téllez

Croatia
Darko Bandic / Antonio Bat / Marko Jurinec / Fjodor Klaric / Vlado Kos / Anto Magzan / Dragan Matic / Marijan Murat / Hrvoje Polan / Matija Rodjak / Petar Sabol / Damir Senčar / Sanjin Strukic / Ivo Vucetic

Cuba
Jorge Luis Baños / Fernando Medina / Noel Miranda / Alejandro Ernesto / Randy Rodriguez Pagés

Cyprus
Yiorgos Doukanaris / Andreas Iacovou / Sarah Malian

Czech Republic
Jana Ašenbrennerová / Patrik Borecký / Tomáš Brabec / Roman Burda / Radek Burda / Martin Divisek / Eduard Erben / Michael Fokt / Michael Hanke / Dereck Hard / Jana Hunterová / Petr David Josek / Tom Junek / Radek Kalhous / Martin Kozak / Stanislav Krupar / Jan Němeček / Filip Singer / Michaela Spurná / Katerina Sulova / David Tanecek / David Tesinsky / Petr Toman / Petra Vlčková / Roman Vondrouš / Petr Wagenknecht / Jan Zarzycka

Denmark
Steven Achiam / Niels Ahlmann / Morten Albek / Bo Armstrup / Jonas Pryner Andersen / Bobby Anwar / Nicolas Asfouri / Jens Astrup / Ursula Bach / Lasse Bak Mejlvang / Stine Bidstrup / Søren Bidstrup / Marcus Trappaud Bjørn / Jeppe Bøje Nielsen / Laerke Posselt / Jakob Carlsen / Jeppe Carlsen / Emil Ryge / Casper Dalhoff / Miriam K. S. Dalsgaard / Astrid Dalum / Jens Henrik Daugaard / Charlotte de la Fuente / Michael Drost-Hansen / Jacob Ehrbahn / Lene Esthave / Simon Fals / Sara Galbiati / Kasper Palsnov / Jan Grarup / Thomas Grøndahl / Marie Hald / Bjorn Stig Hansen / Peter Helles Eriksen / Niels Hougaard / Peter Klint / Lars Just / Jens Juul / Anna Kâri / Sofie Amalie Klougart / Lars Krabbe / Nanna Kreutzmann / Joachim Ladefoged / Asger Ladefoged / Claus Larsen / Soffi Chanchira Larsen / Nikolai Linares / Bax Lindhardt / Mohammed Massoud Morsi / Nils Meilvang / Lars Moeller / Mads Nissen / Sigrid Ryge Nygaard / Jeannette Pardorf / Rasmus Degnbol / Rasmus Flindt Pedersen / Mikkel Berg / Janus Engel Rasmussen / Kim Rasmussen / Torben Raun / Erik Refner / Liselotte Sabroe / Tobias Selnaes Markussen / Thomas Sjoerup / Anders Rye Skjoldjensen / Martin Søby / Morten Stricker / André Thorup / Gregers Tycho / Anthon Unger / Kaspar Wenstrup /

Dominican Republic
Miguel Gomez

Ecuador
Santiago Arcos / Fabiola Cedillo / Dolores Ochoa / Alejandro Reinoso / Misha Vallejo

Egypt
Mohamed Abdou / Mohamed Adel / Roger Anis / Ahmed Ashraf / Khaled Basyouny / Belal Darder / Nour El Refai / Mosa'ab Elshamy / Mohammed Elshamy / Mustafa Emera / Belal Wagdy / Ahmed Hayman / Mohamed Hossam El-Din / Fayez Nureldine / Nasser Nasser / Islam Osama / Jonathan Rashad / Nader Saadallah / Lobna Tarek / Asmaa Waguih

El Salvador
Jose Cabezas / Mauricio Cáceres / Yuri Cortez / Jonatan Funes / Lissette Lemus / Borman Mármol / Salvador Melendez / Frederick Meza / Jaime Eufred Pérez Anaya

Estonia
Tairo Lutter / Jaanus Ree

Faroe Islands
Trondur Dalsgard

Finland
Tatu Blomqvist / Jukka Gröndahl / Heidi Hietanen / Markus Jokela / Petteri Kokkonen / Tatu Lertola / Tuomo Manninen / Niklas Meltio / Soili Mustapää / Juhani Niiranen / Jussi Nukari / Kimmo Penttinen / Timo Pyykkö / Kaisa Rautaheimo / Juha Salminen / Markus Varesvuo /

France
Pierre Abensur / Pierre Adenis / Pascal Aimar / Guilhem Alandry / Matthieu Alexandre / Boris Allin / Jean Pierre Amet / Christophe Archambault / Martin Argyroglo / Patrick Artinian / Hugo Aymar / Eric Baccega / Cyril Badet / Joan Bardeletti / Pascal

Bastien / Pascal Beaudenon / Francois Beaurain / Guillaume Binet / Olivier Boëls / Vincent Boisot / Jérôme Bonnet / Sébastien Boué / Eric Bouvet / Magali Bragard / Christophe Bricot / Cassius Dwem / Antoine Bruy / Axelle de Russé / Anne-Laure Camilleri / Alvaro Canovas / Juan Francisco Capunay / Francesco Carella / Sarah Caron / Madeleine Carrouee / Fabrice Catérini / Nathanael Charbonnier / Mehdi Chebil / Pablo Chignard / Olivier Chouchana / PibAlexis Christiaen / Frederique Cifuentes / Laurent Cipriani / Thomas Coex / Guillaume Collanges / Stephane Compoint / Olivier Coret / Olivier Corsan / Stéphane Coutteel / Antoine Couvercelle / Pierre Crom / Viviane Dalles / julien Daniel / William Daniels / Guillaume Darribau / Florian David / James Keogh / Matthieu de Martignac / Julien de Rosa / Johanna de Tessieres / Veronique de Viguerie / Constance Decorde / Jerome Delay / Pascal Della Zuana / Mathias Depardon / Lionel Derimais / Vincent Desailly / Bénédicte Desrus / Jean Jérôme Destouches / Stephen Dock / Lisa Dorche / Guy Drollet / Gwenn Dubourthoumieu / Fred Dufour / Frederic Dupont / Sophie Ebrard / Christophe Ena / Alain Ernoult / Isabelle Eshraghi / Dominique Faget / Franck Fife / Benjamin Filarski / Corentin Fohlen / Emeric Fohlen / Constant Formé-Bècherat / Julie Franchet / Eric Gaillard / Marta Darowska / Matilde Gattoni / Laurence Geai / Sebastian Gil Miranda / Frédéric Girou / Baptiste Giroudon / Joseph Gobin / Julien Goldstein / Matthieu Gorisse / Capucine Granier-Deferre / Samuel Gratacap / Diane Grimonet / Philippe Grollier / Alain Grosclaude / Ania Gruca / Aude Guerrucci / Jeoffrey Guillemard / Elisa Haberer / Valery Hache / Christian Hartmann / Laurent Hazgui / Guillaume Herbaut / Souad Herve / Boris Horvat / N. Houdin & D. Palanque / Françoise Huguier / Philippe Huguen / Vinciane Jacquet / Pascale Jauserand / Pierre-Etienne Jay / Helene Jayet / Jean-Francois Muguet / Derigny Jeromine / Olivier Jobard / Jérémie Jung / Alain Kaiser / Oan Kim / Pascal Kobeh / Benedicte Kurzen / Olivier Laban-Mattei / Alain Laboile / Brigitte Lacombe / Fréderic Lafargue / Chau-Cuong Lê / Vianney Le Caer / Augustin Le Gall / Alizé Le Maoult / Rose Lecat / Vincent Leloup / Valerie Leonard / Herve Lequeux / Philippe Lopez / Benjamin Loyseau / Jean Christophe Magnenet / Stephane Mahe / Pascal Maitre / David Mareuil / Frédéric Marie / François-Xavier Marit / Pierre Marsaut / Catalina Martin-Chico / Etienne Maury / Didier Mayhew / Nadège Mazars / Valérian Mazataud / Isabelle Merminod / Nicolas Messyasz / Camille Michel / Gregory Michenaud / Julien Mignot / Thomas Morel-Fort / Olivier Morin / Thibaud Moritz / Jean Francois Mutzig / Ikram N'gadi / Sebastien Nogier / Frederic Noy / Jeff Pachoud / Ted Paczula / Denis Palanque / Anne Paq / Gildas Paré / Franck Paubel / Guillaume Payen / Jean-Charles Perrin / Romain Perrocheau / Jacques Pion / Pluquet Pierre-Antoine / Frédéric Mery Poplimont / Brice Portolano / Cyprien Clément-Delmas / Anita Pouchard Serra / Yann Rabanier / Zacharie Rabehi / Eric Rechsteiner / Yann Renoult / Guilhem Ribart / Graziella Riou / Jean-François Robert / Emmanuelle Rodrigue / Erwan Rogard / Emmanuel Rondeau / Marc Roussel / Denis Rouvre / Veronic Roux Voloir / Gilles Sabrie / Joel Saget / Jérémy Saint-Peyre / Erik Sampers / Jan Schmidt-Whitley / Adrien Selbert / Jérôme Sessini / Christophe Simon / Michel Slomka / Jeremie Souteyrat / Michel Spingler / Eleonora Strano / Frédéric Stucin / Jeremy Suyker / Mehdi Taamallah / Fred Tanneau / antoine tempé / Pierre Terdjman / Patrice Terraz / Pierre Teyssot / Antonin Thuillier / Tina Merandon / Gia To / Kenzo Tribouillard / Gerard Uferas / Emilien Urbano / Nicolas Urlacher / Sebastien Valiela / Eric Vandeville / Loic Venance / Maya Vidon-White / Marylise Vigneau / Aymeric Vincenot / Valerio Vincenzo / Christophe Viseux / Vincent Wartner / Mélanie Wenger / Laurent Weyl / Philippe Wojazer / Rafael Yaghobzadeh

Georgia
Ketevan Mghebrishvili / Dina Oganova / Daro Sulakauri /Oliko Tsiskarishvili-Soselia

Germany

231

Anne Ackermann / Lela Ahmadzai / Theo Allofs / Andrea Altemüller / Florian Bachmeier / Sebastian Backhaus / Marc Baechtold / Nils Bahnsen / Julia Baier / Yasmin Balai / Lajos-Eric Balogh / David Baltzer / Lars Baron / Petra Barth / Gil Bartz / Jasper Bastian / Leonora Baumann / Michael Bause / Peter Bauza / Olaf Otto Becker / Fabrizio Bensch / Lars Berg / Guido Bergmann / Jakob Berr / Peter Bialobrzeski / Toby Binder / Stefan Boness / Wolfgang Borm / Hubert Brand / Verena Brandt / Hermann Bredehorst / Roland Breitschuh / Hansjürgen Britsch / Anja Bruehling / Jörg Brüggemann / Andreas Buck / Dominik Butzmann / Jörg Carstensen / Malte C.Christians / Dirk Claus / Stefan Dauth / Jesco Denzel / Barbara Dombrowski / Matthias Ferdinand Döring / Rainer Drexel / Emile Ducke / Ulf Duda / Thomas Dworzak / Johannes Eisele / Thomas Eisenhuth / Micha Ende / Andreas Endermann / Stefan Enders / Stephan Engler / Daniel Etter / Enrico Fabian / Sibylle Fendt / Klaus Fengler / Fabian Fiechter / Kilian Foerster / Juergen Freund / Christian Frey / Sascha Fromm / Jakob Ganslmeier / Frank Gehrmann / Roland Geisheime / Martin Gerner / Ralf Graf / Marcel Gräfenstein / Chris Grodotzki / Julia Gunther / Patrick Haar / Michael Harker / Alexander Hassenstein / David Heerde / Marc Heiligenstein / Melanka Helms / Claudia Henzler / Lukas J. Herbers / Frank Herfort / Juliane Herrmann / Katharina Hesse / Benjamin Hiller / Hirschfeld / Sylvio Hoffmann / Eva Horstick-Schmitt / Sandra Hoyn / Tobias Hutzler / Claudia Janke / Kati Jurischka / Sebastian Kahnert / Enno Kapitza / Michael Kappeler / Daniel Karmann / Corinna Kern / Claus Kiefer / Dagmar Kielhorn / Lorenz Kienzle / Björn Kietzmann / Nora Klein / Timo Klein / Wolfgang B. Kleiner / Felix Kleymann / Tadeusz Klimczak / Carsten Koall / Alexander Koerner / Bjorn Eric Kohnen / Uwe Kraft / Simone Kuhlmey / Moritz Küstner / Florian Lang / Oliver Lang / Martin Langer / Bernd Lauter / Julia Leeb / Quirin Leppert / Ralf Lienert / Christoph Lienert / Kai Loeffelbein / Ulla Lohmann / Stefanie Loos / Marcel Maffei / Evgeny Makarov / Werner Mansholt / Fabian Matzerath / David Maurer / Martin Meissner / Ursula Meissner / Günther Menn / Dieter Menne / Jens Meyer / Sascha Montag / Charlotte Morgenthal / Lena Mucha / Mark Mühlhaus / Moritz Mueller / Christian Muhrbeck / Florian Müller / Hans-Maximo Musielik / Merlin Nadj-Torma / Rainer Nitzsche / Wolfgang Noack / Ingo Otto / Jens Palme / Michael Penner / Laci Perenyi / Carsten Peter / Kai Oliver Pfaffenbach / Piotr Pietrus / Daniel Pilar / Planz Uli / Stephan Rabold / Martina Rall / Baz Ratner / Wolfgang Rattay / Philipp Jonas Reiss / Sascha Rheker / Astrid Riecken / Christina Rizk / Moritz Roeder / Daniel Roland / Jens Rosbach / Daniel Rosenthal / Kaveh Rostamkhani / Dietmar Scherf / Nanni Schiffl-Deiler / Günter Schiffmann / Victor Schittny / Roberto Schmidt / Christoph Schmidt / Kirstin Schmitt / Harald Schmitt / Walter Schmitz / Jakob Schnetz / Rüdiger Schrader / Matthias Schrader / Julius Schrank / Markus Schreiber / Thomas Schreyer / Annette Schreyer / Joerg Schueler / Olaf Schuelke / Hinrich Schultze / Frank Schultze / Claudius Schulze / Oliver Soulas / Philipp Spalek / Martin Specht / Andy Spyra / Christof Stache / Oliver Stahmann / Martin Steffen / Berthold Steinhilber / Marc Steinmetz / Björn Steinz / Patrik Stollarz / Oana Szekely / Holger Talinski / Bernd Thissen / Thomas Koegl / Marc-Steffen Unger / Jan Velber / Ryu Voelkel / Mika Volkmann / Philipp von Ditfurth / Bernd von Jutrczenka / Marc Vorwerk / Vanja Vukovic / Nathan Goldenzweig / Anke Waelischmiller / Marlena Waldthausen / Uwe Weber / Frank Wechsel / Fabian Weiss / Ludwig Welnicki / Gordon Welters / Philipp Wente / Christian Werner / Gerhard Westrich / Mario Wezel / Sebastian Widmann / Kai Wiedenhoefer / Arnd Wiegmann / Claudia Yvonne Wiens / Ann-Christine Woehrl / Rainer Wohlfahrt / Nadja Wohlleben / Urszula Wolek & Kai Ziegner / Jonas Wresch / Solvin Zankl / Frank Zauritz / Sven Zellner / Christian Ziegler / Tamina-Florentine Zuch

Ghana

Geoffrey Buta / Nyani Quarmyne / Emmanuel Quaye

Gibraltar
Donovan Torres

Greece
Alexandros Avramidis / Socrates Baltagiannis / Yannis Behrakis / Evangelos Bougiotis / Dimitris Chantzaras / Androniki Christodoulou / Angelos Christofilopoulos / Yannis Galanopoulos / Petros Giannakouris / Athanasios Gioumpasis / Paraskevi Goti / Louisa Gouliamaki / Iakovos Hatzistavrou / Yannis Karpouzis / Alexandros Katsis / Ino Klossi / Gerasimos Koilakos / Nikos Kokkas / Yannis Kolesidis / Alkis Konstantinidis / Yannis Kontos / Stefanos Kouratzis / Maro Kouri / Dionysis Kouris / Georgios Makkas / Kostas Mantziaris / Alexandros Maragos / Ayhan Mehmet / Dimitri Mellos / Aris Messinis / Dimitris Michalakis / Sakis Mitrolidis / Giorgos Moutafis / Ntamplis Vasilis / Anna Pantelia / Myrto Papadopoulos / Andreas Papakonstantinou / Giannis Papanikos / Antonis Pasvantis / Stratos Pavlellis / Yuksel Petsenik / Kostas Pikoulas / Nikos Pilos / Lefteris Pitarakis / Vladimir Rys / Orestis Seferoglou / Olga Stefatou / Sapfo Tavouti / Dimitris Tosidis / Sofia Tsampara / Kostas Tsironis / Ioannis Tsouratzis / Angelos Tzortzinis / Aristidis Vafeiadakis / Apostolos Zacharakis

Guam
Ed Crisostomo

Guatemala
Santiago Billy / Esteban Biba / Carlos Lopez-Barillas / Saul Martinez

Haiti
Homere Cardichon

Honduras
Milo Flores

Hong Kong
Kin Cheung / Ducky Chi Tak / Katat Ho / Chung Ming Ko / Hok Chun Kwan / Leo Kwok / Ho Chung Kwok / Lam Yik Fei / Yick Ming Lo / Kwok Fai Lo / Lui Siu Wai / Adam Wong / Ka Ho Wong / Bobby Yip / Vincent Yu

Hungary
Ajpek Orsi / Bacsi Robert Laszlo / László Balassa / Laszlo Balogh / Zoltán Balogh / Andras Bankuti / Irene Becker / Béli Balázs / Krisztián Bócsi / Bela Doka / Daniel Dorko / Fazekas István / Balazs Gardi / András D. Hajdú / Daniel Halasz / Laszlo Halasz / Peter Hapak / Hernad Geza / András Jóri / Marton Kallai / Gábor Kasza / Attila Kisbenedek / Tamas Korponai / Zsolt Kudich / Marton Magocsi / Szilvia Magyar / Marton Szilvia / Bence Máté / Márk Mervai / Zoltan Molnar / Simon Móricz-Sabján / Alex Martin / Attila Polyák / Bálint Pörneczi / Milan Radisics / Tamas Revesz / Zsolt Reviczky / Bianka Rostas / Istvan Ruzsa / Sánta István Csaba / Segesvari Csaba / Lajos Soos / Akos Stiller / Szabo Bernadett / Szabolcs Ivan / Robert Szaniszlo / Zsolt Szigetváry / Laszlo Szirtesi / Zoltán Tuba / István Zsíros

Iceland
Eva Björk Aegisdottir / Vilhemm Gunnarsson / Arnaldur Halldorsson / Kristinn Ingvarsson / Pall Stefansson / GH Svendsen / Arni Torfason

India
Pratip Acharya / S. N. Acharya / Sarath Kumar Alapati / Abhijit Alka Anil / Kalyan Varma / Tabeenah Anjum / Anup Bhattacharya / Bindu Arora / Arc Arun / Bijuraj Ayilliath Kuttiyeri / Baba Tamim / Anand Bakshi / Pritam Bandyopadhyay / Siddharta Banerjee / Salil Bera / Kamalendu Sekhar Bhadra / Tanmoy Bahaduri / Adil Hussain / Biju Boro / Burhaan Kinu / Rana Chakraborty / Amit Chakravarty / Ch. Vijaya Bhaskar / Bhanu Prakash Chandra / Anindya Chattopadhyay / C. Suresh Kumar / K.K. Choudhary / Ravi Choudhary / Rain Ridhin / Manjusha Dangeti / Yasin Dar / Sucheta

Das / Sanjit Das / Sudipto Das / Indranil Das / Arko Datto / Amit Rameshchandra / Mandar Deodhar / Uday Deolekar / Indrajit Dey / Karen Dias / Sandesh Rokade / Gajanan Dudhalkar / Enchikkalayil / Sreekumar Ev / Pattabi Raman / Pushpendra Gautam / Sanibarer Chithi / Sanjoy Ghosh / Sayantan Ghosh / Dev Gogoi / Ashish Shankar / Rajat Gupta / Sanjay Hadkar / Imojen I Jamir / Manoj Chemancheri / Bhagya Prakash Kadire / Abhinav Kakkar / Deepak Kamana Ramesh / Atul Kamble / Aditya Kapoor / Harikrishna Katragadda / Mukhtar Khan / Chandan Khanna / Kannagi Khanna / Wakil Kohsar / Sasi Kollikal / Ritu Raj Konwar / Ajit Krishna / B. Murali Krishnan / Pawan Kumar / P.Ravikumar Kumar / Subir Kumar Dutta / Kumar Raj / Prabhat Kumar Verma / Zishaan Akbar Latif / Shankar Lattur Rathinam / Atil Loke / Periasamy M / Shashwat Malik / Caisii Mao / Rinku Raj Mattancheriyil / Riyasannamanada Mohamedreyas / Samir Madhukar Mohite / Indranil Mukherjee / Tauseef Mustafa / Abhishek Chinnappa / Prashant Nakwe / Showkat Nanda / Ashok Nath Dey / Sudharmadas Nr Neelamkulangara / Nagesh Ohal / Swastik Pal / Josekutty Panackal / Anand Patel / Biswajit Patra / Ravi Posavanike / Anshuman Poyrekar / Kunal Pradeep Patil / Chhandak Pradhan / Altaf Qadri / Rajendra Singh Jadon Raj / Ashish Raje / Riya Sharma / Biswaranjan Rout / Parikhit Saikia / Padam Saini / SL Shanth Kumar Shanth / Sajeesh Sankar / Ruby Sarkar / Mallar Sarkar / Partha Protim Sarkar / Arijit Sen / Gautam Sen / Partha Sengupta / Ajeet Kumar Shaah / Azaan Shah / Russel Shahul / Ramesh Shankar / Shantanu Das / Smita Sharma / Anand Sharma / Subhash Sharma / Anand Shinde / Raju Shinde / Debobrata Shome / Danish Siddiqui / Sharath Babu Siddoju / Prakash Singh / Vivek Singh / Rajib Singha / Divyakant Solanki / Sonu Mehta / R.R. Srinivasan / Anantha Subramanyam.K. / Manish Swarup / Waseem Andrabi Syed Nabi Ahmad Andrabi / T. Srinivasa Reddy / Ishan Tankha / T Mohandas Thattankandy / Vishnu Thundathil / Harish Tyagi / Ritesh Uttamchandani / Karan Vaid / Palla Sreenivasu Vasu / Roy Vicky / Vishal Srivastav / Keshav Vitla / Himanshu Vyas / Chirag Dilip Wakaskar / Danish Ismail Wani / Atish Wankhede / Yawar Nazir

Indonesia
Andri Mardiansyah / Sutanta Aditya / Arif Agam / Agung Parameswara / Yuniadhi Agung / Hafidz Mubarak A. / Iqbaluddin Ahmad / Affan Ahmad / Qodrat Al-Qadri / Rizal Amir / FB Anggoro / Slamet Riyadi / Dimas Ardian / Binsar Bakkara / Beawiharta / Widiarso Bin Buradi / Roni Bintang / Sumaryanto Bronto / Riski Cahyadi / Albert Ivan Damanik / Dewi Nurcahyani / Dhana Kencana / Ricky Adrian / Hendra Eka / Mohammad Hilmi Faiq / Muhammad Fajri / Razi / Masyudi Firmansyah / WF Sihardian / BanGhoL / Hariandi Hafid / Jongki Handianto / Michael Eko Hardianto / Boy Harjanto / Y.T Haryono / Nico Haryono / Akrom Hazami / Hendra A Setyawan / Hendro Herjanto / Aditya Herlambang Putra / Afriadi Hikmal / Donal Husni / Ulet Ifansasti / Fauzan Ijazah / Heru Sri Kumoro / P.J. Leo / Abriansyah Liberto / Iqbal Lubis / Raditya Mahendra Yasa / Chaideer Mahyuddin / Maman Sukirman / Muhammad Syofri Kurniawan / Irsan Mulyadi / Mushaful Imam / Arya Manggala / Denny Pohan / Wawan H Prabowo / Arief Bagus / Teguh Prasetyo / Melvinas Priananda / Rommy Pujianto / Erri Kartika / Bahauddin Raja Baso / ramdani / Ardiles Rante / Aman Rochman / Susanto / Yuli Seperi / Antonius Riva Setiawan / Ferdy Siregar / Poriaman Sitanggang / Agus Susanto / Muhammad Adimaja / Tatan Syuflana / Defizal Tanjung / Jefri Tarigan / Kang Ube / Nova Wahyudi / Putu Sayoga / Andika Wahyu / Adek Berry / Taufan Wijaya / Jessica Helena Wuysang / Syifa Yulinas / Yusuf Ahmad / Rony Zakaria / Zhu Qincay

Iran
Mehdi Abbasi / Hamid Akhlaghi / Saghar Amir Azimi / Maryam Ashrafi / Foad Ashtari / Sajjad Avarand / Mohammad Babaei / Seyed Ehsan Bagheri / Amin Bahrani / Amir Behroozi / Mohammad Ali Berno /

Solmaz Ghadimlou Daryani / Javad Erfianian Aalimanesh / Jamshid Farajvand Farda / Mohammed Farnood / Hossein Fatemi / Ali Fathi / Mehdi Fazlollahi / Rouzbeh Fouladi / Arez Ghaderi / Hassan Ghadyani / Borna Ghasemi / Mehrdad Amini / Reza Golchin / Mohammad Golchin / Parviz Golizadeh / Azin Anvar Haghighi / Abbas Hajimohammadi / Ahmad Halabisaz / Ali Hamed Haghdoust / Mohsen Harami / Abdollah Heidari / Hossein Heidarpour / Marziyeh Heydarzadeh Aghdam / Mona Hoobehfekr / Siamak Imanpoor / Amir Jalal / Mehri Jamshidi / Shayan Javan / Younes Jolfaie Azar / Amir Hossein Kamali / Ehsan Kamaly / Morteza Kananix / Parastoo Keshavarz / Arash Khamooshi / Asghar Khamseh / Danial Khodaie / Amir Hossein Khorgoui / Mh. Khozaei / Mehdi Lashani / Soleyman Mahmoudi / Burhan Mardani / Arash Mirsepasi / Yalda Moaiery / Ahmad Moenijam / Masoud Mohammadi / Mehrnaz Mohammadi / Abdolrahman Mojarrad / Hadi Mokhtarian / Tahmineh Monzavi / Shaghayegh Moradian Nejad / Nafise Esmael Motlagh / Amir Narimani / Shahab Naseri / Hamed Nazari / Dariush Nehdaran / Hassan Nezamian / Javid Nikpour / Javad Parsa / Adel Pazyar / Mehrdad Rabie Laleh / Milad Rafat / Mahya Rastegar / Amirali Razzaghi / Faranak Rezaee / Alireza Rostami / Alieh Saadatpour / Zohreh Saberi / Hamed Sadeghi / Fatemeh Sadeghzadeh / Hossein Sadri / Majid Saeedi / Samman Safaei / Sajad Safari / Arash Sahranavard / Hosein Saki / Ako Salemi / Soheila Sanamno / Mohsen Sanei Yarandi / Sohrab Sardashti / Babak Sedighi / Mohamad Raouf Shahbazi / Mohammed Bagher Shahin / Hashem Shakeri / Aitai Shakibafar / Jalal Shamsazaran / Seyed Mehrdad Sharifi / Ali Sharifzade / Ali Akbar Shirjian / Mahdi Shojaeian / Seyed Madyar Shojaeifar / Amir Hossein Shojaii / Sadegh Souri / NazaninTabatabaee Yazdi / Hamed Tabein / Ali Tajik / Amin Talachian / Newsha Tavakolian / Farshid Tighehsaz / Mohsen Vanaei / Alfred Yaghobzadeh / Morteza Yaghooti / Bahram Yazdanpanah / Saeed Zaidi / Majid Zakizade / Soheil Zandazar / Bahman Zarei

Iraq
Jaber al-Helo / Ahmad Al-Rubaye / Ali Arkady / Safin Hamed / Farzin Hassan / Haidar Hamdani / Karim Kadim / Hawre Khalid / Younes Mohammad / Khalid Mohammed / Karim Sahib / Seivan M. Salim / Osama Sami / Bnar Sardar / Ali Haider

Ireland
Phil Behan / Desmond Boylan / Nick Bradshaw / Deirdre Brennan / Matthew Browne / Ramsey Cardy / Michael Chester / James Crombie / Lauren Crothers / Kieran Doherty / Andrew Downes / Mark Duffy / Arthur Ellis / David Farrell / Darragh Mason Field / Ewa Figaszewska / Brenda Fitzsimons / Kieran Galvin / Brian Gavin / Diarmuid Greene / Maurice Gunning / Kim Haughton / James Horan / Steve Humphreys / John D. Kelly / John C Kelly / Clodagh Kilcoyne / David Maher / Stephen McCarthy / Andrew McConnell / Ross McDonnell / Charles McQuillan / Adrian Melia / Denis Mininane / Paul Mohan / Margaret Molloy / Declan Monaghan / Brendan Moran / Seamus Murphy / Cathal Noonan / Piaras Ó Mídheach / Mick O'Neill / Douglas O'Connor / Kenneth O'Halloran / Colm O'Molloy / Joe O'Shaughnessy / Adam Whitley Patterson / Fergal Phillips / Ivor Prickett / Dave Ruffles / Ray Ryan / Bill Smyth / Billy Stickland / Morgan Treacy / Domnick Walsh / Ian Walton / Eamon Ward / Keith Wiseman

Israel
Avivi Aharon / Nir Alon / Eli Atias / David Bachar / Oded Balilty / Rina Castelnuovo / Yuval Chen / Gil Cohen Magen / Yoav Arie Dudkevitch / A. Ershov / Eddie Gerald / Udi Goren / Amnon Gutman / Nitzan Hafner / Dan Haimovich / Ben Kelmer / Ziv Koren / Amir Levy / Tall Mayer / Shay Mehalel / Omer Messinger / Moti Milrod / Lior Mizrahi / Noam Moskowitz / Jorge Novominsky / Hadas Parush / Atef Safadi / Emil Salman / Ariel Schalit / Ahikam Seri / Amit Sha'al / Avishag Shaar-Yashuv / Danielle Shitrit / Abir Sultan / Gali Tibbon / Miriam Tsachi / David Vaaknin / Oded Wagenstein / Eyal

Warshavsky / Kobi Wolf / Gili Yaari / Ilia Yefimovich / Yehoshua Yosef / Ammar Younis / Oren Ziv / Ronen Zvulun / Ohad Zwigenberg

Italy
Gianluca Abblasio / Massimo Abordi / Laura Aggio Caldon / Edoardo Agresti / Gustavo Alàbiso / Alessandro Albert / Salvatore Allegra / Marco Alpozzi / Francesco Anselmi / Marco Aprile / Michele Ardu / Piero Arianos / Giampiero Assumma / Giovanni Attalmi / Pietro Avallone / Fabiano Avancini / Daniele Badolato / Diana Bagnoli / Luigi Baldelli / Danilo Balducci / Jacob Balzani Lööv / Federico Barattini / Giorgio Barbato / Massimo Barberio / Alessandro Barcella / Alessandro Barteletti / Matteo Bastianelli / Azzurra Becherini / Daniele Belosio / Barbara Beltramello / Cristiano Bendinelli / Beniamino Pisati / Valerio Berdini / Simone Bergamaschi / Massimo Berruti / Stefano Bertolino / Delila Marika Bertoni / Marco Bertorello / Maurizio Beucci / Carlo Bevilacqua / Giorgio Bianchi / Giulia Bianchi / Matteo Biatta / Alfredo Bini / Valerio Bispuri / Paolo Bona / Simona Bonanno / Marcello Bonfanti / Riccardo Bononi / Federico Borella / Ugo Borga / Gregorio Borgia / Alberto Bortoluzzi / Michele Borzoni / Alfredo Bosco / Majlend Bramo / Massimo Branca / Roberto Brancolini / Luisa Briganti / Leonardo Brogioni / Annamaria Bruni / Vincenzo Bruno / Luca Bruno / Talos Buccellati / Fabio Bucciarelli / Mario Bucolo / Fulvio Bugani / Giulio Bulfoni / Stefano Buonamici / Matteo Buonomo / Antonio Busiello / Alberto Buzzola / Giuseppe Cabras / Roberto Caccuri / Roberto Cadeddu / Jean-Marc Caimi & Valentina Piccinni / Turi Calafato / Caterina Cambuli & Gianbattista Battaini / Cinzia Camela / Erica Canepa / Violetta Canitano / Marco Cantile / Alessia Capasso / Federico Caponi / Giovanni Capriotti / Andrea Carboni / Maria Cardamone / Carlotta Cardana / Stefano Carini / Giuseppe Carotenuto / Davide Casella / Marco Casini / Pablo Castellani / Luca Catalano Gonzaga / Gianluca Cecere / Pierfrancesco Celada / Loredana Celano / Chiara Ceolin / Alberto Ceoloni / Giancarlo Ceraudo / Simone Cerio / Stefano Cerquetani / János Chialá / Alfredo Chiarappa / Chinellato Matteo / Giuseppe Chiucchiu / Piero Chiussi / Alessandro Ciccarelli / Alberto Cicchini / Giuseppe Ciccia / Laura Cionci / Gianni Cipriano / Paolo Ciriello / Pier Paolo Cito / Francesco Cito / Tomaso Clavarino / Ignacio Maria Coccia / Emanuela Colombo / Giada Connestari / Luna Coppola / Luigi Corda / Giovanni Corsi / Alessandro Cosmeli / Alfredo Covino / Niccolò Cozzi / Emiliano Cribari / Massimo Cristaldi / Thomas Cristofoletti / Alessio Cupelli / Fabio Cuttica / Alessandro D Angelo / Alfredo D'Amato / Cinzia D'Ambrosi / Bruno D'Amicis / Albertina d'Urso / Stefano Dal Pozzolo / Francesco Dal Sacco / Daniel Dal Zennaro / Simone Dalmasso / Chiara Dazi / Guido De Bortoli / Francesco A. de Caprariis / Thomas De Cian / Dario De Dominicis / Stefano De Luigi / Isabella De Maddalena / Serena De Sanctis / Linda de'Nobili / Giovanni Del Brenna / Luciano del Castillo / Valeriano Di Domenico / Pietro Di Giambattista / Marco Di Lauro / Adamo DiLoreto / Giulio Di Sturco / Alfonso Di Vincenzo / Giovanni Diffidenti / Alessandro Digaetano / Alessandro DiMeo / Simone Donati / Linda Dorigo / Patrizia Dottori / Dottori & Pettinelli / Angelo Emma / Salvatore Esposito / Antonio Faccilongo / Alessandro Falco / Alice Falco / Andrea Falcon / Giuseppe 'Pino' Fama / Maurizio Faraboni / Axel Fassio / Santolo Felaco / Sergio Ferraris / Marco Ferraris / Massimiliano Ferraro / Max Ferrero / Matteo Festi / Vito Finocchiaro / Gaetano Fisicaro / Vincenzo Floramo / Simone Fogo / Luca Forno / Andrea Frazzetta / Aldo Frezza / Roberto Fumagalli / Claudio Furlan / Gabriele Galimberti / Gianfranco Gallucci / Alessandro Gandolfi / Alessandra Garagnani / Marco Garofalo / James Gasperotti / Simona Gemelli / Stephanie Gengotti / Vince Paolo Gerace / Elio Germani / Riccardo Ghilardi / Simona Ghizzoni / Carlo Gianferro / Alfio Giannotti / Antonio Gibotta / Claudio Giovannini / Fabrizio Giraldi / Giulia Candussi / Francesco Giusti / Chiara Goia / Claudia Gori / Alessandro Grassani / Mattia

Gravili / Annibale Greco / Eugenio Grosso / Marco Gualazzini / Gianluigi Guercia / Federico Guida / Francesco Guidicini / Giulia Lacolutti / Marina Imperi / Fabrizio Incorvaia / Alessandro Iovino / Roberto Isotti / Giuliano Koren / Maila Lacovelli / Oskar Landi / Silvia Landi / Nicoló Lanfranchi / Michele Lapini / Francesco Lastrucci / Laura Lezza / Gaia Light / Alessandro Lisci / Laura Liverani / Giovanni Lo Curto / Luca Locatelli / Marco Longari / Nicola Longobardi / Gabriele Lopez / Luca Lupi / Chiara Luxardo / Elvio Maccheroni / Lorenzo Maccotta / Francesca Maceroni / Sandro Maddalena / Ilaria Magliocchetti Lombi / Nicola Maiani / Ettore Malanca / Francesco Malavolta / Alessio Mamo / Livio Mancini / Karl Mancini / Christian Mantuano / Romina Marani / Gianmarco Maraviglia / Igor Marchesan / Paolo Marchetti / Giulia Marchi / Nicola Marfisi / Diambra Mariani / Marina Berardi / Enrico Mascheroni / Roberto Masi / Lorenzo Masi / Antonio Masiello / Silvio Massolo / Pietro Masturzo / Giovanni Matarazzo / Daniele Mattioli / Edoardo Melchiori / Ugo Mellone / Myriam Meloni / Lorenzo Meloni / Hermes Mereghetti / Giovanni Mereghetti / Francesco Merlini / Federico Merlo / Erik Messori / Gabriele Micalizzi / Andrea Micelli / Matteo Minnella / Dario Mitidieri / Pierpaolo Mittica / Giuseppe Moccia / Siegfried Modola / Diego Mola / Mimi Mollica / Massimiliano Mona / Guido Montani / Davide Monteleone / Raffaele Montepaone / Claudio Montesano Casillas / Stefano Morelli / Lorenzo Moscia / Filippo Mutani / Fabio Muzzi / Luigi Narici / Annalisa Natali Murri / Roberto Nistri / Antonello Nusca / Emanuelle Ochipinti / Gabriele Orlini / Roberto Orrù / Massimo Pacifico / Alessio Paduano / Silvia Paganino / Mauro Pagnano / Michele Palazzi / Giorgio Palmera / Simona Pampallona / Gianluca Panella / Graziano Panfili / Giovanni Panizza / Maria Pansini / Savino Paolella / Pietro Paolini / Massimo Paolone / Mattia Passarini / Paolo Patrizi / Michele Pavana / Paolo Pellegrin / Carlo Pellegrini / Alessandro Penso / Viviana Peretti / Simone Perolari / Leonardo Perri / Leonardo Perugini / Sebastiano Pessina / Raffaele Petralla / Carlo Pettinelli / Giuseppe Piazzolla / Dario Picardi / Emiliano Pinnizzotto / Pino Rampolla / Marco Piovanotto / Alessandro Piredda / Piergiorgio Pirrone / Giulio Piscitelli / Francesco Pistilli / Sergio Pitamitz / Alberto Pizzoli / Paolo Poce / Fausto Podavini / Valerio Polici / Antonio Politano / Francesca Pompei / Piero Pomponi / Davide Pravettoni / Tommaso Protti / Marika Puicher / Alessandra Quadri / Valentina Quintano / Cesare Quinto / Tommaso Rada / Francesco Ragazzi / Sergio Ramazzotti / Alessandro Rampazzo / Simone Raso / Max Rella / Stefano Rellandini / Andreja Restek / Renata Romagnoli / Alessio Romenzi / Gianluca Rona / Italo Rondinella / Rocco Rorandelli / Max Rossi / Alessandro Rota / Anna Ruggieri / Calogero Russo / Patrick Russo / Andrea Sabbadini / Ivo Saglietti / Marco Sales / Roberto Salomone / Laura Salvinelli / Arianna Sanesi / Andrea Sanfilippo / Luca Santese / Rossella Santosuosso / Maurizio Sartoretto / Alice Sassu / Emanuele Satolli / Riccardo Savi / Loris Savino / Stefano Schirato / Massimo Sciacca / Marcello Scopelliti / Federico Scoppa / Emanuele Scorcelletti / Linda Scuizzato / Massimo Sestini / Christian Sinibaldi / Luca Sola / Andreas Solaro / Mario Spada / Mauro Spanu / Max Spinolo / Gaia Squarci / Andrea Staccioli / Alessandro Stellari / Nicolas Tarantino / Alessandra Tarantino / Giorgio Taraschi / Sebastiano Tomada / Dario Tommaseo / Gianfranco Tripodo / Alessandro Trovati / Lorenzo Tugnoli / Serena Tulli / Mirko Turatti / Nicola Ughi / Marco Vacca / Mattia Vacca / Clara Vannucci / Antonello Veneri / Filippo Venturi / Paolo Verzone / Federico Vespignani / Francesca Vieceli / Mirko Viglino / Manuel Vignati / Fabrizio Villa / Laura Villani / Zoe Vincenti / Alessandro Vincenzi / Christo Viola / Daniele Vita / Massimo S. Volonté / Daniele Volpe / Francesca Volpi / Antonio Zambardino / Filippo Zambon / Barbara Zanon / Elisabetta Zavoli / Fabio Zayed / Francesco Zizola / Nicola Zolin / Mattia Zoppellaro / Lorenzo Zoppolato / Paola Zorzi / Vittorio Zunino Celotto

LANDSCAPE. LIFE. EVERYTHING.

Joel Santos on the EOS 5DS

"When I'm photographing landscapes, my mind set is completely different. I love to be in awe of nature's biggest spectacles and other-worldly phenomena, like the ones you experience in extreme weather conditions and remote places. When I'm in tune with nature, it's possible to capture images beyond what I even imagined before leaving home. When shooting with the 5DS I was instantly amazed by the huge amounts of detail I could get in my shots. I was able to see micro textures on leaves and rocks that were not visible to the naked eye, and also able to use that amazing resolution to accurately manually focus with an industry leading Live View function. Furthermore, new features like the Crop Mode allowed me to frame the picture without changing the lens in challenging weather conditions and unstable terrain. The EOS 5DS is much more than the resolution, its photography made better, raising the bar and the pleasure you take from it."

KEY FEATURES

- 50.6-megapixel full-frame CMOS sensor
- 61-point wide-area autofocus
- Up to 5fps continuous shooting
- Mirror Vibration Control System
- Built-in 1.3x and 1.6x cropped shooting modes
- Time-lapse movies with interval timer shooting
- Weather-sealed controls
- USB 3.0 connectivity

© **Joel Santos** Canon Explorer

EOS 5D s
EOS 5D sr

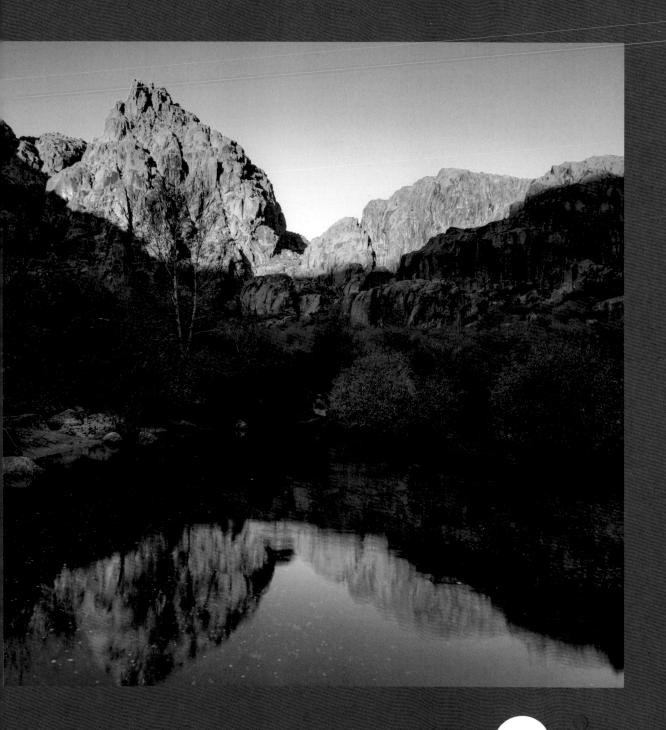

come
and
see

Canon

Search: CPN EOS 5DS

Jamaica
Jermaine Barnaby / Ricardo Makyn / Andrew P. Smith

Japan
Hiroshi Aoki / Takashi Aoyama / Itaru Chiba / Yasuyoshi Chiba / Toru Hanai / Yusuke Harada / Noriko Hayashi / Shinichi Iizuka / Madoka Ikegami / Yuki Iwanami / Yasushi Kanno / Yosuke Kashiwakura / Keisuke Kato / Ai Kawahira / Rei Kishitsu / Koide Yohei / Yusuke Komatsu / Rei Kubo / Dai Kurokawa / Naoki Maeda / Hiroyasu Masaki / Hiroko Masuike / Shigeki Miyajima / Miyazaki Makoto / Toru Morimoto / Takuma Nakamura / Shiro Nishihata / Kazuma Obara / Satoshi Oga / Yasuhiro Ogawa / Kosuke Okahara / Takashi Ozaki / Q. Sakamaki / Kazushige Shirahata / Rei Shiva / Akira Suemori / Dai Sugano / Ryuzo Suzuki / Takagi Tadatomo / Satoshi Takahashi / Kentaro Takahashi / Tsutomu Takasu / Atsushi Taketazu / Terazawa Masayuki / Kenichi Unaki / Shin Yahiro / Yuta Yasumoto / Yutaka /

Jordan
Ammar Awad / Nadia Bseiso / Muhammed Muheisen

Kazakhstan
Grigoriy Bedenko / Rizabek Isabekov / Ratmir Nazirov / Valeriya Shin

Kenya
Thomas Abuoga / Georgina Goodwin / Tony Karumba / Monicah Mwangi / Kevin Ouma / Humphrey Odero / Ray Ochieng Olewe / Kevin Onnoka / James Otieno / Ian Yatich

Kosovo
Jetmir Idrizi / Ferdi Limani

Latvia
Reinis Hofmanis / Anna Jurkovska / Dace Voitkevica

Lebanon
Hussein Baydoun / Patrick Baz / Mustapha Elakhal / Bilal Hussein / Anwar Amro / Marwan Naamani / Hasan Shaaban / Marwan Tahtah / Rodrigue Zahr

Liberia
Ahmed Jallanzo

Libya
Wadea El Atrash / Mahmud Turkia

Lithuania
Ramunas Danisevicius / Kazimieras Linkevičius / Renaldas Malychas / Arturas Morozovas / Rita Stankeviciute / Berta Tilmantaitė

Luxembourg
Alain Schroeder

Macedonia
Robert Atanasovski / Igor Banskoliev / Tomislav Georgiev / Boris Grdanoski / Georgi Licovski / Liu Mingzhao

Malaysia
Osman Adnan / Aizuddin Saad / Ahmad Izzrafiq Alias / Muhamed Fathil Asri / Teng Ruen Ban / Azman Ghani / Tan Chee Hon / Wei Seng Chen / Voon Chung Chong / Stefen Chow / Joshua Paul Gilbert / Glenn Guan / Firdaus Latif / Kah Meng Lek / Mohd Yusni Mohd Ariffin / Faihan Ghani / Ahmad Yusni Mohd Said / Muhammad Ong / Kah Vee Pan / Samsul Said / Kamal Selleuddin / Soo Hon Keong / Lo Sook Mun / Chen Soon Ling / Sang Tan / Jeremy Tan / Ian Teh / James Tseu Kui Jin / FL Wong / Marcus Yam

Mali
Bakary Emmanuel Daou / Amadou Keita

Malta
Domenic Aquilina / Darrin Zammit Lupi

Mauritius
Kadrewvel Pillay Vythilingum

Mexico
Octavio Aburto / Theda Acha / Jesús Almazán / Enrique Alvarez del Castillo / Antonio Ojeda / Guillermo Arias / Armando Arorizo / Gerardo Avila / Jorge Arturo Bermudez Gonzalez / Vidal Berrones Murillo / Fernando Brito / Fernando Carranza Garcia / Ivan Castaneira / Luis Castillo / Narciso Contreras / Alejandro Cossio / Elizabeth Dalziel / Mario Domínguez / Alfredo Dominguez Noriega / Jorge Dueñes / Emilio Espejel / Alfredo Estrella Ayala / Eduardo Feldman / Carlos A Ferrer / Bernardo Flores / Rodolfo Flores / Rafael Gaviria Santos / David Eliud Gil Samaniego / Ricardo González Macias / Hector Guerrero / Aldo Chacon / Fernando Gutiérrez Juárez / Ada Hinojosa / Jimena Cristina Ibarra Rangel / Rodrigo Jardon / Carlos Jasso / Miguel Juarez Lugo / Leopoldo Kram / Eduardo Loza / Prometeo Lucero / Johny Magallanes / Yael Martinez / Chema Martiéz / Victor Medina Gorosave / Imelda Medina / Jorge Alberto Mena Riezco / Joel Merino / Consuelo Pagaza / Saul Muñoz Contreras / Mauricio Palos / Anuar Patjane Floriuk / David Polo / Pedro Pardo / Alejandro Prieto / Rodrigo Reyes Marin / Agustín Reyes / Cesar Rodriguez Becerra / Cristopher Rogel Blanquet / Joel Sampayo Climaco / Armando Santibáñez Romellón / Rashide Frias / Jorge Serratos Reyes / Ramon Sienra / Diego Ricardo Sierra Moreno / Octavio Hoyos / Jonathan Telles / Joel Trejo / Ricardo Vargas Sánchez / Sergio Tapiro / Eduardo Verdugo / Gerardo Vieyra / Irving Villegas

Moldova
Denis Buchel

Morocco
Zara Samiry

Myanmar
Ye Aung Thu / Rentsendorj Bazarsukh / Davaanyam Delgergargal / Thet Htoo / Htoo Tay Zar / Sai Kham Lynn / Minzayar Oo / Zarni Phyo / Soe Zeya Tun

Namibia
Dirk Heinrich / Karel Prinsloo

Nepal
Nabin Baral / Uma Bista / Navesh Chitrakar / Bikash Karki / Narendra Mainali / Prakash Mathema / Bibi Funyal / Satish Pokhrel / Sunil Pradhan / Bimal Gautam / Sunil Sharma / Kishor Sharma / Narenda Shrestha / Hemanta Kumar Shrestha / Naresh Shrestha / Niranjan Shrestha / Amul Thapa / Pratap Thapa / Prakash Chandra Timilsena

The Netherlands
Jaap Arriens / André Bakker / Jan Banning / Amit Bar / Nico Bastens / Loulou Beavers / Renate Beense / Gerlo Beernink / Henri Blommers / Cynthia Boll / Theo Bosboom / Henk Bothof / Yvonne Brandwijk / Geert Broertjes / Eelkje Colmjon / Ernst Coppejans / Rachel Corner / Chris de Bode / Henk de Boer / Hans de Clercq / Duncan de Fey / Bas de Meijer / Bernadet de Prins / Vincent DeVries / Sander de Wilde / Allard de Witte / Peter Dejong / Hester den Boer / Aleid Denier van der Gon / Joep Derksen / Linelle Deunk / Jasper Doest / Ellis Doeven / Chantal Ruisseau / Marc Driessen / Willeke Duijvekam / Kjeld Duits / Sandra Dunk / Jan Everhard / Flip Franssen / Martijn van de Griendt / Anouk Griffioen / Jasper Groen / Guillaume Groen / John Gundlach / Ko Hage / Johan G. Hahn / Eddo Hartmann / Rod Henderson / Sarah Mei Herman / Piet Hermans / Thijs Heslenfeld / Bastiaan Heus / Harry Heuts / Hille Hillinga / Inge Hondebrink / Hans Hordijk / Jasper Juinen / Jeroen Jumelet / Karijn Kakebeeke / Hans Kamstra / Chris Keulen / Huub Keulers / Arie Kievit / Theo Kingma / Knikman Hans / Antoinette de Jong and Robert Knoth / Ton Koene / Bart Koetsier / Carla Kogelman / Willem Kuijpers / Mirjam Letsch / Floris Lok / Bas Losekoot / Bart Maat / Marinka Masséus / Brian Megens / Dida Mulder / Liny Mutsaers / Arnold

Nienhuis / Ilvy Njiokiktjien / Paco Nunez / Marco Okhuizen / Annabel Oosteweeghel / Anneloes Pabbruwee / Mardoe Painter / Frans Poptie / Patrick Post / Elske Riemersma / Wouter Roosenboom / Peter Rothengatter / Isabella Rozendaal / Raymond Rutting / Maikel Samuels / Alexander Schippers / Nicole Segers / Rob Severein / Carolien Sikkenk / Bianca Sistermans / Corné Sparidaens / Jan-Joseph Stok / Koen Suyk / Jeroen Swolfs / Hans Tak / Pieter ten Hoopen / Ruben Joachim Terlou / Cris Toala Olivares / Ton Toemen / Jeroen Toirkens / Frank Trimbos / Robin Utrecht / David van Dam / Anne van de Pals / Carla van de Puttelaar / Kees van de Veen / Piroschka van de Wouw / Mona van den Berg / Catrinus van der Veen / Marieke van der Velden / Klaas Jan van der Weij / Marten van Dijl / Rogér van Domburg / Eveline van Elk / Guus van Goethem / Donald van Hasselt / Jan van IJken / Gé-Jan van Leeuwen / Inge van Mill / Paul van Riel / Rogier van 't Slot / Marielle van Uitert / Eddy van Wessel / Peter Verdurmen / Anne-Marie Vermaat / Jan Vermeer / Frank Viergever / Dirk-Jan Visser / Yolanda Visser / Rob Voss / Pascal Vossen / Marlies Wessels / Edwin Wiekens / Alice Wielinga / Bert Wieringa / Fleur Wiersma / Emily Wiessner / Sinaya Wolfert / Paolo Woods / Xiaoxiao Xu / Andy Zuidema

New Zealand
Scott Barbour / Braden Fastier / Robin Hammond / Sam Hodgson / Leon LI / Ruth McDowall / Iain McGregor / Marty Melville / Mike Millett / Jiongxin Peng / Max Reeves / Richard Robinson / Martin de Ruyter / Dwayne Senior / Lawrence Smith / Ingetje Tadros / Dean Treml / Cornell Tukiri / John Williams

Nicaragua
Bpicado / Oswaldo Rivas

Nigeria
Yinka Adeparusi / Immanuel Afolabi / Ademola Ajayi / Kunle Ajayi / Lola Akinmade Åkerström / Sunday Alamba / Kingsley Azanor / Kingston O. Daniel / Andrew Esiebo / Oboh Agbonkhese Kenneth / Odutayo Odusanya / Saheed Olugbonv / Tom Saater / Akeem Salau / Abiodun Sivowaku

Norway
Jarle Aasland / Paul S. Amundsen / Odd Andersen / Christian Belgaux / Jonas Bendiksen / Jon-Are Berg-Jacobsen / Stein Jarle Bjorge / Andrea Gjestvang / Eirik Grønningsæter / Johnny Haglund / Thomas Haugersveen / Pål Hermansen / Katinka Hustad / Luca Kleve-Ruud / Kyrre Lien / Robert McPherson / Verdens Gang / Peter Mydske / Linda H. Naesfeldt / Jon Olav Nesvold / Dagens Naeringsliv / Ken Opprann / Line Ørnes Søndergaard / Mette Randem / Espen Rasmussen / Patrick da Silva / Siv Johanne Seglem / Kristian Skeie / Helge Skodvin / Jo Straube / Marie von Krogh / Kristian Westgård / Vegard Wivestad Grøtt

Pakistan
Shakil Adil / Bilal Ahmed / Fareed Khan / Bilal Latif / Rana Sajid Hussain / Mohammad Sajjad / Akhtar Soomro

Palestinian Territories
Issam Rimawi / Mohammad Alhaj / Musa Alshaer / Laura Boushnak / Ahmed Deeb / Mahmoud Hams / Momen Faiz / Ahmad Gharabli / Adel Hana / Mustafa Hassona / Shadi Hatem / Mahmoud Issa / Abbas Momani / Mussa Qawasma / Mohammed Saber / Mohammed Salem / Suhaib Salem

Panama
Anselmo Mantovani / Edward Ortiz

Paraguay
Jorge Saenz / Luis Vera

Peru
Eitan Abramovich / Cynthia Koehler / Omar Lucas / Martin Bernetti / Sebastian Castaneda / Janine Costa / Oscar Durand / Gladys Alvarado / Hector

Emanuel / Handrez García-Gonzales / Carlos Garcia Granthon / David Huamaní / Miguel Ángel Mejía Castro / Miriam Patricia Moreno Serpa / Musuk Nolte / Martin Pauca / Leslie Searles / Raul Sifuentes / Manuel Milko / Paul Vallejos Coral

The Philippines
Robert Oswald Alfiler / Xyza Bacani / Mark Balmores / Jun M. Cargullo / Alexis Carlo Corpuz / Gregorio Dantes / Rolex dela Pena / Aaron M. Favila / Romeo Gacad / Dianne Faye Magbanua / Jeoffrey Maitem / Francis Malasig / Dennis Mallari / Hannah Reyes / Kriz John Rosales / Ernesto Sarmiento / Lawrence Dizon Sumulong / Veejay Villafranca / Jophel Botero Ybiosa

Poland
Michal Adamowski / Michal Adamski / Piotr Apolinarski / Mateusz Baj / Andrzej Banas / Grzegorz Banaszak / Marek M. Berezowski / Maciej Biedrzycki / Krystian Bielatowicz / Marcin Bielecki / Mateusz Birecki / Magdalena Błachuta / Piotr Bławicki / Andrzej Bogacz / Kamil Broszko / Jan Brykczynski / Dawid Chalimoniuk / Filip Cwik / Łukasz Cynalewski / Grzegorz Czarnecki / Maciej Dakowicz / Dariusz Delmanowicz / Grzegorz Dembinski / Tomasz Desperak / Krystian Dobuszynski / Irek Dorozanski / Slawoj Dubiel / Piotr Dymus / Jacek Fota / Ania Freindorf / Pawel Frenczak / Daniel Frymark / Robert Gajda / Jacek Gasiorowski / Maciej Gillert / Marcin Makówka / Kornelia Glowacka-Wolf / Arkadiusz Gola / Szymon Górski / Jan Graczyński / Michal Grocholski / Andrzej Grygiel / Wojciech Grzedzinski / Maciej Grzybowski / Tomasz Gudzowaty / Adam Guz / Jarosław Harmata / Andrzej Hulimka / Mariusz Janiszewski / Piotr Jaruga / Hanna Jarzabek / Maciej Jawornicki / Maciek Jaźwiecki / Pawel Jedrusik / Karolina Jonderko / Barttłomiej Jurecki / Maciej Kaczanowski / Marcin Kadziolka / Krzysztof Kalinowski / Marcin Kalinski / Grzegorz Klatka / Grzegorz Komar / Tytus Kondracki / Tadeusz Koniarz / Luc Kordas / Michal Korta / Joanna Kosowska / Kacper Kowalski / Andrzej Kozioł / Damian Kramski / Paweł Krok / Wiktor Kubiak / Arkadiusz Kubisiak / Adam Lach / Pawel Lączny / Marek Lapis / Tomasz Lazar / Robert Lesiuk / Maria Litwa / Michal Luczak / Luka Lukasiak / Aleksander Majdanski / Piotr Malecki / Julia Malinowska / Marek Maliszewski / Rafal Malko / Krzysztof Maniocha / Jacek Marczewski / Tymon Markowski / Wojciech Matusik / Franciszek Mazur / Slawomir Mielnik / Justyna Mielnikiewicz / Rafal Milach / Marcin Miroslawski / Filip Modrzejewski / Maciej Moskwa / Joanna Mrowka / Agnieszka Murak / Maciek Nabrdalik / Borys Niespielak / Mikolaj Nowacki / Konstancja Nowina Konopka / Adam Nurkiewicz / Jakub Ochnio / Karol Patka / Adam Panczuk / Michal Patron / Mieczyslaw Pawlowicz / Kacper Pempel / Radek Pietruszka / Jerzy Pinkas / Marcin Plonka / Jakub Porzycki / Krzysztof Racoń / Magda Rakita / Agnieszka Rayss / Jarosław Respondek / Maksymilian Rigamonti / Kuba Rubaj / Wojciech Ryzinski / Bartek Sadowski / Karolina Sekuła / Michał Siarek / Rafał Siderski / Szymon Sikora / Magdalena Siwicka / Maja Smiejkowska / Adam Stepien / Hubert Stojanowski / Bartosz Stróżyński / Elwira Szczecian / Tom Szustek / Jacek Szydłowski / Jakub Szymczuk / Piotr Tracz / Adam Tuchlinski / Jacekt Turczyk / Przemek Walocha / Adam Warżawa / Piotr Wittman / Grzegorz Wójcik / Dominika Zarzycka / Filip Zawada / Beata Zawrzel / Michal Zemanek / Grzegorz Ziemianski / Alicja Zmysłowska

Portugal
Rodrigo Cabrita / Diogo Baptista / Vitor Manuel Barros / Carlos Barroso / Júlio Barulho / Ana Brígida / Rui Caria / José Carlos Carvalho / Nuno Moura / Vladimir Rodas / Paulo Alexandre Coelho / Bruno Colaço / João Couto / Mário Cruz / Gonçalo Delgado / Rui Duarte Silva / Elisabete Farinha / José Fernandes / Jose Ferreira / Nuno André Ferreira / Jorge Firmino / Pedro Fiúza / Bruno Fonseca / Eduardo Leal / Raquel Leite / Sérgio Lemos / Delfim Machado / Ruben Mália / Egidio Santos / Adelino Meireles / Violeta Santos-Moura / Paulo Nunes dos Santos / Rui Oliveira / Octávio Passos / Pedro Patrício / Antonio Pedrosa / Luis Barbosa / Ceci de Fatima Pereira Gonçalves dos Santos / Jorge Monteiro / Rui Pires / Miguel Marques / Daniel Rodrigues / António Luís Campos / Francisco Salgueiro / António Pedro Santos / Francisco Seco / Tiago Miranda / Joao Silva / Pedro Simões / Gonçalo Lobo Pinheiro / Marcos Sobral / Paulo Alexandrino

Puerto Rico
Ricardo Arduengo /Dennis Jones

Romania
Andreea Alexandru / Mihai Barbu / Cosmin Bumbutz / Petrut Calinescu / Andreea Campeanu / Corneliu Cazacu / Vlad Chirea / Ioana Cîrlig / Vadim Ghirda / Cornel Gingarasu / Ciprian Hord / Cosmin Iftode / Darius Mitrache / Iulia Mitrache / Ioana Moldovan / Cristian Munteanu / Adelin Petrisor / Vlad Pop / George Popescu / Andrei Pungovschi / Mircea Restea / Calin Strajescu / Szigeti Vajk Istvan / Mugur Varzariu

Russia
Alexey Abanin / Fail Absatarov / Alexey Malgavko / Ekaterina Anokhina / Elena Anosova / Petr Antonov / Alexander Anufriev / Andrey Arkhipov / Vladimir Astapkovich / Max Avdeev / Dmitry Azarov / Maxim Babenko / Uldus Bakhtiozina / Vyacheslav Bakin / Dimitri Beliakov / A.Beliakov / Dmitry Berkut / Nigina Beroeva / Sergei Bobylev / Andrey Borodulin / Julia Borovikova / Viktor Borovskikh / Kristina Brazhnikova / Artem Brits / Den Butin / Konstantin Chalabov / Chelyapindi / Andrey Chepakin / Alexander Chernavsky / Mstyslav Chernov / Artem G. Chernov / Elena Chernyshova / Gennady Chubko / Oksana Danilova / Roman Demianenko / Boris Dolmatovsky / Misha Domozhilov / Nikolay Dutkin / Tatyana Egorova / V.Fedorenko / Alexander Fedorov / Evgeny Feldman / Filippov Alexey / Vladimir Finogenov / Ramil Gilvanov / Liailia Gimadeeva / Andrey Golovanov / Pavel Golovkin / Elena Gorbacheva / Mikhail Grebenshchikov / Maxim Grigoryev / Gennady Gulyaev / Viktor Guseinov / Elena Ignatyeva / Sergei Ilnitsky / Daria Isaeva / Evgenii Ivanov / Victoria Ivleva / Misha Japaridze / Anna Kabisova / Oleg Kargapolov / Vyacheslav Kasyanov / Yury Khodzitskiy / Sergei Kivrin / Valeriy Klamm / Oleg Klimov / Yuri Kochetkov / Alexey Kompaniychenko / Sergey A. Kompaniychenko / Oleg Konstantinov / Nickolay Koreshkov / Eduard Korniyenko / Vladimir Korobitsyn / Artyom Korotayev / Dmitry Kostyukov / Ludmila Kovaleva / Denis Kozhevnikov / Evgeny Kozyrev / Yuri Kozyrev / Stanislav Krasilnikov / Roman Kruchinin / Alexandr Kryazhev / Kirill Kudryavtsev / Alexey Kunilov / Vladimir Larionov / Kirill Lebedev / Julia Lisnyak / Alex Lomaev / Alexey Loshchnilov / Dmitry Lookianov / Lvova Natalia / Ruslan Makhmud-Akhunov / Roman Makhmutov / Marina Makovetskaya / Igor Maleev / Anatoly Maltsev / Olga Maltseva / Sergey Maximishin / Ekaterina Maximova / Valery Melnikov / Viatcheslav Mitrokhin / Mikhail Mordasov / Boris Mukhamedzyanov / Anton Mukhametchin / Arseniy Neskhodimov / Juri Nesterenko / Andrey Nikerichev / Sergey Novikov / Vitaliy Novikov / Natalya Onishchenko / Alexander Oreshnikov / Sergey Orlov / Vladimir Pesnya / Alexander Petrov / Ilya Pitalev / Maria Pleshkova / Maria Plotnikova / Alexandr Polyakov / Vova Pomortzeff / Sergey Ponomarev / Igor Samolet / Evgeny Potorochin / Vyacheslav Prokofyev / Pronin Andrey / Katia Repina / Katya Rezvaya / Vladimir Rodionov / Dmitriy Rogulin / Maria Romakina / Andrey Rudakov / AnaStasia Rudenko / Salavat Safiullin / Katerina Savina / Vladimir Syomin / Anna Sergeeva / Sergey Shchekotov / Ivan Shapovalov / Andrey Shapran / Tatiana Sharapova / Valery Sharifulin / Daria Wings / Max Sher / Maxim Shipenkov / Vyacheslav Shishkoedoff / Anastasia Shpilko / Ksenia Sidorova / Denis Sinyakov / Sitdikov Ramil / Vladimir Smirnov / Olga Ingurazova / Vlad Sokhin / Ekaterina Solovieva / Donat Sorokin / Alexander Stepanenko / Sergei Stroitelev / Natalia Stupnikova / Julia Sundukova / Kristina Syrchikova / Grigory Sysoev / Igor Tabakov / Alexander Taran / Fyodor Telkov / Natalia Tolkatcheva / Anastasia Tsayder / Lena Tsibizova / Ilnar Tukhbatov / Maria Turchenkova / Vadim Turnov / Denis Tyrin / Kirill Umrikhin / Anton Unitsyn / Alexander Usanov / Sergey Pyatakov / Sergey Vdovin / Vladimir Velengurin / Tatiana Vinogradova / Pavel Volkov / Natalia Volvach / Roman Vukolov / Vladimir Vyatkin / Anastasya Yerofeyeva / Victor Yuliev / Oksana Yushko / Jegor Zaika / Konstantin Zavrazhin / Valeriy Zaytsev / Alexander Zaytsev / Anatoly Zhdanov / Maxim Zmeyev

St. Kitts & Nevis
Wayne Lawrence

Saudi Arabia
Raad Adayleh / Tasneem Alsultan / Barry Christianson / Gary Van Wyk

Senegal
Mamadou dit Behan Touré

Serbia
Milos Bicanski / Marko Djurica / Darko Dozet / Marko Drobnjakovic / Andrej Isakovic / Milovan Milenković / Nemanja Pancic / Igor Pavicevic / Marko Risović / Marko Rupena / Goran Tomasevic / Tamás Tóth / Tanja Valic / Darko Vojinovic / Dragomir Vukovic

Singapore
Suhaimi Abdullah / Ooi Boon Keong / Chan Bin Kan / Amrita Chandradas / Alphonsus Chern / Chua Chin Hon / Betty Chua / Gavin Foo / Zann Huizhen Huang / Sean Lee / Yong Teck Lim / Desmond Lim / Lim Yaohui / Kevin Lim / Joseph Nair / Lionel Ng / Ong Wee Jin / Seah Kwang Peng / Edgar Su / Trevor Tan / Chih Wey Then / Hui fen Wang / Desmond Wee Teck Yew / David Wirawan / Maye-E Wong / Jonathan Yeap

Slovakia
Martin Balaz / Andrej Balco / Andrej Ban / Martin Bandzak / Jana Cavojska / Rene Fabini / Eduard Genserek / Jan Husar / Milan Illík / Jozef Jakubco / Joe Klamar / Robert Tappert / Jure Makovec / Peter Mercell / Juraj Mravec / Jozef Mytny / Tomas Rafa / Slavek Ruta / Michal Šebeňa / Mano Strauch / Adrian Svec / Gabriel Szabo / Laura Wittek

Slovenia
Aleš Beno / Luka Cjuha / Luka Dakskobler / Jošt Franko / Jaka Gasar / Maja Hitij / Arne Hodalic / Ciril Jazbec / Matjaz Krivic / Matej Lancic / Matej Leskovsek / Miro Majcen / Matej Povse / Matej Pušnik / Klemen Skubic / Oto Zan / Tadej Znidarcic / Matic Zorman

Somalia
Feisal Omar

South Africa
Neil Aldridge / Michel Bega / Nic Bothma / Jay Caboz / Daylin Joseph Paul / Adrian de Kock / Antoine de ras / Felix Dlangamandla / Ilan Godfrey / Julian Goldswain / Nigel Jabu / Tebogo Letsie / Masi Losi / Thulani Mbele / Sandile Ndlovu / James Oatway / Alet Pretorius / Samantha Reinders / Mujahid Safodien / Karin Schermbrucker / Roger Sedres / Marc Shoul / Siphiwe Sibeko / Alon Skuy / Gareth Iain Smit / David Southwood / Brent Stirton / Waldo Swiegers / Herman Verwey / Michael Walker / Hein Waschefort / Mark Wessels / Graeme Williams

South Korea
Woohae Cho / Jinsub Cho / Jong Won Cho / Cho Sung-Bong / SeongJoon Cho / Dong Jun / Choi Hyungrak / Shin Dong Phil / Heo Ran / Jae C. Hong / In Chul Kim / Jeon Heon-Kyun / Chris Jung / Jin Hyoung Kang / Youngho Kang / Kim Hong-ji / Yeon Soo Kim / H D Kim / Kyung-Hoon Kim / SeongGwang Kim / Truth Leem / Andrew Lim, Oh / Park Soo Hyeun / Jun Michael Park / S.Y Shin / Joonhee Shin / Donghoon Sung / Sung Nam-Hun / Jee Ung Yang / Sung ho / Seo Young Hee

Spain
Tomás Abella / Maysun / Pedro Acosta / Victoria

237

Adame Lopez / Alfredo Aguilar / Rafa Alcaide / Asier Alcorta / Benito Pajares / Joan Alvado / Bego Antón / Antonio Aragón Renuncio / Samuel Aranda / Celestino Arce / Javier Arcenillas / Pablo Argente / Xoan A. Soler / Bernat Armangue / Nebridi Aróztegui / Maria Arranz / Gonzalo Arroyo Moreno / Antolin Avezuela / Arnau Bach / Tina Bagué / Raul Barbero Carmena / Alvaro Barrientos / Ignacio Barrios / Edu Bayer / Raúl Belinchón Hueso / Iván Benítez / Javier Bernal Revert / Unai Beroiz / Joana Biarnés / Eduardo Blanco Mendizabal / Jesus Blasco de Avellaneda / Jordi Boixareu / Albert Bonsfills / Manu Brabo / Daniel Burgui Iguzkiza / Jordi Busque / Jordi Busquets / Albert Busquets Plaja / David Cabrera / Marina Calahorra / Alfredo Cáliz / Álvaro Calvo / Enrique Calvo / Olmo Calvo / Sergi Camara / Santi Carneri / Sergio Caro / Andres Carrasco Ragel / Daniel Casares Román / José Cendón / Guillermo Cervera / Xavier Cervera / Pablo Cobos / Jose Colon / Pep Companys / Javier Corso / Ramon Costa / Anna Dalmàs / Alberto de Isidro / Joan de la Malla / Francisco de las Heras / Cristina de Middel / Ofelia de Pablo del Valle / Oliver de Ros / Elena del Estal / Oscar del Pozo / Emilio Fraile / Cesar Dezfuli / Alberto Di Lolli / Nacho Doce / Adrián Domínguez / josep echaburu / Sergio Enríquez-Nistal / Ramon Espinosa / Patricia Esteve / Alberto Estévez / Javier Etxezarreta / Eneko Fenoy Nuñez / Manu Fernandez / Hugo Fernández / Claudio de la Cal / Jesus F. Salvadores / Edu Ferrer Alcover / Angel M. Fitor / Juan Flor / Carlos Folgoso Sueiro / Victor Fraile / Esteve Franquesa / Pedro Galisteo / Raul Gallego Abellan / Santiago Garcés / Jesús G. Pastor / Jordi Play / Rafael Trapiello / Carlos García Pozo / Pablo Garcia / Àngel García / Ricardo Garcia Vilanova / Javier García Zurita / Gabriel Garcia-Villamil / Héctor Garrido / Omar Havana / Pablo Garrigós / Juli Garzon / Rafa Gassó / Eugeni Gay Marín / Josep Gil / Sonia Giménez Bellaescusa / Cesc Giralt / Susana Girón / David Glez del Campo Garcia / Rafa Arjones / Joaquin Gomez Sastre / David González / Mdolors G-Luumkab / Daniel Gonzalez Acuña / Albert Gonzalez Farran / Pedro Armestre / Gabriel González-Andrío / J.M. Gutiérrez Caballero / Jesus Gutierrez / Tarek Halabi / Antonio Heredia / Elena Hermosa / Nacho Hernandez / Juan Herrero / Xavi Herrero / Juan Carlos Hidalgo / Diego Ibarra Sánchez / Javier Lizon / Czuko Williams / Kiko Jimenez / Javi Julio / Josep Lago / Álvaro Laiz / Aitor Lara / Daniel Leal-Olivas / Laura Leon / Sebastian Liste / Miki López / Joel López Beltrán / Antonio Lopez Diaz / Jorge López Muñoz / Ángel López Soto / Javier Luengo / Carlos Luján / Cesar Manso / Fernando Marcos / Xurde Margaride / Francisco Márquez / Guillermo Martínez / Andrés Martinez Casares / Martínez-Conde / Jacobo Medrano / Patrick Meinhardt / Yeray Menéndez / Javier Merelo de Barbera Llobet / Francisco Mingorance / Álvaro Minguito / Fernando Moleres / David Molina / Isma Monfort Vialcanet / Javier Morales / Freya Morales / Emilio Morenatti / Marcos Moreno / Jesus Moron / Angel Navarrete / Cristina Núñez Baquedano / Daniel Ochoa de Olza / Nathalie Paco / Santi Palacios / Meritxell Parera / Iker Pastor Guerra / Miguel Pérez / Francis Pérez / Eneko Pérez / Jose Gegundez / Xavier P. Moure / Jordi Pizarro / Juan Plasencia / Edu Ponces / Paco Puentes / Oriol Puig Cepero / David Ramos / Eli Regueira / Miguel Riopa / Eva Ripoll / Roberto Rivas Caravaca / Angel Rivero / Jesús Robisco / Sergio R. Moreno / Jose Luis Rodriguez / Alberto Hugo Rojas / Jaime Rojo / Manuel Romarís / Abel F. Ros / Jordi Ruiz Cirera / Abel Ruiz de Leon / Luis Miguel Ruiz Gordón / Mar Sáez / David S. Bustamante / Rubén Salgado Escudero / Dani Salvà / Moises Saman / Natalia Sancha / Borja Sanchez-Trillo / José Antonio de Lamadrid / Javier Sanchez Martinez / Ivan Sanczewski / Javier Sanchez-Monge Escardo / Álvaro Sánchez-Montañés / Marc Sanye / Eduardo Sanz Nieto / Lourdes Segade / Jesus Serrano Redondo / Jose Silveira / Tino Soriano / Carlos Spottorno / Anna Surinyach / Javier Taveras / Juan Teixeira / Itziar Telletxea Rocha / Enrique Truchuelo Ramirez / Felipe Trueba / Josu Trueba Leiva / Raúl Urbina / Georgie Uris Domingos / Manu Valcarce / Quintina Valero / Guillem Valle / Lucas Vallecillos / Joan Valls / Mingo Venero / Susana Vera / Jaime Villanueva / Oscar Villanueva / Alvaro Ybarra Zavala / Andrea Yrazu Barreda / J. Zabalza / Julio L. Zamarrón / Alejandro Zapico / Miguel Zavala

Sri Lanka
Tharaka Basnayaka

Sudan
Mohamed Nureldin Abdallah

Surinam Roy Ritfeld

Sweden
Joel Alvarez / Anders Andersson / Urban Andersson / Henry Arvidsson / Gunnar Ask / Christian Aslund / Andreas Bardell / Johan Bävman / Mathias Bergeld / Anette Brolenius / Lars Brundin / Henrik Brunnsgård / Lars Dareberg / Hussein El-alawi / Åke Ericson / Charlotte Fernvall / Malin Fezehai / Jan Fleischmann / Anders Forngren / Linda Forsell / Jessica Gow / Niclas Hammarström / Paul Hansen / Anders Hansson / Dagens Nyheter / Christoffer Hjalmarsson / Tommy Holl / Pontus Hook / Torbjörn Jakobsson / Eva-Lotta Jansson / Olof Jarlbro / Simon Johansson / Johan Persson / Moa Karlberg / Jesper Klemedsson / Stefan Bladh / Roger Larsson / Magnus Laupa / Fred Lerneryd / Jonas Lindkvist / Nerikes Allehanda / Staffan Löwstedt / Chris Maluszynski / Joel Marklund / Stefan Mattson / Jack Mikrut / Jonathan Nackstrand / Anette Nantell / Michael Nasberg / Nils Petter Nilsson / Daniel Nilsson / Thomas Nilsson / Brita Nordholm / Loulou d'Aki / Axel Oberg / Tomas Ohlsson / Malin Palm / Andrea Peter Fly / Katarina Premfors / Sebastian Sardi / Åsa Mikaela Sjöström / Linus Sundahl-Djerf / Roger Turesson / Elisabeth Ubbe / Martin von Krogh / Anna Wahlgren / Tom Wall / Magnus Wennman / Torbjörn Wester / Peter Wixtröm / Jacob Zocherman

Switzerland
Zalmaï Ahad / Kurt Amsler / Sébastien Anex / Daniel Auf der Mauer / Denis Balibouse / Franco Banfi / Fabian Biasio / Christian Bobst / S.Borcard / Jean-Christophe Bott / Mathias Braschler / Pit Buehler / Stéphanie Buret / David Carlier / Fabrice Coffrini / Régis Colombo / Michele Crameri / Philippe Dudouit / Pierre-Emmanuel Fehr / Sibylle Feucht / Yvain Genevay / Laurent Gilliéron / Marco Grob / Maurice haas / Markus Bühler-Rasom / Mario Heller / Hans Peter Jost / Joseph Khakshouri / Patrick B. Kraemer / Yves Leresche / Christian Lutz / Benjamin Manser / David Marchon / Kostas Maros / Nicolas Metraux / Pascal Mora / Dominic Nahr / Klaus Petrus / Stephan Rappo / Jean Revillard / Daniel Rihs / Patrick Rohr / Didier Ruef / Roland Schmid / Philipp Schmidli / Beat Schweizer / Lazar Simeonov / Dominic Steinmann / O Vogelsang / Andreas Walker / Stefan Wermuth / André Widmer / Matthieu Zellweger / Michael Zumstein

Syria
Ammar Abdullah / Carole Alfarah / Sameer Al-Doumy / Baraa Al-Halabi / Zakariya Al-Kafi / Karam Al-Masri / Zein Al-Rifai / Khalel Ashawe / Amer Almohibany / Khalil Ashawi / Mohammed Badra / Abd Doumany / Omar Haj Kadour / Abdalrhman Ismail / Hosam Katan / Bassam Khabieh / Alaa Khweled / Rodi Said / Omar Sanadiki / Hisham Zaweet / Rami Zayat

Taiwan
Simon Chang / Martti Chen / Nana Chen / I-Hwa Cheng / Chi Chih-Hsiang / Wei-Sheng Huang / Jack Huang / Tzu Cheng Liu / Yingting Shih / Chienyi Tseng / Wang Fei Hwa / Chih-Wei Yu / Yuan Chun-Te

Thailand
Piti A Sahakorn / Bundit Chotsuwan / Sittichai Jittatad / Athit Perawongmetha / Korbphuk Phromrekha / Suracheth Prommarak / Ekkarat Punyatara / Atiwat Silpamethanont / Natis Sirivatanacharoen / Piyavit Thongsa-Ard

Trinidad & Tobago

Andrea De Silva

Tunisia
Ons Abid / Omar Nejai

Turkey
Ilyas Akengin / Yasin Akgul / Fatih Aktas / Mete Aktas / Hüseyin Aldemir / Hakan Burak Altunoz / Usame Ari / Oktay Bayar / Tumay Berkin / Özkan Bilgin / Aydin Çetinbostanoglu / Nilüfer Demir / Cagdas Erdogan / Salih Zeki Fazlıoğlu / Sait Serkan Gurbuz / Barbaros Kayan / Ertugrul Kilic / Bulent Kilic / Ozge Elif Kizil / Celil Kırnapcı / Oguzhan Kose / Ozan Kose / Levent Kulu / Sahan Nuhoglu / Emin Özmen / Ali Ihsan Öztürk / Fatih Pinar / Mehmet Ali Poyraz / Murat Saka / Halit Onur Sandal / Mustafa Seven / Murad Sezer / Uygar Onder Simsek / Furkan Temir / Ercin Top / Tahir Ün / Sule Tulin Uner / Ömer Ürer / Yakut Islam / Mustafa Yalcin / Ibrahim Yaldiz / Mehmet Yaman / Zeki Yavuzak / Firat Yurdakul

Uganda
Williams Moi Arimo / Edward Echwalu / Johnson Grace Maganja / Nsubuga Michael

Ukraine
Mykola Bochek / Arthur Bondar / Vadim Braydov / Alexander Chekmenev / Oleg Dubyna / Yurko Dyachyshyn / Alexander Ermochenko / Alexander Feldman / Alexey Furman / Gleb Garanich / Kirill Golovchenko / Oleksandr Klymenko / Oleksandr Kozlovskyi / Dmitriy Kutz / Maksym Liukov / Andriy Lomakin / Telyut / Oleg Makovskyi / Evgeniy Maloletka / Natasha Masharova / Pavlo Maydikov / Olya Morvan / Zhenya Nesterets / Oleg Nikitenko / Mikhail Palinchak / Sergii Polezhaka / Serge Poliakov / Roman Pilipey / Stepan Rudyk / Oleksandr Rupeta / Anatolii Stepanov / Ruslan Stepanov B. / Valerii Tkachenko / Vitaliy Turovskyy / Volodymyr Tverdokhlib / Ivan Tykhy / Max Vetrov / Roman (Raphael Isaak) Vilenskiy / Anastasia Vlasova / Anton Volk

United Arab Emirates
Kamran Jebreili

United Kingdom
Ed Alcock / Timothy Allen / Jane Barlow / Rosie Barnes / Justin Barton / Alison Baskerville / Guy Bell / Eleanor Leonne Bennett / Frederick Bernas / Vince Bevan / Peter Blake / Will Boase / Harry Borden / Rich Bowen / Andrew Boyers / Jonathan Brady / Joshua Bright / Kayte Brimacombe / Adrian Brown / Clive Brunskill / Simon Bruty / Jason Bryant / Tessa Bunney / Gary Calton / André Camara / Brian Cassey / Helen Cathcart / Angela Catlin / Peter Caton / Matt Cetti-Roberts / James Chance / David Chancellor / Wattie Cheung / Carlo Chinca / D J Clark / Phil Clarke Hill / Nick Cobbing / Rebecca Conway / Christian Cooksey / Gareth Copley / Sam Christopher Cornwell / Vicki Couchman / Helen Couchman / Damon Coulter / Carl Court / Andrew Cowie / Michael Craig / Alan Crowhurst / Ben Curtis / Simon Dack / Nick Danziger / Prodeepta Das / Jabruson / David Davies / Carl de Souza / Adam Dean / Adrian Dennis / Nigel Dickinson / Kieran Dodds / Luke Duggleby / Matt Dunham / Jillian Edelstein / Mike Egerton / Neville Elder / Drew Farrell / Rick Findler / Julian Finney / Jason Florio / Stu Forster / Stuart Forster / Michael Fox / Charles Fox / Andrew Fox / Patrick Fraser / Sam Frost / Christopher Furlong / Sean Gallagher / Nick Gammon / George Georgiou / Dan Giannopoulos / Michael Goldrei / Andy Gotts / Charlotte Graham / Sophie Green / Johnny Green / Andy Hall / Neil Hall / Charlie Hamilton James / Jay Shaw-Baker / Sara Hannant / Brian Harris / Olivia Harris / Haakon Michael Harriss / Rahman Hassani / Mark Henley / Mike Hewitt / Clare Hewitt / Jack Hill / Paul Hilton / Liz Hingley / Jane Hobson / Daniel James Homewood / Tom Hoops / Rip Hopkins / Derek Hudson / Mike Hutchings / Iain McLean / Susannah Ireland / Thabo Jaiyesimi / Tom Jamieson / Tom Jenkins / Doug Jewell / Justin Jin / Spike Johnson / Will Johnston / Ed Jones / Eddie

Keogh / Glyn Kirk / Dan Kitwood / Ian Spencer Langsdon / Louis Leeson / Jed Leicester / David Levenson / Matthew Lewis / Ian Longthorne / Lucy Ray / Luke Macgregor / Murdoch MacLeod / Ian MacNicol / Bob Martin / Guy Martin / Dylan Martinez / Clive Mason / Leo Mason / Jenny Matthews / Andrew McCaren / Rachel Megawhat / Julie McGuire / David McHugh / Toby Melville / Robert Andrew Mercer / Graham Miller / Dan Milner / Jeff Mitchell / Bora Shamlo / Yui Mok / Phil Moore / James Morgan / Eddie Mulholland / Lucy Nicholson / Cian Oba-Smith / Pete Oxford / Tracey Paddison / Samuel Bay / Laura Pannack / David Parry / Andrew Paton / Ben Stansall / Teri Pengilley / Robert Perry / Kate Peters / Tom Pilston / Lucy Piper / Giles Price / Andrew Redington / Darran Rees / Stephen Robinson / Nigel Roddis / Will Rose / Stefan Rousseau / Hugh Routledge / Anita Russo / Jeff Gilbert / Honey Salvadori / David Sandison / Oli Scarff / Michael Schofield / Mark Seager / Bradley Secker / Justin Setterfield / Richard John Seymour / John Sibley / Jamie Simpson / Sam Spickett / Anthony Stanley / Michael Steele / Craig Stennett / Rob Stothard / Chris Stowers / Geoffrey Swaine / Sam Tarling / Colin James Tennant / Edmond Terakopian / Andrew Testa / Ed Thompson / Jon Tonks / Abbie Trayler-Smith / Chris Trotman / Francis Tsang / Nino Alavidze / Mary Turner / Mat Twells / Mike Urwin / Charlie Varley / Aubrey Wade / John Walton / James Warwick / Richard Wayman / Andy Weekes / Tom White / Amiran White / Kirsty Wigglesworth / Greg Williams / James Williamson / Des Willie / Will Wintercross / Andrew S.T. Wong / Matt Writtle / Chris Young / Tariq Zaidi

United States

Mustafah Abdulaziz / Nick Adams / Lynsey Addario / James Edward Albright Jr. / K.C. Alfred / Carol Allen-Storey / Kainaz Amaria / Joe Amon / Scott Anderson / Jason Andrew / John Angelillo / Bryan Anselm / Casey Atkins / Tony Avelar / Jeffrey Barbee / Tracy Barbutes / Rebecca Barger / Laylah Amatullah Barrayn / David Bathgate / Chad Batka / David Bauman / Will Baxter / Robert Beck / Robyn Beck / Keith Bedford / Al Bello / Bruce Bennett / Josh Bergeron / Alan Berner / Adam Berry / Keith Birmingham / Rebecca Blackwell / Peter Blakely / Victor J. Blue / Craig Boehman / Nancy Borowick / Jabin Botsford / Anna Boyiazis / Bobby Bradley / Alex Brandon / M. Scott Brauer / Scott Brennan / Daniel Brenner / William Bretzger / Daniel C. Britt / Ben Brody / Paula Bronstein / Nathaniel Brooks / Milbert Brown / Andrea Bruce / Kevin Bubriski / Chris Buck / Joe Buglewicz / Robert F. Bukaty / Gregory Bull / Tony Bullard / Gerard Burkhart / Andrew Burton / Matthew Busch / David Butow / Renée C. Byer / Andrew Caballero-Reynolds / Mary F. Calvert / Gary Cameron / D. Ross Cameron / Ricky Carioti / Brett Carlsen / Darren Carroll / Nelvin Cepeda / Dominic Chavez / Ray Chavez / Minghui Chen / Henry Cherry / Jahi Chikwendiu / Barry Chin / LiPo Ching / Ringo Chiu / André Chung / Giles Clarke / Jay Clendenin / Brian Clopp / Nadia Shira Cohen / Robert Cohen / Carolyn Cole / Sebastian Collett / Clayton Conn / Eduardo Contreras / Veasey Conway / Thomas Cordova / Andrew Craft / Mary D'Anella / Scott Dalton / Jim Damaske / Jonathan Daniel / Lauren DeCicca / Jason DeCrow / James Whitlow Delano / Gabriella Demczuk / Amanda Demme / Bryan Denton / Bryan Derballa / Julie Dermansky / Robert Deutsch / Peter DiCampo / James Dickman / Kevin Dietsch / Bobby Doherty / Douglas Seifert / Olivier Douliery / Travis Dove / Michael Downey / Christena Dowsett / Daniel Dreifuss / Melanie Dunea / Aristide Economopoulos / Matt Eich / Scott Eisen / Sean D. Elliot / Ronald W. Erdrich / Josh Estey / Timothy Fadek / Steven M. Falk / Patrick Fallon / Megan Farmer / Gina Ferazzi / Jon Ferrey / Molly Ferrill / Stephen Ferry / Deanne Fitzmaurice / Mikel Flamm / Lauren Fleishman / Cristina M. Fletes / Kate Flock / Michael Forster Rothbart / Tom Fox / Bill Frakes / Frank Frank / Brian L. Frank / Gary Friedman / Misha Friedman / Noah Friedman-Rudovsky / Trevor Beck Frost / Rebecca Gaal / Pearl Gabel / Michelle Gabel / Noam Galai / Phyllis Galembo /

Preston Gannaway / Marco Garcia / Elie Gardner / Mark Garfinkel / Mark Garten / Robert Gauthier / Joseph Paul Gidjunis / David Gilkey / Joseph M. Giordano / Melissa Golden / David Goldman / Al Golub / Glenna Gordon / Mark Greenberg / Stanley Greene / Pat Greenhouse / Michael Greenlar / Osie Greenway / David I. Gross / Ackerman Gruber / David Gulden / Erol Gurian / David Guttenfelder / Jane Hahn / Bob Hallinen / Andrew Hancock / Josh Haner / David Hanson / Michael Hanson / Mark Edward Harris / Cheryl Hatch / Matthew Hatcher / Laura Heald / Todd Heisler / Ryan Henriksen / Gerald Herbert / Sam Heydt / Tyler Hicks / Erik Hill / Ed Hille / Derick Hingle / Sarah Hoffman / Brendan Hoffman / Jonathan Hollingsworth / Loren Holmes / Mark Holtzman / Erin Hooley / Alexandra Hootnick / Cable Hoover / Lisa Hornak / Vasha Hunt / Jed Jacobsohn / Yasamin Jafari Tehrani / Terrence Antonio James / Yalonda M. James / Jay Janner / Ian Thomas Jansen-Lonnquist / Monique Jaques / Janet Jarman / Shannon Jensen Wedgwood / Angela Jimenez / Krisanne Johnson / David Joles / Octavio Jone / Renée Jones Schneider / Allison Joyce / Moe Zoyari / Greg Kahn / Anthony Karen / Ed Kashi / Karen Kasmauski / Carolyn Kaster / Jeff Kennel / Laurence Kesterson / Natalie Keyssar / Pete Kiehart / Hyunsoo Leo Kim / John J. Kim / Yunghi Kim / Michael Vince Kim / Patrick Kim / John Kimmich-Javier / Kohjiro Kinno / Paul Kitagaki Jr. / Mackenzie Knowles-Coursin / Jim Korpi / Isadora Kosofsky / Brooks Kraft / Lisa Krantz / Suzanne Kreiter / Elizabeth Kreutz / Charles Krupa / Teresa Kruszewski / David L. Ryan / Vincent Laforet / Tim Laman / Rod Lamkey / John Lamparski / Tamar Lando / Justin Lane / Adrees Latif / Gillian Laub / Aaron Lavinsky / Streeter Lecka / Mark Leong / Marc Lester / Heidi Levine / William Wilson Lewis III / Sara Naomi Lewkowicz / David Liittschwager / Ariana Lindquist / Jim Lo Scalzo / John Locher / Jeremy Lock / John Loomis / Rick Loomis / Delcia Lopez / Dario Lopez Mills / Kirsten Luce / Erik Lunsford / Matt Lutton / Patsy Lynch / Tom Lynn / Chris Machian / Jose Luis Magana / Brandon Magnus / M. Scott Mahaskey / David Maialetti / Andre Malerba / Mary Ellen Mark / Diana Markosian / Pete Marovich / Dan Marschka / Jacquelyn Martin / Joel Martinez / Pablo Martinez Monsivais / AJ Mast / Joanne Matuschka / Ian Maule / Tannen Maury / Matthew McClain / Michael F. McElroy / Maddie McGarvey / Scott McIntyrer / Win McNamee / Eric Mencher / Justin Merriman / Rory Merry / Nhat Meyer / Garth Milan / Bob Miller / Leah Millis / Lester Millman / Daniel Sangjib Min / Donald Miralle, Jr. / Jillian Mitchell / Logan Mock-Bunting / Philip Montgomery / John Moore / Karsten Moran / David Paul Morris / Stephen B. Morton / Laura Morton / Paul Moseley / Bonnie Jo Mount / Dijana / Jordan Naholowa'a Murph / Daniel Murphy / Edward J. Murray / Ana Nance / Jake Naughton / Sol Neelman / Andrew A. Nelles / Greg Nelson / Grant Lee Neuenburg / Jonathan Newton / Gregg Newton / Jason Nocito / Landon Nordeman / Adriane Ohanesian / Katie Orlinsky / Francine Orr / Kevin Oules / Darcy Padilla / Stuart Palley / Yana Paskova / Joshua Paul / San Diego Union-Tribune / Eli Pedraza / Joe Penney / Michael Perez / Algerina Perna / Corey Perrine / Mark Peterson / Spencer Platt / Robert Pluma / Suzanne Plunkett / Lisette Poole / Mamta Popat / Alex Potter / Jiohn Protopapas / Juan Carlos / Raul Rubiera / Staton Rabin / Connor Radnovich / Joe Raedle / Erick W. Rasco / Barry Reeger / Tom Reese / Andrew Renneisen / Tim Revell / Damaso Reyes / Adam Reynolds / Andy Richter / Joe Riis / Jessica Rinaldi / Amanda Rivkin / Syracuse Media Group / Larry Roberts / Julia Robinson / Michael Robinson Chávez / Rick Rocamora / Paul Rodriguez / James Rodriguez / Andrea DiCenzo / Aaron Rosenblatt / Jenny E. Ross / Jessica Rotkiewicz / Angela Rowlings / John Rudoff / Benjamin Rusnak / Andrew Russell / J.B. Russell / Craig Ruttle / Carlos M. Saavedra / Ryan Salm / Wil Sands / RJ Sangosti / April Saul / Allen Schaben / Kevin Schafer / Mindy Schauer / Erich Schlegel / Bastienne Schmidt / Alyssa Schukar / Jenny Schulder / Erika Schultz / Robert Seale / Sean Gallup / Mark Seliger / Patrick

Semansky / Andrew Seng / Joe Shalmoni / Ezra Shaw / Allison Shelley / Kathy Shorr / Ricci Shryock / Sam Simmonds / Denny Simmons / Mike Simons / Stephanie Sinclair / Keith Sirchio / Wally Skalij / Laurie Skrivan / Patrick Smith / Drew Anthony Smith / Steven G. Smith / Michael Kirby Smith / Brian Snyder / Nichole Sobecki / Chip Somodevilla / Paul Souders / Anthony Souffle / Andrew Spear / Tristan Alexei Spinski / Sarah Stacke / Andrew Stanbridge / Jeremiah Stanley / John Stanmeyer / Shannon Stapleton / Susan Stava / Justin L. Stewart / Sean Stipp / Matthew Stockman / Robert Stolarik / Stephanie Strasburg / Scott Strazzante / Theo Stroomer / Justin Sullivan / Andrew Sullivan / Chitose Suzuki / Lexey Swall / Joseph Sywenkyj / John Taggart / Ramin Talaie / Mario Tama / Wei Tan / Nima Taradji / Patrick Tehan / Mark J. Terrill / Sara Terry / Bizuayehu Tesfaye / Shmuel Thaler / Bryan Thomas / Lonnie Timmons III / John Tlumacki / Tara Todras-Whitehill / Jonathan Torgovnik / Ken Touchton / Erin Grace Trieb / Rob Tringali / Linda Troeller / John Trotter / Richard Tsong-Taatarii / Nicole Tung / Jane Tyska / Dana Ullman / Gregory Urquiaga / Nuri Vallbona / Peter van Agtmael / Carolyn Van Houten / Will van Overbeek / Anand Varma / Shawna Whelan / Brad Vest / Danielle Villasana / José Luis Villegas / Leigh Vogel / Amanda Voisard / Sarah Voisin / Fred Vuich / Mark W Kelley / Craig F. Walker / Mark Wallheiser / B. Ware / Guy Wathen / James Watson / Susan Watts / Troy Wayrynen / Diane Weiss / David H. Wells / Mickey Welsh / Jim West / Tito West / Max Whittaker / Christian Wilbur / Rick T. Wilking / Dalyce / Damon Winter / Steve Winter / Patrick Witty / Sam Wolson / Alex Wong / Alison Wright / Alex Wroblewski / David Wuerth / Caroline Yang / David Yoder / Michael Zajakowski / Daniella Zalcman / Mark Zaleski / Ariel Zambelich / Zhao Jingtao / Jane Zuo

Uruguay

Julio Etchart / Agustin Fernandez / Christian Rodríguez

Uzbekistan

Elyor Nematov / Dana Oparina

Venezuela

Pedro Antonuccio Sanó / Carlos Becerra / Oscar B. Castillo / Alejandro Cegarra / Luis Cobelo / Fenelon Diaz / Andrés Gutiérrez / Efrén Hernández-Arias / Adriana L. Fernández / Vladimir Marcano / Humberto Matheus / Jacinto Oliveros / Javier Plaza / José M. Ramírez / Carlos Sanchez / Jimmy Villalta

Vietnam

Eddie Tien / James Duong / Lai Khanh / Le Anh Dung / Luong Phu Huu / Tan Nguyen / Phan Quang / Vo Trung Nghia Trinh

Yemen

Mohammed Huwais / Abdulnasser Alseddik / Yahya Arhab / Hani Mohammed

Zimbabwe

Alexander Joe / Wallace Munodawafa Mawire /

Copyright © 2016
Stichting World Press Photo, Amsterdam,
the Netherlands
www.worldpressphoto.org
Schilt Publishing, Amsterdam,
the Netherlands
All photography copyrights are held by
the photographers.

First published in Great Britain in 2016 by
Thames & Hudson Ltd,
181A High Holborn, London WC1V 7QX
www.thamesandhudson.com

First published in the United States of
America in 2016 by Thames & Hudson Inc.,
500 Fifth Avenue, New York, New York 10110
www.thamesandhudsonusa.com

Art director
Teun van der Heijden
Design
Heijdens Karwei
Production coordinator
Anaïs Conijn
Picture coordinator
Thera Vermeij
Captions
Rodney Bolt
Editorial coordinators
David Campbell
Laurens Korteweg
Rosalyn Saab
Editor
Kari Lundelin

Print & Logistics Management
KOMESO GmbH, Stuttgart, Germany
www.komeso.de
Lithography, printing and binding
Offizin Scheufele, Stuttgart, Germany
www.scheufele.de
Production supervisors
Maarten Schilt
Yasmin Keel
Schilt Publishing, Amsterdam,
the Netherlands
www.schiltpublishing.com

ISBN 978-0-500-97073-7